香港葫蘆

賣也藥

HONG KONG APOTHECARY:
A Visual History of Chinese Medicine Packaging

Simon Go

Princeton Architectural Press New York

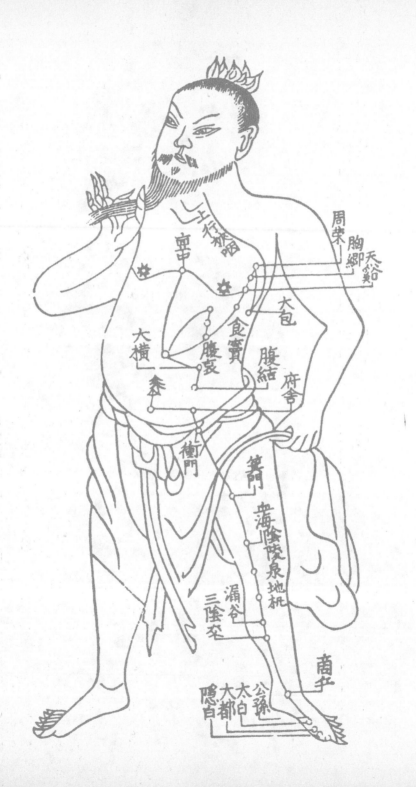

Dedicated to my wife, Iman, and to my mother, and in memory of my grandmother.

This book also pays tribute to the devoted practitioners of traditional Chinese medicine for their considerable contribution to society.

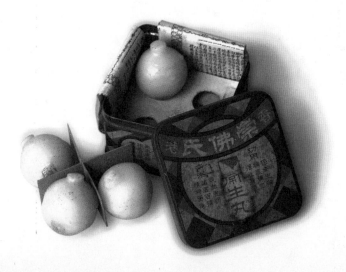

Princeton Architectural Press
37 East Seventh Street
New York, New York 10003
U.S.A.

For a free catalog of books, call 1.800.822.6657.
Visit our web site at www.papress.com.

Originally published in Chinese in Hong Kong 2001.
© 2003 Simon Go
All rights reserved.
Printed and bound in Hong Kong.
06 05 04 03 5 4 3 2 1 First Edition

Editor: Jennifer N. Thompson
Copyright and project management: MCCM Creations
Editorial and translation work team: Diane Bennett, Rita Lee, Phoebe Wong
Designer: Match Box Idea

Special thanks to Nettie Aljian, Ann Alter, Nicola Bednarek, Janet Behning, Megan Carey, Penny (Yuen Pik) Chu, Russell Fernandez, Jan Haux, Clare Jacobson, Mark Lamster, Nancy Eklund Later, Linda Lee, Nancy Levinson, Katharine Myers, Jane Sheinman, Scott Tennent, Joe Weston, and Deb Wood of Princeton Architectural Press —Kevin C. Lippert, publisher

Library of Congress Cataloging-in-Publication Data
Go, Simon, 1967-
Hong Kong apothecary : a visual history of Chinese medicine packaging/ Simon Go.
p. cm.
ISBN 1-56898-390-5 (pbk. : alk. paper)
1. Drugs--Packaging--China--Hong Kong--History.
2. Medicine, Chinese--History.
3. Materia medica--China--Hong Kong--History.
I.Title.
RS159.5 .G6 2003
615'.1'0951--dc21
2003006087

Contents

Frontispiece: Dried hollowed-out gourd was a practical medicine container

Introduction

In the last twenty years, the urban landscape of Hong Kong has undergone rapid change. Accompanying the replanning and redevelopment of obsolete districts, older buildings have been demolished to give way to high-rises. Dwellers and tradespeople have moved and resettled, resulting in the waning of trades and the closing down of many old shops. With the passing away of the older generations, the stories of these old shops and trades have disappeared almost unnoticed. Losing these pieces of evidence and valuable experiences would be a sad loss to the history of traditional Chinese medicine.

Nevertheless, through patchy personal recollections, it is sometimes possible to put together a more complete picture of the past. The odors of medicinal herbs coming from Chinese medicine shops always brings flashbacks of my childhood.

Herbal medicine is an integral part of Chinese culture. Its early development in Hong Kong can be traced back to pedlars selling medicine and the barefoot doctors who practiced medicine as the family business. The more established Chinese medicine shops and manufacturers mostly originated in the mid-nineteenth century as branches of the main companies, located in the Foshan and Guangzhou regions. The well-known companies Tong Sap Yee 唐拾義, Poon Goor Soe 潘高壽, Shing Chai Tong 誠濟堂, and Chan Li Chai 陳李濟 successively established medicine factories in Hong Kong. From the beginning of the twentieth century until the founding of the People's Republic of China in 1949, the growth of the industry arose from the establishment of many big brand names in Hong Kong. These century-old medicine manufacturers, each having its own secret formula for reputable products in the Pearl River Delta region, prospered in the territory.

The increased demand led subsequently to keen competition among the manufacturers. Besides placing advertisements in newspapers and on the radio, many companies improved their packaging. With the exception of conservative manufacturers, who continued to use plain paper wrappings, most of them returned to gracefully printed packets or boxes. Initially the portraits of company founders were used as trademarks and their names made the companies successful; Tong Yeu Ling 唐堯齡, Cheung Guo Ling 張九齡, Tong Sap Yee, and Leung Pui Kee 梁培基 were prime examples. Later, characters or events from folk tales were used as trademarks: Wah Tor 華陀, Ling Chi 靈芝, and Filial Piety 二十四孝.

Since medicine trading could be a profitable business, swindlers produced counterfeit goods. In response, manufacturers began to use more sophisticated packaging designs. Some even resorted to bank-note-printing technology to produce guarantee coupons and embossed sealing labels to impede forgery. However, owing to the general lack of consumer awareness at that time, or to the cunning of the swindlers, there were frequent fatalities from the consumption of counterfeit medicine.

In order to prevent forgery and protect their reputation, the most established manufacturers were willing to commission specific designers to do the packaging. This not only increased the products' salability but also facilitated stocktaking of commodities and transportation to both local and overseas markets. As a result, smaller manufacturers tended to imitate the designs of their larger counterparts to promote salability, and products of similar packaging design came onto the market all at once.

From its very beginning, medicine manufacturing has been a professional business. Initially, manufacturers, certified by the Republican government, earned the general approval of Hong Kong consumers. Later the Hong Kong government enacted legislation to regulate the trade manufacturers to gain the general confidence of consumers by depending on the "Made in Hong Kong" label.

As an old master of the industry once said, "What the Chinese value most is honesty; credibility is especially important in the business of medicine trading." Indeed the idea of helping a person in need is a pleasure, and to heal and dispense medicine altruistically to the poor is a traditional moral virtue. A pill contains every essence of wisdom; it is imbued with the piety, honesty, and righteousness of the Chinese. Packaging design, as an adorning overcoat, should perhaps be a testament to the everlasting quality of these virtues.

Simon Go

Rejuvenating Design

"When you have something as beautiful as the little Pak Fah Yeow 白花油 bottle," commented the distinguished Hong Kong designer Henry Steiner, "it is only necessary to freshen up the packaging such as the company's subtle replacement of the black Bakelite cap with one matching its famous blue label. Sometimes a designer should be rewarded for rejuvenating, rather than completely revising, traditional design."

Steiner's reflection on Hong Kong's best-known medicine packaging reveals no sentimental indulgence on the part of a Western designer, but rather professional respect for the integrity of early modern Chinese design. Outside herbal-medicine packaging, this genre has long since been displaced by the conventions of international graphic design or by an egregiously "retro" Shanghai style.

Those expecting Simon Go's richly illustrated study of traditional medicine packaging to be a compendium of nostalgia will therefore be surprised to discover the contemporary significance of early modern Chinese design. For alongside the packaging of cosmetics, teas and tobacco design and promotion of herbal pills, powders, creams, and infusions was a surprisingly modern, professional export oriented industry, established in response to the influx of foreign pharmaceutical firms during the mid-nineteenth century.

The mid-nineteenth century was a time that happily combined throwbacks to an imagined past with radical social change and economic development. This was the era of "invented traditions," both in the East and the West. The realization of new nation states required both a patriotic appeal to imagined traditions (such as the Scottish tartan) alongside drastic political, industrial, and cultural change. In China, for example, the revival of martial arts cultivated variously by sections of the gentry, underground societies, and popular novels, was a patriotic movement, at once atavistic and revolutionary, spurred on by colonial invasion.

On the commercial front, the arrival of colonial pharmaceutical companies, like Watson's (established in Hong Kong in 1841, the year the territory was ceded to Great Britain), forced local herbalists to invent a compelling imagery for their products. Taking advantage of expanded opportunities for trade in the colony, many Foshan and Guangzhou medicine companies opened branches in Hong Kong. The export of their products to overseas Chinese communities spread across Southeast Asia. By the end of the nineteenth century, many such companies had expanded their markets to as far as the West Coast of America.

Naturally the sources of early modern Chinese medicine packaging were eclectic. In the richly ornamented labels and intricate cartouches framing certificates of authenticity or instructions for use, the influence may be traced to both popular New Year prints and elite snuff bottles, alongside Western bank notes (adapted to guard against imitation, which was already rife), Japanese commercial art, and later the French art deco style, which were all imported through Shanghai.

Go's study reveals how early modern Chinese design was not static but evolved continually to meet the challenge of foreign competition, the requirements of trademark and copyright legislation (the first international copyright laws were devised in Hong Kong in the 1870s), the graphic opportunities presented by lithography and other new printing technologies, and the marketing potential of promotional media such as posters and newspaper advertisements. Returning to the example of Pak Fah Yeow, this study shows how every aspect of the bottle, label, package, and cap design, including graphics and typography, changed successively over the decades.

Indeed the rapid social changes of the late-nineteenth and early-twentieth centuries demanded continual innovation on the part of packaging designers. The lurid imagery and text appropriate to earlier preparations blatantly directed at opium addiction and venereal disease were hardly appropriate to the expanding market for herbal medicines, which targeted the hypochondriac male fascination with diets, medicines, potency, and general health. These packages followed the late Qing-dynasty obsession (in the face of visible social decay) with guarantees of multiple progeny and personal longevity. During the modern, Nationalist era, Chinese medicine companies once again rejuvenated their packaging, highlighting images of well-fed babies, beautiful women, and happy families a not-so-subtle appeal to political ideologies that ran from the "self-strengthening" to "new life" movements, which emphasized strong, healthy families in the modernizing project of nation building.

Remarkably, many Chinese medicines have outlasted the foreign imports of the nineteenth century that gave rise to early modern Chinese packaging design. What, for example, became of "Dr Williams' Pink Pills for Pale People," so enthusiastically marketed a century ago?

Herbal medicines even survived the global Westernization of pharmaceutical industries. We may now smile at the blatant claims and charmingly naive images that wrap old-time Chinese remedies, but were they any more untested than the claims made by the makers of thalidomide or any more naive than the implied claims to rugged good health and masculine potency still peddled by the Marlboro Man? As the world grows skeptical of the claims (and profits) of Western drug companies and more critical of the insidious influence of global marketing and branding, increasing numbers of people have begun to explore traditional herbal remedies, complementary therapies, and alternative medicine.

At the same time we are witnessing a transformation of what was once a passing nostalgia for Hong Kong taste into a global interest in Chinese visual culture. In graphics, decor, fashion, and film there is now an appreciation that there is not one but many competing traditions of modernism, offering rich directions for future design. Steiner was right: sometimes designers ought to be rewarded for rejuvenating instead of completely revising tradition.

Simon Go's study of early modern Chinese medicine packaging certainly contributes much to our understanding of the tangled undergrowth of modern visual culture.

Professor Matthew Turner, School of Design and Media Arts
Napier University, Edinburgh, Scotland

The Origin of Chinese Medicine

Centuries ago the primitive living conditions of our forefathers represented a constant struggle with extreme climatic variations and fierce attacks from wild animals. Suffering frequently from illnesses and injuries, they gradually learned to use plants, animals, and minerals as a means of preserving their health. In the course of hunting, fishing, and foraging for plants, they discovered through trial and error the infinite remedies offered up by nature.

The external application of medicine derives from the practice of placing soil, leaves, and grass on wounds inflicted during battle. This treatment developed further when our ancestors began to warm medicinal ingredients over a fire to form a paste for topical application.

Chinese medicine encompasses a wealth of basic philosophical knowledge, with the principles of yin yang 陰陽 and the five elements (metal, wood, water, fire, and earth) 五行 forming the mainstay. Great emphasis is placed on cultivating one's health on a day-to-day basis. When illness strikes, doctors can mobilize the body's resistance to disease by heeding symptoms rather than the disease itself. In other words, when pathogens upset the normal functioning of the internal organs and entrails, Chinese medicine is used to correct these abnormal symptoms and restore the equilibrium of yin yang thereby regaining the patient's good health.

What is Traditional Chinese Medicine?

Generally speaking, traditional Chinese medicine takes seven basic forms: plasters, pellets, pills, powders, teas, oils, and wine, all of which are derived from herbs, animals, and minerals. Prescriptions have developed over time resulting in instant medicines, for example, which can be taken orally or applied externally without the need for decocting. Traditional Chinese medicine is characterized by a vast array of mild but effective remedies causing few side effects. Typically prescriptions contain not one but many carefully balanced ingredients producing remarkable therapeutic effects while promoting general well-being.

Distilled into attractive pocket-size packages, these tried and true remedies have gained widespread acceptance among the public for their convenience and are generally available over the counter without a doctor's prescription.

景仲張

佗華

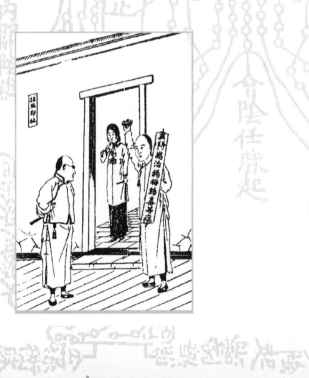

The legendary figure Seng Nong, thought to have lived around 2500 B.C., discovered the healing powers of plants by personally testing hundreds of species and was known as the "holy farmer."

About Chinese Medicine Packaging

Chinese medicine has a reputation for miraculous cures, perpetual rejuvenation, and secret formulas handed down through generations. The packaging of Chinese medicine has similarly seen the development of a strong and dynamic tradition, yielding a vocabulary of basic forms that have had a direct influence on the modes and materials used in packaging.

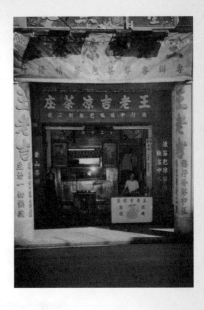

In the early period of development, paper, wood, ceramics, brass, and wax were the principal materials used for packaging. Among these, wax was widely considered the best material and the one that was especially valued for the long term preservation of drugs. The opening up of China in the mid nineteenth century introduced foreign products and new technologies, and by the turn of the twentieth century the import of medicines dealt an unexpected blow to traditional Chinese medicine. This situation brought significant change to the traditional handcrafted methods of packaging. For instance, glass and machine printing replaced ceramics and block printing.

Improvements in packaging provided one means for Chinese medicine traders to become more competitive and to counteract bogus medicines. Traditional Chinese painters were employed as "modern designers." In addition, a variety of counterfeit prevention devices were developed, such as sealing labels, guarantee coupons, trademarks printed with manufacturers' portraits, and complex decorative patterns. These "designers" also created new concepts by amalgamating Western and Chinese aesthetics. In doing so they brought about a revolution in medicine packaging in China. This was furthered by the use of plastics and by developments in printing techniques in postwar China. More attractive, market-oriented medicinal packages began to appear.

After the Communist revolution in China, medicine manufacturers both large and small from Foshan and Guangzhou gradually moved to Hong Kong, which became a major medicine manufacturing center of southern China. Some were exported to Chinese communities in Southeast Asia and North America, establishing the medicine trade as a major export business in Hong Kong.

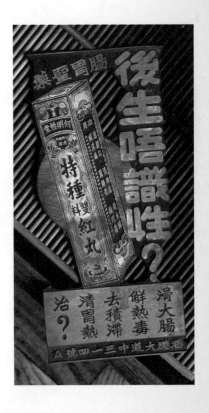

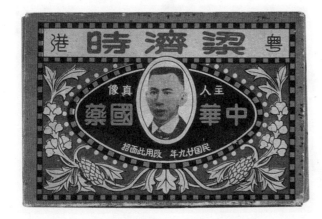

1840

1842

Under the Sino-British Treaty of Nanking, the United Kingdom agrees not to interfere with local Chinese traditions, including the use of Chinese herbs and medicines for healing ailments.

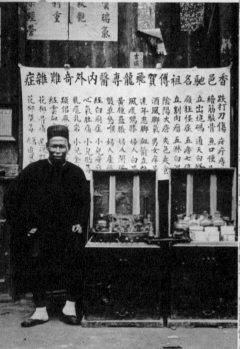

A herbalist presiding over his stall in the late Qing period.

1844

Hong Kong's Chinese population reaches nearly 20,000.

1852

The Nam Pak Hongs 南北行 [firms selling goods from North and South] gradually take shape. As a strategic center for local Chinese merchandisers, the association handles the import and export of sundry goods. The industry of Chinese medicine springs from the Nam Pak Hongs based on Wyndham Street.

1860

1861

More than seventy foreign firms set up in Hong Kong.

1872

The Tung Wah hospital 東華醫院 is founded, providing basic medical services to the disadvantaged. Diagnoses are carried out entirely by Chinese medical practitioners, who bestow free medicine and treatment.

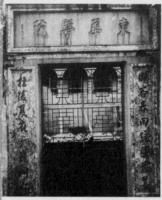

The main entrance to the Tung Wah hospital.

1880

Physicians trained in Western medicine are already practicing in Hong Kong. They include Macau-born Portuguese doctors and other practitioners from the Malay Peninsula and Indonesia, serving mainly Western patients.

1884

The Medical Registration Ordinance 醫藥登記條例 is enacted, setting standards for physicians trained in Western medicine; however, it imposes no restrictions on Chinese medicine.

1885

The first local Chinese medicine shop, Shing Chai Tong 誠濟堂, sets up a branch at 180 Queen's Road Central. Its main store is located on Wende East Road in Guangzhou.

1887

The Hong Kong College of Medicine 香港西醫書院, which later becomes a part of the University of Hong Kong, is founded in 1887. Sun Yat Sen majors in Western medicine there.

1894

An outbreak of bubonic plague sweeps Hong Kong, and the Kau U

Fong 九如坊 and Tai Ping Shan areas 太平山地區 are the worst hit. Nearly 2,500 people die. Over the following decade, there are further outbreaks of the plague, claiming a total of 13,000 lives. Since Hong Kong Governor Sir William Robinson does not recognize the status of Chinese practitioners, the latter have no right to sign death certificates.

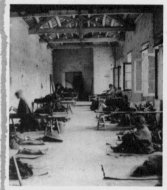

Chinese residents undergo quarantine for diagnosis and treatment during an outbreak of bubonic plague.

1896

The Tung Wah hospital introduces Western medical services. In the same year Wong Lo Kat 王老吉 sets up its first branch behind Man Mo temple on Chik Street.

1900

1904

Western physicians are unable to halt the spread of smallpox. The

Chinese gentry request laws to be established permitting the freedom to choose between Chinese and Western treatment at home. Chinese doctors begin to take a prominent role in society as medical healers.

1911

The Republic of China 中華民國 is established.

1912

The University of Hong Kong 香港大學 is founded in 1911 and in 1912 is combined with a medical college for training doctors in Western medicine.

Sun Yat Sen (second from left) majors in Western medicine at the Hong Kong College of Medicine, founded in 1887, which later becomes the University of Hong Kong.

1917

A night school is set up to hold classes to train Chinese practitioners.

1918

A resolution is adopted to allow home treatment of smallpox. It is later revoked.

1920

1924

Chinese practitioners from Guangzhou create a school in Hong Kong to train local practitioners.

1926

The first local medical group, the Chinese Pharmaceutical Merchants Association 中醫藥商會, is established and unites the import and export businesses of agencies and

medical firms. The group boasts more than three hundred members.

1930

The earliest local journal on Chinese medicine is published by the Chinese Medical Society 中華國醫學會: *Chinese Medical Journal* 國醫雜誌.

Cover of publication commemorating the sixtieth anniversary of the founding of the Hong Kong Medicine Dealers Guild.

1935

Lee Yiu Cheung 李耀祥 proposes the compilation of Yim Fong Jap 驗方集, a collection of empirical prescriptions.

1938

An outbreak of smallpox kills nearly 2,000 people. The government provides free vaccinations against the disease.

1938

The Hong Kong Medicine Dealers Guild 香港藥行商會 is established to promote not only unity among those in the trade but also active participation in various relief efforts and social welfare projects. An attached unit of physicians trained in Western med-icine provides free diagnoses.

1939

Guangzhou falls under Japanese occupation, and numerous refugees flee to Hong Kong. Appalling sanitary conditions encourage the rapid growth of infectious diseases. More than four thousand people are killed by pulmonary tuberculosis. The Guangdong Chinese Medical School 廣東中醫藥學校 relocates to Hong Kong. The spread of cholera kills several hundred people.

Opium smoking, which peaked in the nineteenth century, resulted in the rapid physical deterioration of addicts.

1940

1942

During the Japanese occupation of Hong Kong, Chinese practitioners are required to register. The Hong Kong Chinese Medical Society, under the authority of the Japanese Governor's Office of the Captured Territory of Hong Kong 香港佔領地日本總督部中醫學會, is established in July. Transportation is at a standstill and there is a shortage of medical resources; Chinese medicine practitioners resort to using local raw herbs for treatment.

種痘及注射紀錄卡

PROPHYLACTIC VACCINATION RECORD CARD

1943

During their occupation of Hong Kong the Japanese issue an order to ban Chinese medicine. Following the war, the Tung Wah and Kwang Wah hospitals 廣華醫院 reopen their outpatient services run by Chinese practitioners.

1945

Flooding takes place in Guangdong and Guangxi provinces, and Hong Kong initiates relief efforts to help people in the affected areas. The Hong Kong Medicine Dealers Guild donates medicine as part of the aid program.

Throughout the decade Hong Kong remains poverty-stricken.

1947

After the Second World War Chinese medicine practitioner Tam Bo Kwan 譚寶鈞中醫師 establishes the Hong Kong Chinese Medical Institute 香港中國國醫學院.

Membership papers are issued by the Hong Kong Chinese Herbalists Association 香港中醫師公會.

1955

The Trademarks Ordinance 商標條例 is issued on January 1, 1955, with the Hong Kong Medicine Dealers Guild aiming to strike a blow against bogus medicine manufacturers.

1958

The Urban Council conducts a "Cleaning-Up of Filth and Removal of the Threat of Illness" campaign 掃除污穢及疾齊運動.

1959

Those in the trade are overjoyed by the quashing of stamp duties imposed on Chinese medicines.

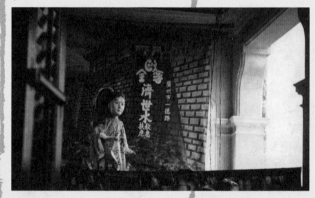

Advertisements for a medicine shop appear on the curtains of a puppet-show theater.

1980

1989

The setting up of the Working Party on Chinese Medicine 中醫藥工作小組 finally affords Chinese doctors fully legitimized professional status where previously they had been labeled "pedlars of Chinese herbs" 中草藥販賣者.

1990

1994

The Hong Kong government publishes *Report of the Working Party on Chinese Medicine* 中醫藥工作小組報告, which proposes creating a statutory framework for promoting and regulating the industry.

1995

The Preparatory Committee on Chinese Medicine 香港中醫藥發展籌備委員會 is appointed by the government in March 1995. The committee submits its report on chinese medicine to the government in March 1997 香港中醫藥發展籌備委員會報告書.

1996

A registration system of Chinese medicine practitioners in Hong Kong 香港中醫登記計劃 is completed and there is a proposal for setting up the Chinese Medicine Council of Hong Kong 香港中醫藥管理委員會.

1997

The Hong Kong Special Administrative Region is established on July 1, 1997. Article 138 of the Basic Law states: "The Government of the Hong Kong Special Administrative Region shall on its own formulate policies to develop Western and traditional Chinese medicine and to improve medical and health services."

1998

The Hong Kong Baptist University offers a degree course in Chinese medicine.

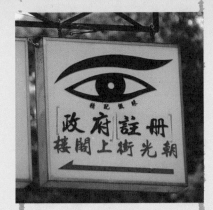

A sign points to an eye clinic.

1999

The second *Report on Chinese Medicine* 中醫藥報告書 is published and submitted to the Legislative Council. Chief Executive Tung Chee-hwa announces the setting up of an international center for Chinese medicine and medical services 國際中醫中藥中心, dubbed "Herbal Port" by the press. Plans are discussed to set up the Chinese Medicine Council of Hong Kong, which will be responsible for regulating the practice of Chinese physicians and the use, production, and sale of Chinese medicine.

Herbs are one of the oldest and most commonly used forms of medication.

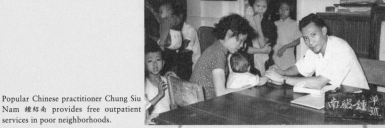

Popular Chinese practitioner Chung Siu Nam 鍾紹南 provides free outpatient services in poor neighborhoods.

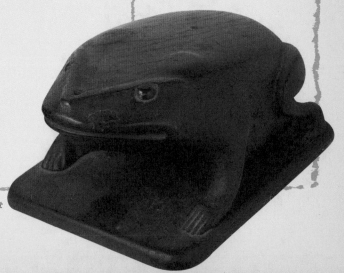

This wooden toad, representing the Man Chun Tong herbal shop 萬春堂 in Yau Ma Tei, is more than eighty years old.

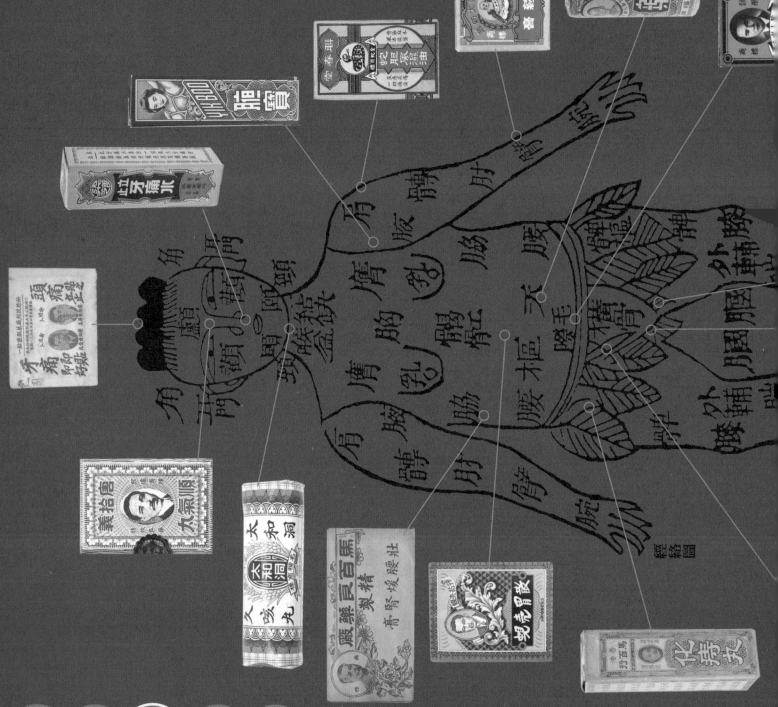

現代藥人圖

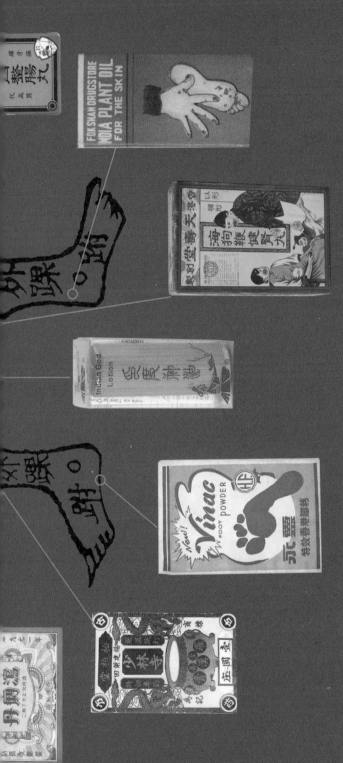

The Art of Processing Chinese Medicine

Processing Chinese medicine is like commanding an army. Like a fiercely brave warrior, strong and powerful medicine that is dry or volatile in nature can, if skillfully handled, be refined to form an effective cure for diseases.

However, the improper preparation of a powerful medicine is like a fearless soldier who is not yet accomplished in the military arts. Healers unfamiliar with medicine production tend to view with apprehension the violent and dry nature of some herbs. They evade responsibility by discouraging patients from taking such medicine, claiming it is of little benefit.

I began my trade by learning the properties of various medicines; then I concentrated on refining them. Through the ages Chinese medicine has been processed in vastly diverse ways: cool medicine as a tonic; hot medicine as a tonic attacking disease; medicines of opposing but complementary natures used in combination with subtle variations in property and flavor, be they warm, cool, upbearing, or downbearing. In short, it is necessary to neutralize the medicine and preserve the purity of its flavor, paying particularly close attention to the correct prescription and dosage.

After forty years of painstakingly acquiring knowledge, I am fully versed in the effects of powerful Chinese medicine and am confident that with judicious processing, patients can be healed quickly and successfully. Only now do I discern a parallel between the strength of powerful medicine and that of a brave army: medicine should be prepared with military precision. Because ancient medical tomes are far from exhaustive in their description of powerful medicines, I have sought to bridge the gap with the compilation of my records in one comprehensive volume.

Excerpt from a discourse written by Poon Hoi Shan 潘海山 of the Po Chai Tong 普濟堂 medicine shop, circa eighteenth century.

Gou 膏 [plaster] is an odorous drug in solid form that is dark brown or black in color. To prepare the plaster, different kinds of carefully selected Chinese medicine are boiled into a paste, which is then cooled and hardened. Once reheated, it softens and turns into a strongly adhesive paste for the external treatment of rheumatism, injuries, scabies, and other skin complaints. The popular Chinese expression, "Once it is stuck to your body, you can't get rid of it," aptly describes the adhesive quality of such plasters. The pain of tearing them from your skin is, of course, something you have to live with, and unsightly residual stains must be removed by using alcohol. Another saying among those in the trade refers to plasters that have, on the contrary, lost their stickiness, "A plaster intended for the waist eventually ends up on the hip!" Why don't plasters stay put? The secret lies in carefully controlling the flame during the reheating process, which if not properly observed causes the plaster to lose its stickiness.

In the past a precut square of cloth, silk, or leather (see opposite) was used as a material for making plasters. An appropriate amount of a freshly boiled paste was evenly applied to the surface of the said material(s) while it was still hot. Today waxed paper or plastic is used instead. Once the paste cools and hardens it forms an adhesive plaster, which is then folded in half for packing.

To retain its therapeutic effects, a plaster has to be used immediately upon opening. Before being applied to the body, it is softened on a hot pot, boiler, or teapot. The patient's body heat further renders the plaster pliable. Ideally a plaster should not restrict the wearer's freedom of movement.

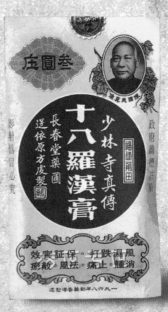

Packaging of plasters known as "18 Arhats" made from a formula transmitted from the famed martial arts Shaolin Temple.

Production of Leung Choi Shun Plasters 梁財信跌打膏藥

The making of plaster was normally carried out in an open space far away from built-up areas, because the time-consuming process of heating the paste on a high flame produced a strong and offensive odor. Ample space was also needed to accommodate the great variety of utensils employed. Before the process actually began, an auspicious date and time were selected for the occasion, and a ceremony was held on the spot for worship and the offering of prayers to heaven.

(2) Cooling the bubbling liquid with cold water.

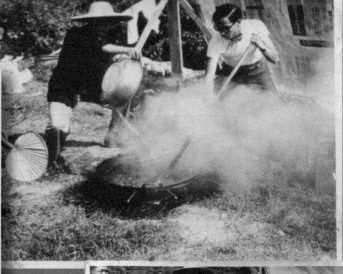

(1) Weighing medicinal ingredients in a Chinese steel yard.

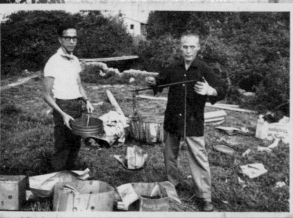

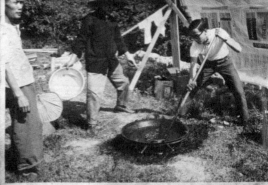

(3) Repeating the refinement process, with close attention to controlling the heat, to obtain the medicinal extracts.

A veteran of the profession would supervise each stage of the complicated manufacturing process, with help from his assistants. The various steps were conducted in a systematic manner, and carefully controlled boiling of the paste was paramount. A few decades ago this backyard method of decocting medicine was extremely common in the countryside and on construction sites, but in recent years it is nowhere to be found.

(4) Filtering the medicinal residue to obtain the essence.

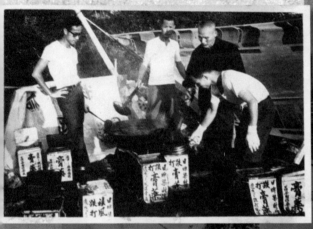

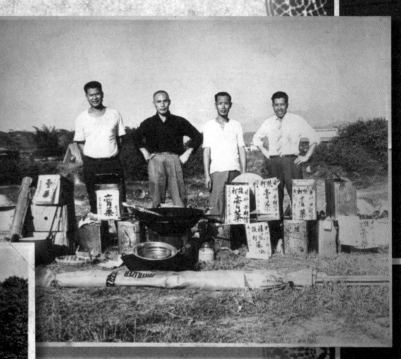

(6) Placing refined medicines in an iron bucket, thereby completing the process.

(5) Allowing the heat to diminish and the paste to cool and solidify.

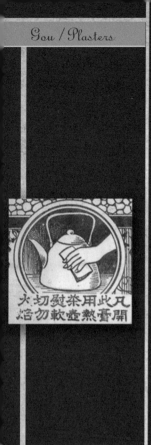

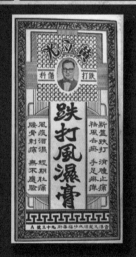

The Immortal Tie Guaili Eats Dog Meat and Leaves Behind Dog-Skin Plaster

Long ago there was a shopkeeper named Wong who lived in Zhangde county, Henan province 河南彰德府. He was known far and wide for his homemade plasters, and his charitable deeds earned him yet more acclaim. One day a lame beggar passed by. He had a large sore on his leg, and he supported himself with a wooden staff. Wong caught sight of him and presented him with a plaster to heal the wound. Some days later the beggar returned and complained that the sore had not healed but had, in fact, grown much worse. Wong promised to cure the monk even if it caused his financial ruin. All of a sudden Wong's dog barked furiously and sunk its teeth into the beggar's leg. In the heat of the moment Wong struck the dog so hard with the wooden staff that he killed it. To his amazement the beggar laughed heartily and said that he now had the luck of a gourmet to dine on dog meat. The beggar promptly tore off the dog's skin and cooked the animal on the spot. He pasted Wong's plaster, together with the dog's skin, onto his sore and, all at once his wounds healed up completely. Just as Wong clicked his tongue in alarm, the beggar turned into a cloud of smoke and vanished without a trace. It was thought that the beggar was the incarnation of one of the Eight Immortals 八仙, Tie Guaili 鐵拐李, who appeared with the intention of leaving the dog's skin behind as a plaster to relieve the ailments of mere mortals. To this day those in the trade continue to worship Tie Guaili as the patron saint of medicine.

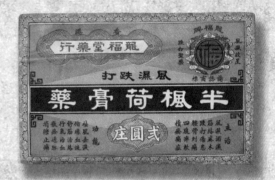

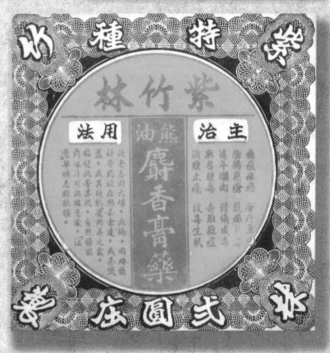

Plasters were generally sold at low prices and simply packaged. Printed on the front or back of the wrapper, in either monochromatic or two-color print, were the plaster's main curative effects and uses, along with the producer's portrait and trademark. Lau Kwok Ying plasters 劉國英風濕跌打膏藥 (see below) for healing rheumatism and injuries from falls are, on the other hand, much more elaborate. Although monochromatic, its exquisitely decorated borders and composition are symmetrical and complex in design. Also of note is the word *Foshan* 佛山 on the upper part of the package. Although the plaster was produced in Hong Kong, Foshan was, in fact, its place of origin and the place where it established its reputation. Long-standing customers only

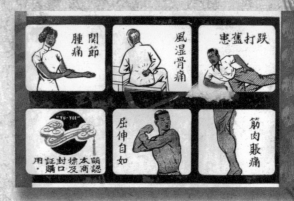

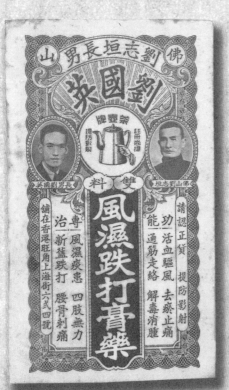

trusted in the authenticity of the Foshan Lau Kwok Ying 佛山劉國英 product, and the name became a mainstay of medicine packages of that time. By comparison, the Chi Chu Lam musk plaster 紫竹林麝香膏藥 (see the big square packet opposite) was much more costly to produce, as the name of the medicine was exquisitely printed in gold at the center of the square paper packet.

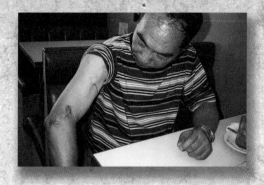

Ching Wah Sih Toad Plasters: An Everlasting Scar

Almost sixty years of age, Mr. Yip, producer of Ching Wah Sih Toad Plasters 拯華氏蟾蜍膏, is a stocky man with a loud voice. He bears a deep scar on his right arm, caused by the careless spilling of boiling-hot toad paste many years ago. "I don't worry about it, I have to make a living," he says, stoically dismissing the subject.

Yip took over the business from his father-in-law Au Sing Wah 區醒華 in 1975, managing everything single-handedly from the boiling of the paste to the marketing of toad plasters to every pharmacy in town. He casts a mysterious light on the origin of the product itself. As the story goes, his father-in-law came across an old monk while seeking refuge from troubles in his home village. Having received the utmost care from Yip's father-in-law, the monk left behind a prescription for toad plasters. The monk urged him to share the obscure medicine with the general public. When asked where he obtains such a large quantity of toads to make the paste, Yip at first turns mysterious again. He then reveals, quite matter-of-factly, that his father-in-law paid children to catch toads around Kowloon Tsai Park and Shek Kip Mei. The boys readily seized the chance to earn money while having fun, Yip says with a smile. Before use, the internal organs of each toad are removed and the body is washed, cleaned, and dried in the sun.

The toad oil, retained after frying, was boiled together with a variety of herbs to make five to twelve catties of toad plasters. Because the paste gave off a particularly strong odor when boiled over a raging fire, it was judged best to decoct the medicine out in the countryside. Once, Yip boiled the toad paste in the open space of an old public-housing estate, attracting a large crowd of boys and girls, all buzzing with noise and excitement. Yip recalls that the golden years of the plaster industry were the 1950s and '60s. With economic progress and improved sanitary conditions, common children's ailments, such as boils, were virtually wiped out, and using poison to combat poison became a thing of the past. Thankfully for Yip, there is still a market for toad plasters from countries such as Thailand and Indonesia. Since 1972, Yip concedes, toad plasters

Toad Plasters: Poison to Combat Poison

Belonging to the frog species, toads are, despite their ugliness, highly prized for their medicinal properties. Typically seven to ten centimeters in length, with light brownish stripes on their backs and a lighter color on their bellies, their skin secretes a toxic jelly intended for self-preservation. Nontoxic to humans, however, the jelly is an effective painkiller, believed to strengthen the heart and reduce swelling. It is used to cure serious cases of scabies, infantile malnutrition and indigestion, aches, and swellings in the throat.

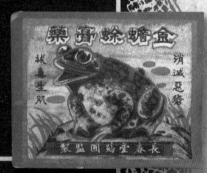

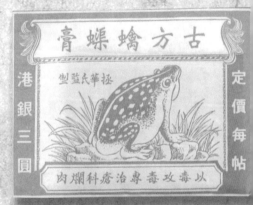

Ching Wah Sih toad plasters sold for HK$3 each in the 1990s.

no longer contain real toad ingredients. They have been replaced by herbs, because finding wild toads is difficult, but this has not adversely affected the therapeutic effects of the plasters. Facing an uncertain future, Yip shrugs and says, "We work while we can and expect no more!" The scar on his arm seems more obvious now than ever.

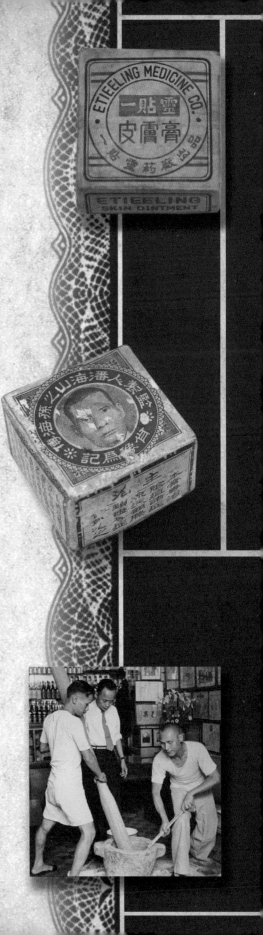

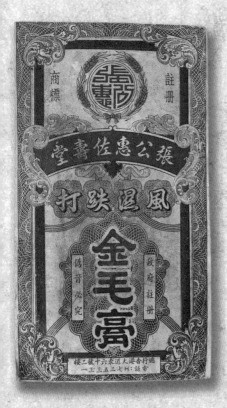

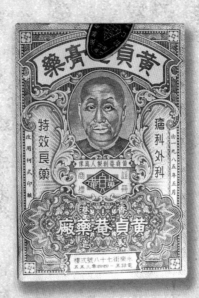

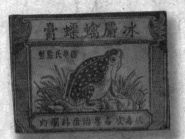

A small pack of toad plaster cost five cents in the 1950s.

Another commonly sold *gou* came in ointment form, packed in a small tin or plastic case. Highly popular on account of its compact, spill-proof container, the ointment was easy to apply, gave extensive coverage, and yielded notable healing results.

In the past people frequently felt dizzy when traveling in a hot climate. Women would carry in their purses plasters or medicinal oil, which they dabbed on their nostrils or temples to relieve the discomfort.

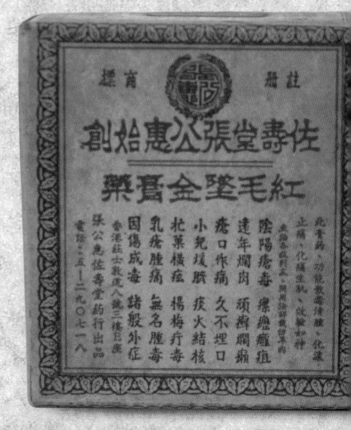

Such medicine normally came in small round tins, often with attractive embossed patterns. Early tins were simply printed in one or two colors, but when color printing was introduced later on, manufacturers began to spend more on the production of packaging, giving rise to more decorative and colorful designs.

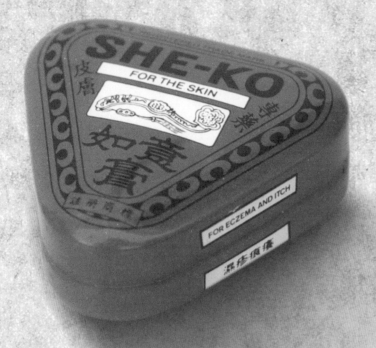

Tins of ointment enjoyed widespread appeal, because they could be carried with ease. The name of the shop and the medicine were printed on the surface of multicolored, embossed containers, like Jor Sau Tong Medicine Company's ointment (left). The tin had a rich Chinese flavor, featuring the yin yang symbol on a striking contrasting ground of red and black.

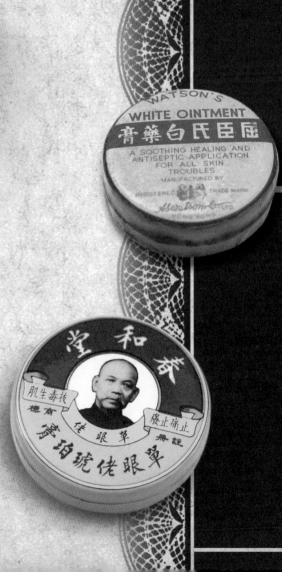

Through the ages, daan 丹 [pellets] have been steeped in mysticism and associated in people's minds with miraculous healing powers. Ancient Chinese emperors and nobles who nurtured hopes of eternal life, with its promise of high status and great wealth, placed all their trust in the alchemists of the day, who were renowned for their ability to make immortality pills. The art of alchemy flourished during this period.

Alchemy was the making of pellets through the mineral refinement of cinnabar, lead, and mercury (and the occasional addition of animal parts or plants) in a brazier. Demonstrating the close ties between alchemy and ancient science, alchemists were also specialists in medicine, on the one hand carrying out medical practices for dispelling impending doom and illness, on the other practicing the religious fantasy of ascending to the heavens as an immortal. The two pursuits were inextricably interwoven, and it is evident that alchemy had a profound influence on ancient science and medicine.

Pellets are no longer produced by alchemists for two reasons. Firstly, blind faith in such practices fell victim to the progress of time, as most ancient cultures passed into oblivion. Secondly, many ancient Chinese emperors and refined scholars overdosed on the heavy metals and other toxins contained in the pellets. They did indeed "ascend to the heavens," but without fulfilling their desire for immortality.

Nowadays the term *daan* is used merely as a marketing strategy. According to pharmacists, there is no difference between the production of pellets and pills—they differ in name only. Yet merchandisers have continued to dream up various names for pellet, to give the illusion that they contain some magical elixir.

A Lullaby for the Time-Honored Production of Hand-Rolled Pills

The once thriving age-old tradition of producing *dit yun* 跌丸 [hand-rolled pills] has ground to a virtual standstill over the past fifty years. Requiring tremendous manpower and physical strength, the manufacture of hand-rolled pills cannot compete with the modern trend toward mass production. As early as the 1930s, a drum-type machine was introduced to replace the hand-rolling method, answering the need for lower production costs, greater efficiency, and reduced manpower. The one and only local workshop to still use this ancient method is run by the Lam brothers 林氏兄弟, and it is a truly fascinating spectacle to behold.

Occupying centre stage in the workshop is a large rattan basket, almost four feet in diameter, which in the trade is known as a *wo* 窩 [a holder or container]. Rustling sounds can be heard as the

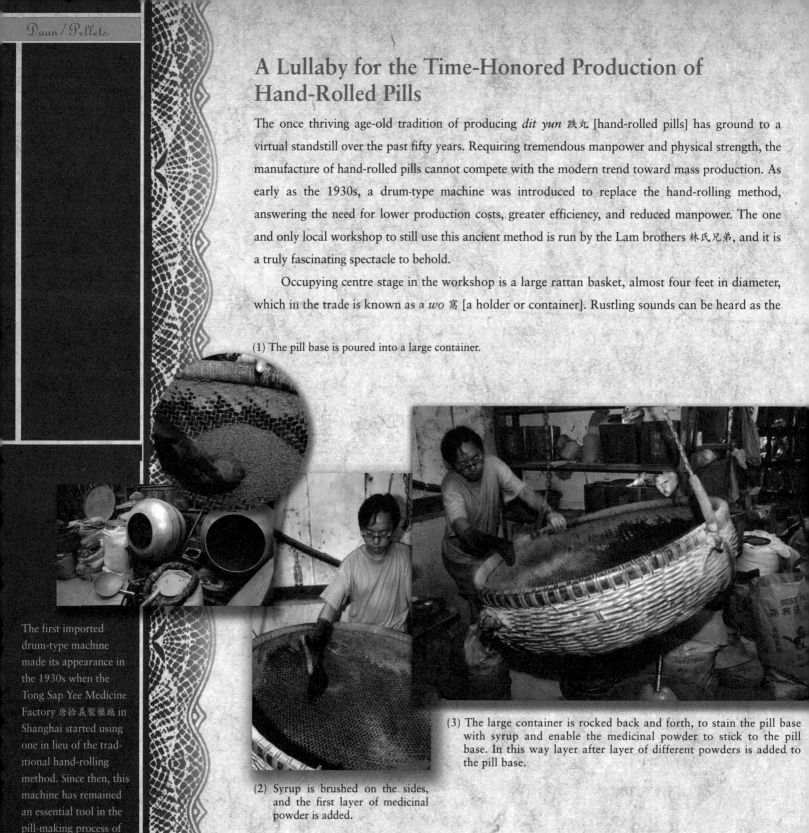

(1) The pill base is poured into a large container.

The first imported drum-type machine made its appearance in the 1930s when the Tong Sap Yee Medicine Factory 唐拾義製藥廠 in Shanghai started using one in lieu of the traditional hand-rolling method. Since then, this machine has remained an essential tool in the pill-making process of pharmaceutical factories large and small.

(2) Syrup is brushed on the sides, and the first layer of medicinal powder is added.

(3) The large container is rocked back and forth, to stain the pill base with syrup and enable the medicinal powder to stick to the pill base. In this way layer after layer of different powders is added to the pill base.

Lams work hard, pushing and pulling on the large basket, which is suspended from the ceiling. He seems to be gently rocking a baby to sleep in a cradle. Lam deftly adds an even layer of medicinal powder to the pill base, *yun chung* 丸種. The frequency of the rolling action depends on the amount of mixture required.

The Lam brothers' business has already seen the passing of two generations. The company was originally founded in Guangzhou and later moved to Hong Kong, and most of the Lam family has engaged in the industry at some time or another. Though the Lams are pessimistic about the workshop's prospects and foresee losing their jobs one day, they will continue to adopt this ancient mode of production for as long as they receive orders from Chinese practitioners and small drugstores.

As early as the 1970s some pharmaceutical factories began to produce traditional Chinese medicine in capsules.

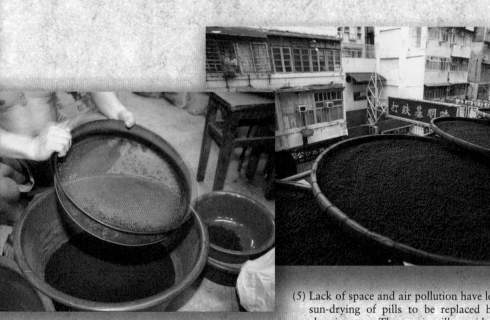

(5) Lack of space and air pollution have led the traditional sun-drying of pills to be replaced by drying on an electric stove. The sun is still considered the best way to dry the pills.

) Substandard pills are screened out using sieves with mesh of varying sizes, and irregularly shaped pills are picked out by hand. The process is repeated to regulate the appearance of the pills.

Initially the Western-style capsules were not well received by the public, which was accustomed to more traditional forms of medicine.

In their raw state the pills have an un-processed, unpolished, and rough surface. They have to undergo a "glossing" process, to give them a smooth and polished surface that makes them easier to swallow.

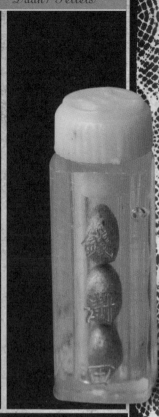

The trademark of the Yuen Tin brand 圓田牌 is particularly worthy of note. Designed by the founder, Chin Shu Tin, more than two centuries ago, the trademark fully demonstrates Chin's wisdom, as well as his personal style and originality. Outwardly the trademark looks like a coin, but on closer inspection the character *tin* 田 [field] is revealed. The concept of possessing both money and land is a traditional Chinese value.

Chin Shu Tin: Admirable Sentiments

Established in Guangzhou in 1790, Jin Sau Tong's Chinese medicine factory 敬修堂 boasts a long history, spanning more than two centuries. Though a learned and respected doctor, the founder, Chin Shu Tin 錢澍田, was by trade a silk merchant, and the founding of Jin Sau Tong came about by accident. A tycoon wished to reward Chin for healing his son's chronic and stubborn disease, but Chin's refusal to accept payment won the man's respect and appreciation. He then provided the kind doctor with enough capital to fulfill his wish to relieve the suffering of the poor.

Hui chun daan 回春丹 [rejuvenating pellets] and *yu yi gou* 如意膏 [wish-fulfillment plasters] were the two most famous products produced by Jin Sau Tong. Made according to the most exacting standards, these items garnered widespread praise for their superior quality and excellent healing effects. Take the production of *yu yi gou*. To avoid excessive internal heat, the freshly made medicine, was poured into an earthenware bowl and wholly immersed in water for three months to decoct the essence. The entire drug-making process took half a year. As for Jin Sau Tong Hui Chun Daan, they gained enormous popularity in both the northern and southern parts of China. During the 1930s and '40s, gold shops in Shanghai and Ningbo displayed the brand in a special showcase, for it was considered to be as precious as gold.

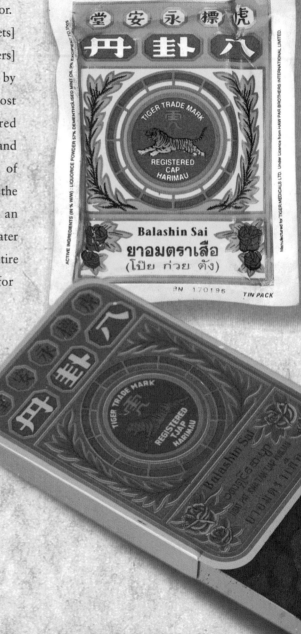

There was once a rich variety of pellets sold in local street stalls, including antipyretics, analgesics, and medicine for treating diarrhea, vomiting, and stomach pains. They were also unique in terms of their packaging, like the popular Bat Gua Pellets 八卦丹 (see lower right opposite), produced by Wing On Tong 永安堂, whose printing and production were of matchless sophistication. The innovative push-type flat case was easy to carry around, but the metal of the container was prone to rust and oxidation and thus tended to taint the medicine. Furthermore, the tin's sharp edges suggest it was hardly designed with the user's safety in mind.

Yun 丸 [pills] are the most common form of drug in Chinese medicine. They vary in size from as large as an egg to as small as the tip of a needle. Taken orally they possess mild therapeutic effects and are slowly absorbed in the stomach.

Water and honey form the compound agent in the pill-making process, and different kinds of medicinal powder are stuck to one another, layer upon layer. An airtight wax coating forms the pill's first layer of protection and is considered the most durable method for storing medicine and guarding against decay. The pills can safely be stored anywhere from three to five years.

Some believe this intelligent device was created by the Chan Li Chai Medicine Shop 陳李濟藥店 four centuries ago and later widely adopted. Others claim that evidence of wax used for storage purposes was uncovered in an ancient tomb, dating back some 2,000 years.

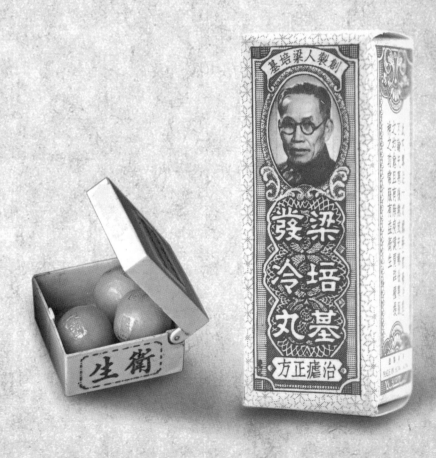

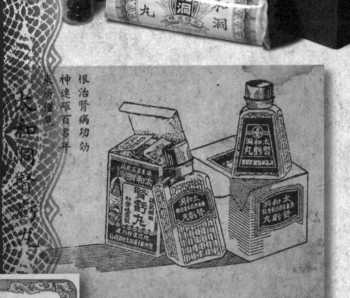

Tai Wo Tung

The Tai Wo Tung Drug Company 太和洞 boasts a long and proud history and is renowned in the medical world for its efforts in healing kidney ailments. As early as the reign of Daoguang 道光, during the Qing dynasty, great-grandfather Kan Tao Chun 靳道純 took charge of the imperial hospital. An enlightened man with a unique understanding of the kidney, Kan had an effective prescription of pills for healing kidney deficiencies, which he handed down to later generations. Currently in charge of Tai Wo Tung is Kan Kwok Ying 靳國英, whose grandfather Kan Siu Chi 靳肇枝 founded Tai Wo Tung in Guangzhou in 1884. The pharmacy produced pills for healing chronic coughing and kidney ailments. It is thought that the pills cured the kidney problems of the noted Qing statesman Li Hongzhang 李鴻章 and enjoyed wide-spread fame as a result. Tai Wo Tung's anti-coughing pills and those produced by Tong Sap Yee were equally famous and effective remedies.

Kan Kwok Ying believes that the role of the medicine business is not making a profit but rather benefiting society in the light of ancestral guidance. Following every lunar year during the postwar period, whenever there was a surplus after the accounts had been settled, Kan's father would distribute free medicine to residents in the neighborhood. Needless to say, this charitable act was greatly appreciated.

Tai Wo Tung moved to Hong Kong in 1952. Having run a successful business for more than five decades, Tai Wo Tung did not need to publicize widely and only occasionally placed advertisements in newspapers or posted placards to attract customers during the 1950s and '60s.

Though they are no longer hand-rolled, Tai Wo Tung's cough pills retain their original packaging: the bottles are stopped with Chinese cypress corks and sealed with wax.

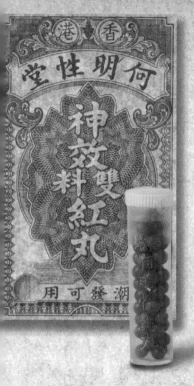

Ho Ming Sing Tong Red Pills

Ho Ming Sing Tong 何明性堂 was founded more than two centuries ago during the Qing dynasty. It produced *hung yun* 紅丸 [red pills] (also called *jong hung yun* 撞紅丸). The pills were taken by men to counteract toxins discharged by women having sexual intercourse during their menstrual cycle. The phrase *jong hung* 撞紅 referred to a woman's having sex before completing her menstrual cycle. The older generation considered menstrual blood impure and worried that men who came into contact with menses during sex would contract diseases, so they took the medicine to flush out the toxins and thereby escape disaster. *Jong hung yun* are regarded as the forerunner of medicines meant to discharge bodily toxins. Today such medicine is used by both sexes, and women in particular take the medicine both to eliminate toxins and to enhance their beauty.

Sung Fat Sih

Sung Fat Sih 崇佛氏 was founded in the early twentieth century. The company has changed hands several times over the past century, from the Kans 簡氏 to the Leungs 梁氏 to the Puns 潘氏 after the Second World War and finally to Tong Wun Tung 唐煥通 in 1988. The medicine factory produced plasters, pellets, pills, medicinal oils, and powder, of which Sung Fat Sih Bat Bo Oil 崇佛氏八寶油 and Sung Fat Sih Luk Mei Pills 崇佛氏六味丸 were the most popular. A plaque presented as a commendation in 1937 by the Fong Bin hospital 方便醫院 in Guangdong has hung in the factory ever since.

For the multitude of minor discomforts caused by lack of acclimatization and overindulgence, such as stomach pains, vomiting, diarrhea, or indigestion, medicine companies marketed pills accordingly, but there was little novelty in the packaging design. Similar in terms of design, packaging, and form, the pills were sold in small, standardized red packs measuring 5.5cm by 15cm. Their printing and packaging were rather commonplace on the whole.

The laxative Tong Yan Se Yun 唐人瀉丸 [laxatives for Chinese] gained wide acceptance not just among the Chinese, because the name elicited a sense of warmth and friendliness.

Lei Yunshang Liu Sheng Pills

The maker of Lei Yunshang Liu Sheng Pills 雷允上六神丸 was Lei Dasheng 雷大升, known to his family simply as Yunshang 允上 and by the alias Nanshan 南山. He was born in 1696 to a family of scholars. Devoted to the study of traditional Chinese medicine, he scaled famous mountains and crossed mighty rivers to gather medicinal herbs. Lei set up the Lei Yunshang Song Feng Tang medicine store 雷允上誦芬堂藥舖 in Changmen, Suzhou 蘇州, in 1734. He practiced under the name of Lei Yunshang and became a specialist. His two rarest and most celebrated products were Lei Yunshang Liu Sheng Pills 雷允上六神丸 and Zhuge *hang kwan saan* 諸葛行軍散 [powder use as first-aid]. His descendants established a branch in Shanghai (now known as the south store) in 1863, complementing the existing drugstore in Suzhou. Pictured here is a box of *liu sheng* pills produced by Lei's descendant Lei Shanjue 雷善覺. Packed in a brocade box, the package gives a sense of luxury and rarity.

Liu sheng pills were as tiny as the eye of a needle and came in small bottles. Plastic bottles were used in the later stages of production, but in the beginning bull or cow bone was the preferred material for pill bottles. In the first batch of plastic bottles the lids could only be opened in a counter-clockwise direction. But rather than rectify the error, the medicine factory opted, serendipitously, to make the lid a unique feature of the product. Unaware of the story behind the pill bottle, the consumer succeeded in tightening rather than opening it, causing one hapless soul to smash the bottle and in doing so spoil the contents.

Some medicine factories would put a little roasted rice in the bottle, as a mark of ingenuity to preserve both the flavor and remedial effects of the pills.

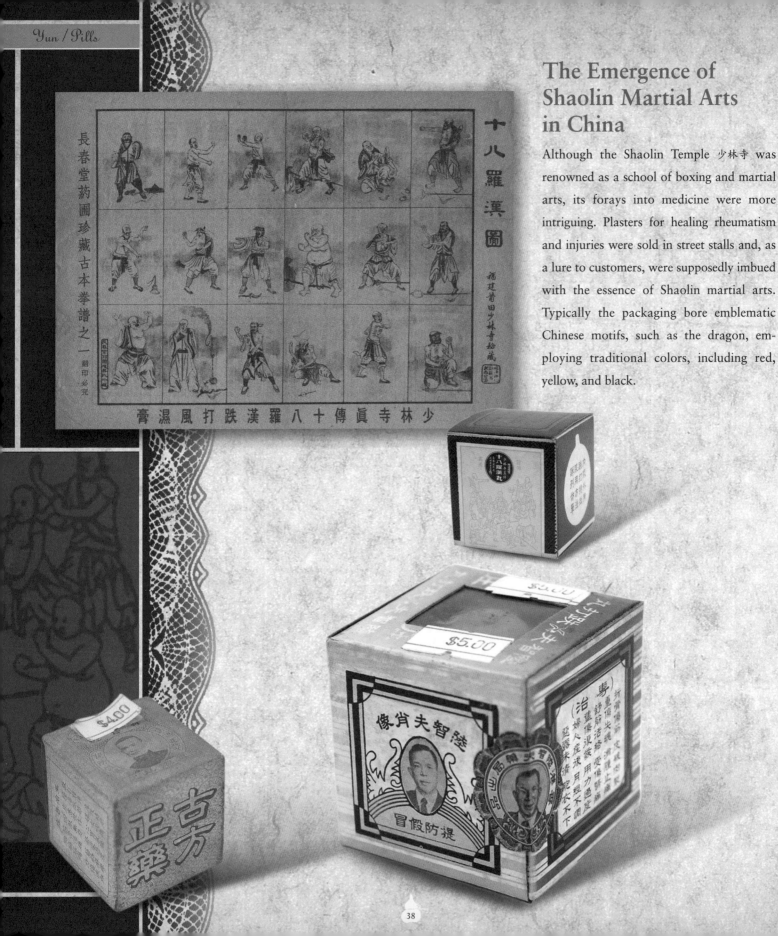

The Emergence of Shaolin Martial Arts in China

Although the Shaolin Temple 少林寺 was renowned as a school of boxing and martial arts, its forays into medicine were more intriguing. Plasters for healing rheumatism and injuries were sold in street stalls and, as a lure to customers, were supposedly imbued with the essence of Shaolin martial arts. Typically the packaging bore emblematic Chinese motifs, such as the dragon, employing traditional colors, including red, yellow, and black.

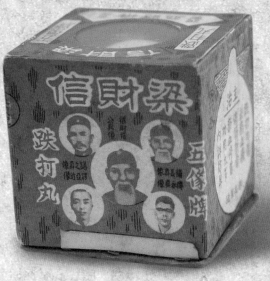

Although large rolled pills were protected by an airtight and waterproof wax shell, pressure sometimes caused the wax coating to crack, and the resultant contact with the air would taint the pill. Fortunately, the instruction leaflets accompanying the medicine and the outer paper packaging formed additional protective layers. As a means of safeguarding the invulnerability of its wax-coated Leung Choi Shun *dit da yun* 梁財信跌打丸 [pills for healing injuries from falls], the makers of the "heaven and earth" packaging 天地盒 used cardboard for the top (heaven) and bottom (earth) of the box. The lid of the carton was made hollow with a thin circle of glass through which the pills could plainly be seen. Information regarding the pills and the registered trademark were printed on the four surfaces of the box.

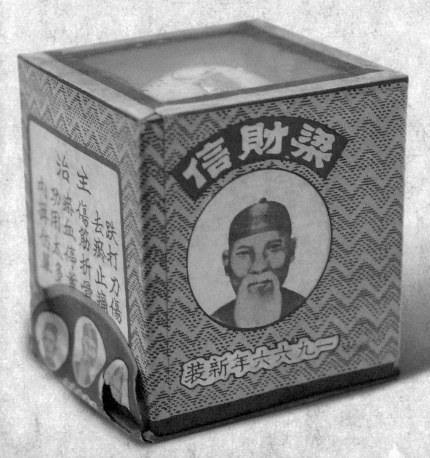

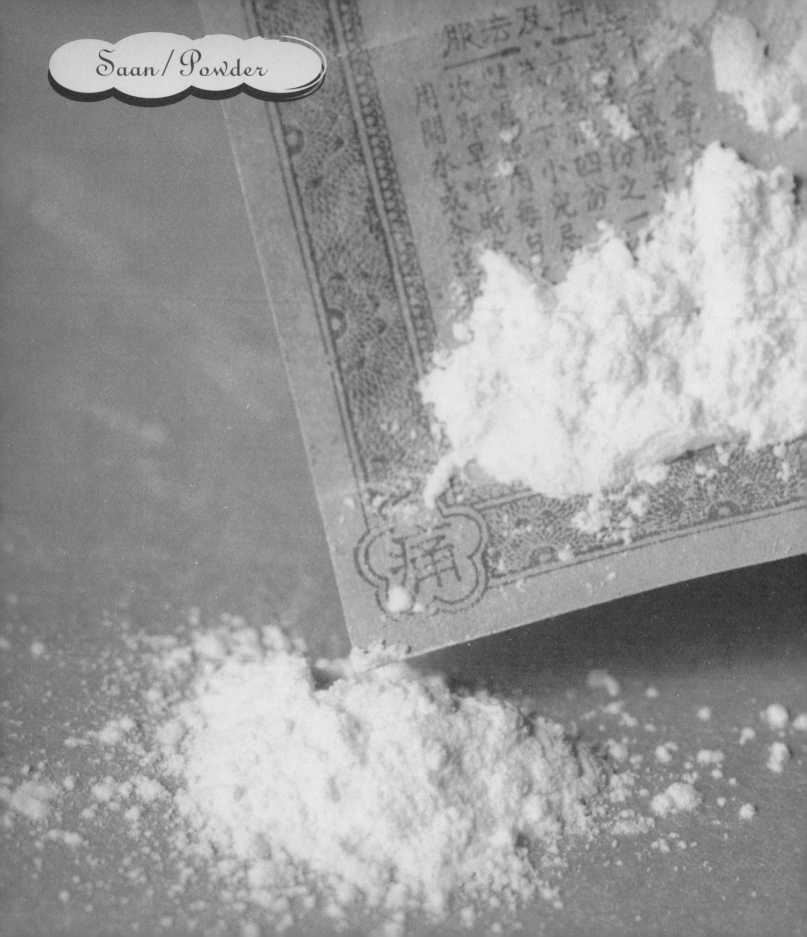

Saan / Powder

Saan 散 [powder] is usually taken orally. Dissolved in water, the powder drug is easily absorbed by the body for fast-acting relief and is commonly prescribed for babies, since, unlike pills, it eliminates the risk of choking. The production of powdered drugs is much simpler too, as it involves merely the preparation and blending of the required amount of medicine, which is then ground into fine powder by machine before being bottled. The only inconvenience of powdered medicine is its tendency to stick to the lips and corners of the mouth.

Tung kwan saan 通關散 and *hang kwan saan* 行軍散 are both fast and effective remedies for dizzy spells and fainting fits. In the event of someone's falling unconscious and closing his mouth too tightly for medicine to be administered, the powder can be sprayed into the patient's nostrils to revive the senses.

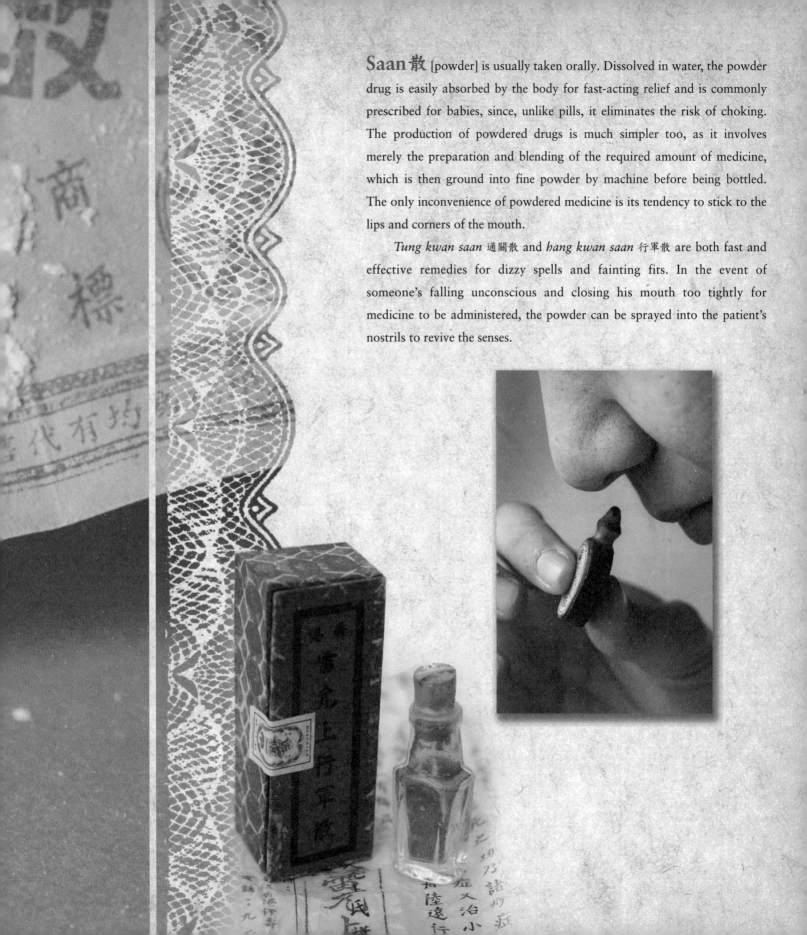

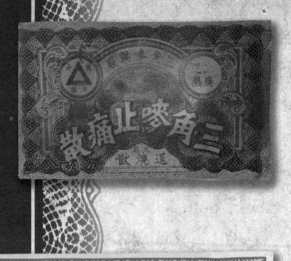

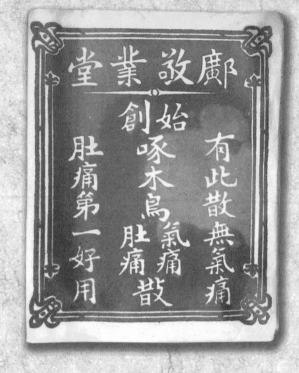

In Chinese medicine, powder is sometimes called *choy* 菜 [vegetable] or *ching* 精 [essence], but this is a marketing ploy devised by medicine factories to sell what is, in fact, just powder.

The *yan seun* 研船 [milling boat], or *yeuk seun* 藥船 [medicine preparation boat], is a grinding tool commonly used in Chinese medicine shops. In rowing movements, the wheellike pestle is pushed pack and forth in the boat-shaped vessel, propelled either by hand or foot. The strenuous effort and the time required to produce even a small portion of powder led the milling boat to be gradually replaced by machinery. However, the wooden utensil is still kept in traditional Chinese medicine shops for small-scale production.

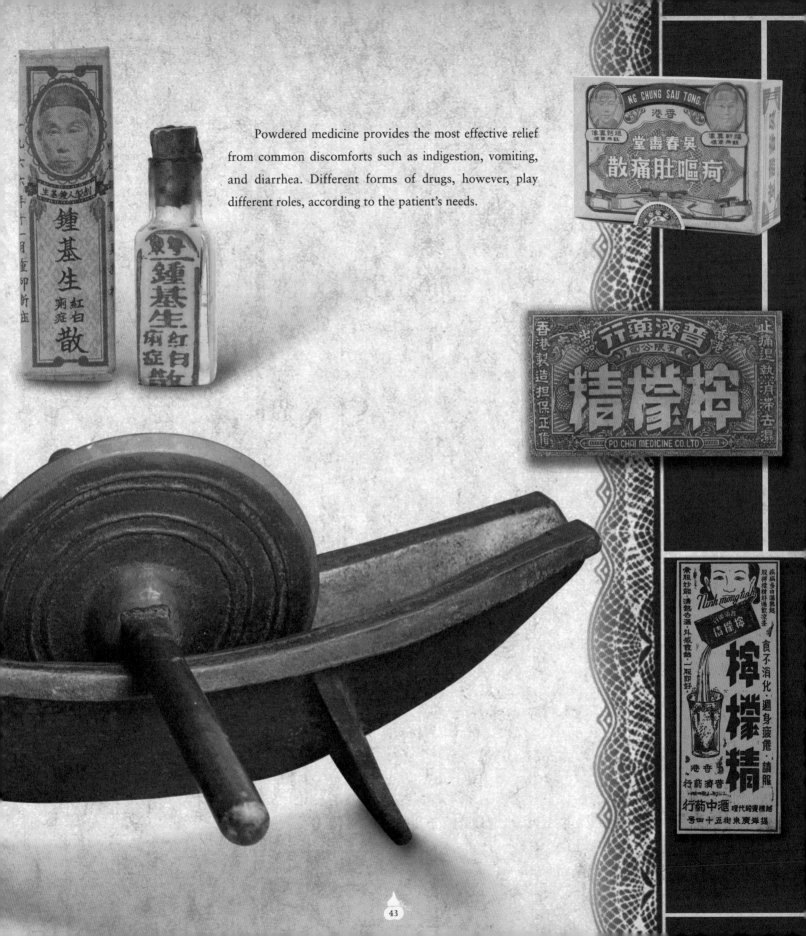

Powdered medicine provides the most effective relief from common discomforts such as indigestion, vomiting, and diarrhea. Different forms of drugs, however, play different roles, according to the patient's needs.

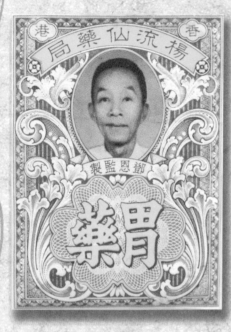

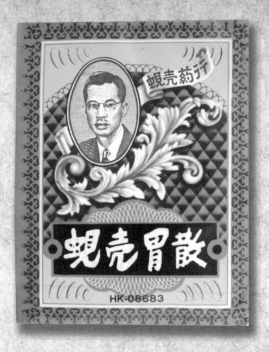

As people succumbed to the stress and strain of modern city life, stomach trouble became one of the most common health complaints. Medicine offering temporary relief from such discomforts included Hin Hok Wai Saan 蜆殼胃散 and Yeung Lau Sin Wai Yeuk 楊留仙胃藥, both companies boasting a history of more than fifty years. The two companies produced small, exquisitely printed packages that were unique in color and design. Particularly striking was the bright green packaging of Hin Hok Wai Saan, which broke with traditional practice by placing the manufacturer's portrait to one side instead of in the center.

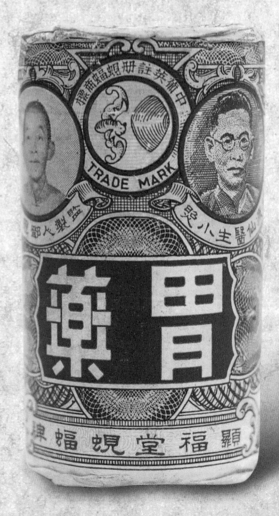

Among the more infamous ailments peculiar to Hong Kong was "Hong Kong foot" 香港腳. It is, in fact, an extremely common form of athlete's foot, or ringworm of the foot, though it is unclear why the territory came to be associated with the ailment. Nonetheless, medicinal powders for external treatment and soaking solutions for Hong Kong foot were marketed as required. What distinguishes these foot powders are the simplicity and clarity of their packaging, featuring comic big-foot motifs that can be plainly understood even by a child.

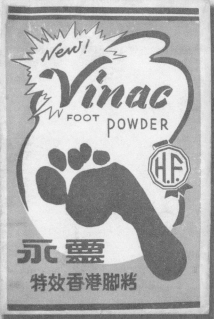

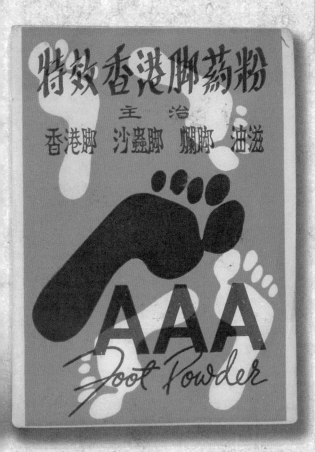

Hong Kong foot is defined as the propagation of dermatophytes, causing a fungal infection that thrives in very warm and humid conditions. The symptoms include extreme itchiness; scaly, dry skin; and blains on the feet. In acute cases, festering sores may develop between the toes, and a bad odor may be emitted. Leukonychia, or whiteness of the toenails, may also set in.

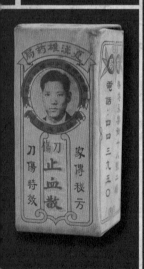

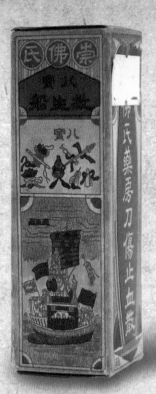

There are various forms of medicine used to treat injuries incurred by serious falls. Powder is but one type of medicine and is used to arrest profuse bleeding 止血散. The powder is applied to the wound to quicken the clotting of blood and to accelerate the healing process. Powders also serve as antiseptic and as antiseptic and anti-inflammatory medicines.

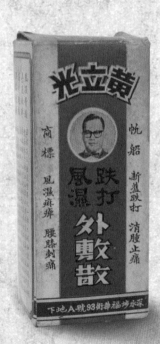

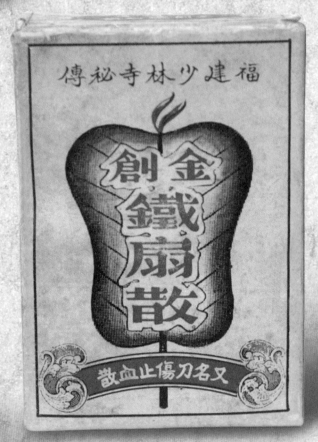

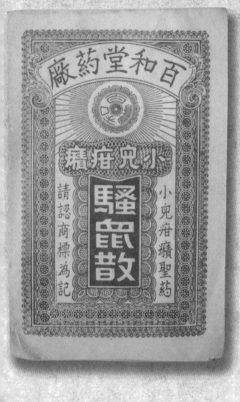

The vulnerable condition of young babies often gives rise to excessive perspiration, which was treated in the past with *tam hoi saan* 淡汗散 [powder for treating excessive perspiration] in much the same way that talcum powder is used today to dry an infant's skin.

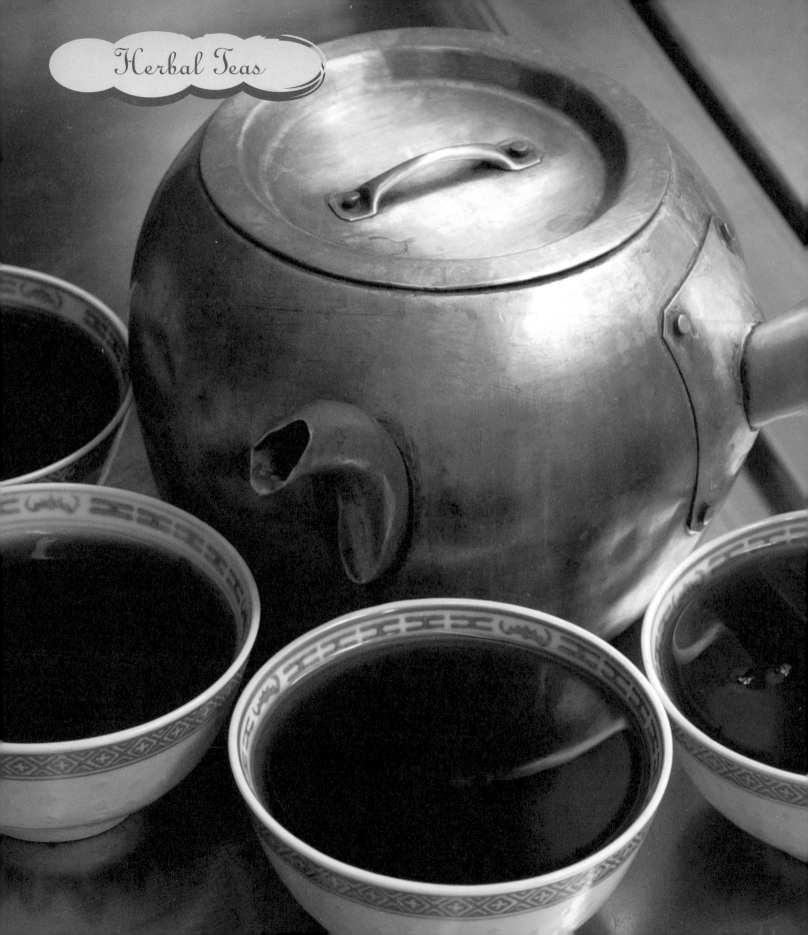

Herbal Teas

Restorative **leung cha** 涼茶 [herbal teas], based on extracts of various raw herbs, have long been taken by the Cantonese as a means of cooling down "internal heat," serving both as an effective diuretic and as a tonic for an upset stomach. In the past the people of southern China frequently suffered from colds, flu, and fever, brought on by the region's hot and muggy climes, so herbal teas were welcomed as an affordable remedy for dispelling these seasonal miseries. They remain just as popular today and are regularly taken to help stave off illness and abate thirst. Traditional herbal teas generally fall into two categories: bitter teas, like that of the Myrtaceae flower, which may contain as many as twenty-four medicinal ingredients, and sweet teas, derived from flowers like honeysuckle and chrysanthemum or based on hemp seed and sugarcane.

Naturally the boiling of herbs is a time-consuming process, so nowadays most herbal-tea shops prepare a wide selection of instant herbal teas for customers to drink on the spot or take with them. Before TV and radio became common household entertainments, teahouses had seating and TVs and radios installed, providing a favorite meeting place for friends who liked to sip invigorating infusions over a game of chess or to the sounds of Cantonese opera. In other efforts to embrace modern trends, tea producers have sought to supplement their traditional products with newly developed lines of thirst-quenching health drinks.

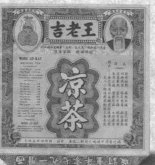

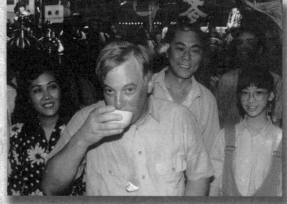

Hong Kong's last governor, Christopher Patten, perhaps more accustomed to the British "cuppa," revives his spirits with a bowl of Chinese herbal tea!

One-Eyed Man's Herbal Teas

Having a proud history of more than eighty years, Daan Ngan Lou Leung Cha 單眼佬涼茶 [one-eyed man's herbal teas] is a fourth-generation business that has its base in Yau Ma Tei and Mongkok. Daan Ngan Lou was a herbal-tea producer, surnamed Li, who possessed one eye that was bigger than the other. Out of self-consciousness, he tended to turn his face to the side during conversation, leading people to believe, mistakenly, that he was blind in one eye. Hence he earned the moniker one-eyed man—and with it an eye-catching name for his product. Its exquisite packaging design is reminiscent of that used by Wong Lo Kat (see previous page).

For almost a century Wong Lo Kat 王老吉 has been one of southern China's leading herbal-tea brands. In recent years the company has diversified its business by developing a new range of health drinks; however, they retain the original packaging design, despite making the switch from paper to foil packets. The company had the foresight many years ago to produce tinned packaging for its herbal teas, in a bid to capture a larger share of both the local and overseas markets.

The golden age of the herbal-tea trade spanned the decades immediately preceding and following the Second World War. During that time, local herbal-tea shops opened all over the territory, among them famous names like Wong Lo Kat, Kung Wo Tong 恭和堂, Ma Lei Yu 孖鯉魚, Tam Yu Sing 譚如聖, and Chiu Chi Chun 徐子真 卑巴桶茶, who produced Man Ying Tong Barrel Medicine Tea.

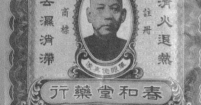

Before the days of plastic bags, tea shops would bind the sachets of tea with string, to form a light and portable package for those who wished to make their herbal tea at home. From the beginning of its establishment, Chun Wo Tong Medicine Shop 春和堂 also provided convenient herbal tea bags for consumption on the premises by local and foreign customers, some of whom have visited the shop from as far afield as Canada.

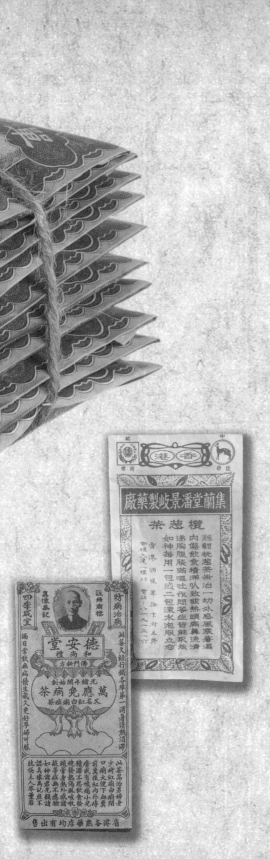

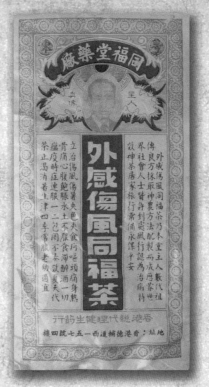

Herbal-tea bags used to be sold in small rectangular packs of ten to a dozen sachets made of two-tone ad paper, which was glossy on one side and matte on the other. Thicker cardboard packaging was used to protect the delicate contents, which increased production costs. From 1947 onward, for the customer's convenience, Wong Lo Kat Herbal Extract 涼茶精 was sold in packs smaller than what was generally available at the time.

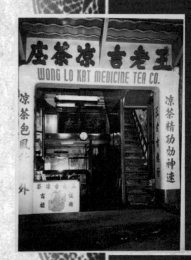

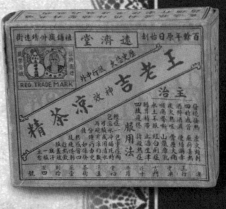

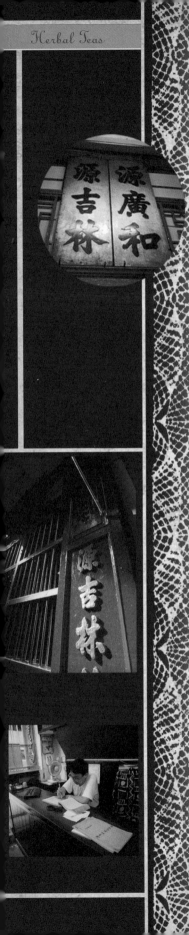

Yun Kat Lam

Yun Kat Lam Medicine Shop was established in Foshan in 1892 by Yun Kat Sun 源吉蓀. Having returned to China from Japan in 1882, Yun initially set up the Sam Cheung dye-color shop in Foshan and, as business was booming, he opened another shop in 1890 in Guangzhou. The successful businessman's son, Yun Man Jam 源文湛, was an amateur Chinese herbalist who possessed a good knowledge of medicine. Under the banner of Lau Chak Tong Yun Kat Lam 流澤堂源吉林號, he began to produce and sell herbal products, including *kum wo* tea 甘和茶 [sweet and harmonious tea], *hui chun* powder 回春散 [a powder to cure sickness and diarrhea], and *gar yin* pills 戒煙丸 [pills to stop smoking]. To promote his products, he distributed samples of the tea and medicine free of charge to those living in the neighborhood. With the constant threat of infectious diseases, fever, and flu in the Pearl River Delta, *kum wo* tea was a timely product and rapidly gained popularity in Guangdong province. By the early twentieth century, the business had expanded to include a branch in Hong Kong, located at Jervois Street, which sold the aforementioned dye stuffs and *kum wo* tea.

Kum wo tea is a decoction formed by soaking a selection of tea leaves from Yunnan and Guangxi provinces and thirty-two other medicinal materials. Once the decoction process is completed, the tea leaves are then baked once more and dried over a low fire. To prepare the herbal tea, one simply has to add hot water and cover the pot, allowing the ingredients to infuse for a while. To this day the old Yun Kat Lam shop stands at the original site on Jervois Street, a four-story prewar building distinguished by its bright red exterior. Inside, the shop retains a flavor of the past, with its time-worn wooden counter. Yun Yu Dong 源汝當, the family member currently in charge of the business, explains that aside from being an agency for dye stuffs, Yun Kat Lam sells only *kum wo* tea. Before the war, the shop also produced *hui chun* powder, an effective cure for sickness and diarrhea and, with the addition of opium, a painkiller. Of course, opium smoking has long since been outlawed, so the product is no longer sold in Hong Kong, but Yun still remembers the days when local boat people flocked to the shop for the powder to help cure sickness caused by the woeful sanitary conditions on board.

When it came to promoting the company's products early on, Yun Kat Lam went all out, paying for costly calendars, paper fan souvenirs, and newspaper advertisements. Yun says that they even called upon the talents of the most famous calendar artist of his time, Kwan Wai Nung of the Asiatic Lithographic Printing Press, to help them achieve their objectives. The calendars and gifts were so beautiful that they covered every inch of the shop's wall space. Today, gesturing at the blank walls around him, Yun recollects the past with considerable regret. Now that these poster calendars have become highly prized collectors' items, he feels a great sense of loss, because he threw away many of the shop's earlier decorative pieces. He thought there was no sense in keeping them, as they were old and worn out. Little did he know they would become sought-after treasures.

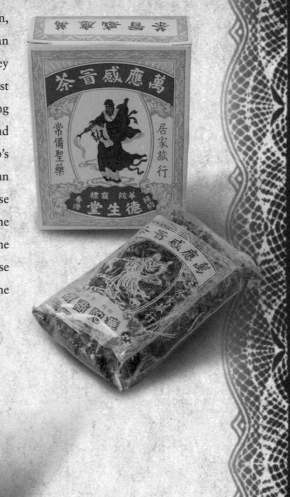

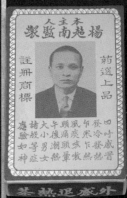

The Origins of Ng See Tea

Containing more than twenty Chinese medicinal ingredients, *ng see* tea 午時茶 [midday tea] was a mild prescription for healing flu, fever, headaches, and abdominal pain. It was of particular relief to sufferers of indigestion after overindulgence during traditional holidays, like the Mid-Autumn Festival.

Medicinal oil, or you 油, is an odorous and volatile liquid used for external application. Noted for its refreshing and invigorating effect, it cures dizziness, headaches, insect bites, burns, and itchy skin. It typically contains peppermint oil, *wuzhu* oil 五柱油, lilac, and extract of licorice root.

No elderly Chinese woman would be without her trusty little bottle of medicinal oil, but its popularity has significantly grown over the years, extending beyond China. When Westerners first visited China, they were struck by a heady and unfamiliar cocktail of fragrances; the tang of salted fish and shrimp paste from the coast, sandalwood incense wafting from temples, and the distinctive smell of medicinal oil emanating from women and children. The visitors soon realized that the Chinese oil served a dual purpose: deodorant and medicine. Today Hoe Hin Pak Fah Yeow Manufacturing Limited 和興白花油藥廠有限公司 has further developed this idea, widening the market by creating an aromatherapy line on top of its renowned medicinal oils.

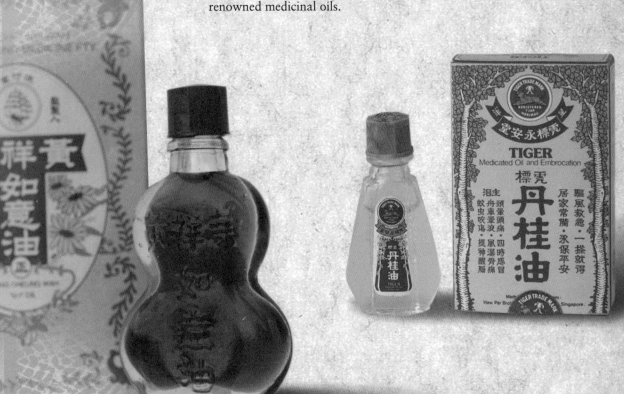

Applying Medicinal Oils

In the past medicinal oils were either applied on affected parts of the body or taken orally. In recent decades, however, instructions on the packaging clearly indicate that such oils should be used only externally.

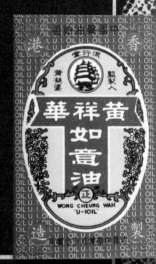

Wong Cheung Wah U-I-Oil

Wong Cheung Wah 黃祥華 (born Wong Siu Cheung 黃兆祥) came from Foshan. His father, Wong Yuen Kat 黃元吉, made a living by handcrafting ornate lanterns, floral decorations, and trinkets for worshipping deities, while Wong Cheung Wah sold the decorative items from the family shop in Wanming Lane. One day the elder Mr. Wong, a devout Buddhist, obtained a miracle cure from an old nun living in a nearby Buddhist nunnery, and it healed his family's sunstroke. Indeed the prescription seemed to provide an excellent cure for any illness that befell the Wong family. This inspired Wong's fourth and youngest son, Yick Nam 奕南, to suggest producing the medicine not just for family use but for a commercial market, too.

Wong Yick Nam called upon a doctor he knew to discuss the plan and, after repeated tests and refinements, they finally produced an oil concentrate with medicinal effects for external application. Named Wong Cheung Wah U-I-Oil 黃祥華如意油, it became a universal remedy for seasonal bouts of flu, stomach upsets, bronchial coughs, and insect bites. The medicinal oil was initially sent out as a gift to customers of the family's lantern shop, but eventually, when it was put on sale, it became more profitable than the family business, so they set up the Wong Cheung Wah Medicine Shop 黃祥華藥舖 and focused on selling medicinal products instead.

Then in 1884 this famous shop gained further recognition after a visit from a high-ranking court official, Li Hongzhang 李鴻章, who presented Wong Yick Nam with a commemorative plaque for having healed a favored member of the imperial household. The plaque bore an inscription stating that Wong had reached the pinnacle of success in his art as a healer, equating him with the renowned herbalist Han Kang. The Wong Cheung Wah Medicine Shop thrived until the Japanese occupation of China, which was a period of complete chaos, causing the family business to fold in 1945. It took several decades for the company to revive the business and reestablish its prestige, a move spearheaded by Wong's daring and determined successor, Wong Ying Lau 黃凝鏐. Concentrating all his efforts on reproducing the family's famed Wong Cheung Wah U-I-Oil, Wong strove to regain a significant foothold in the market, and after several years of hard struggle U-I-Oil finally went on sale again in the mainland in 1987. Today the oil is a bestseller in China, Singapore, and Malaysia. Operating from its head-quarters in Hong Kong and from a second branch in Singapore, this century-old company is well on its way to recapturing its former glory.

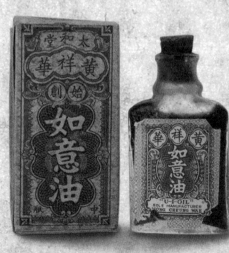

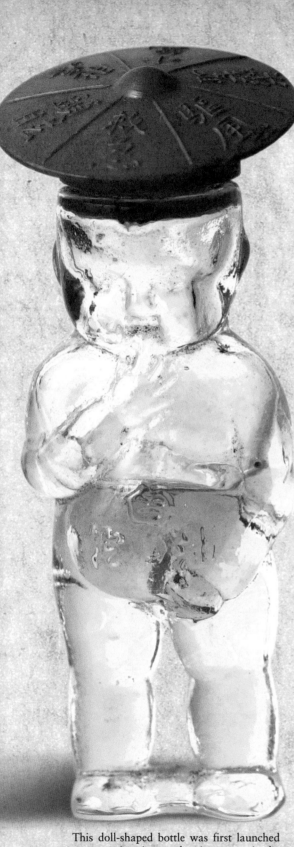

Good things come in small packages: manufacturers often touted their bottled medicinal oils as universal panaceas, capable of healing a wide variety of common ailments when applied to acupuncture points.

This doll-shaped bottle was first launched as a premium item to be given away in the 1950's and 1960's.

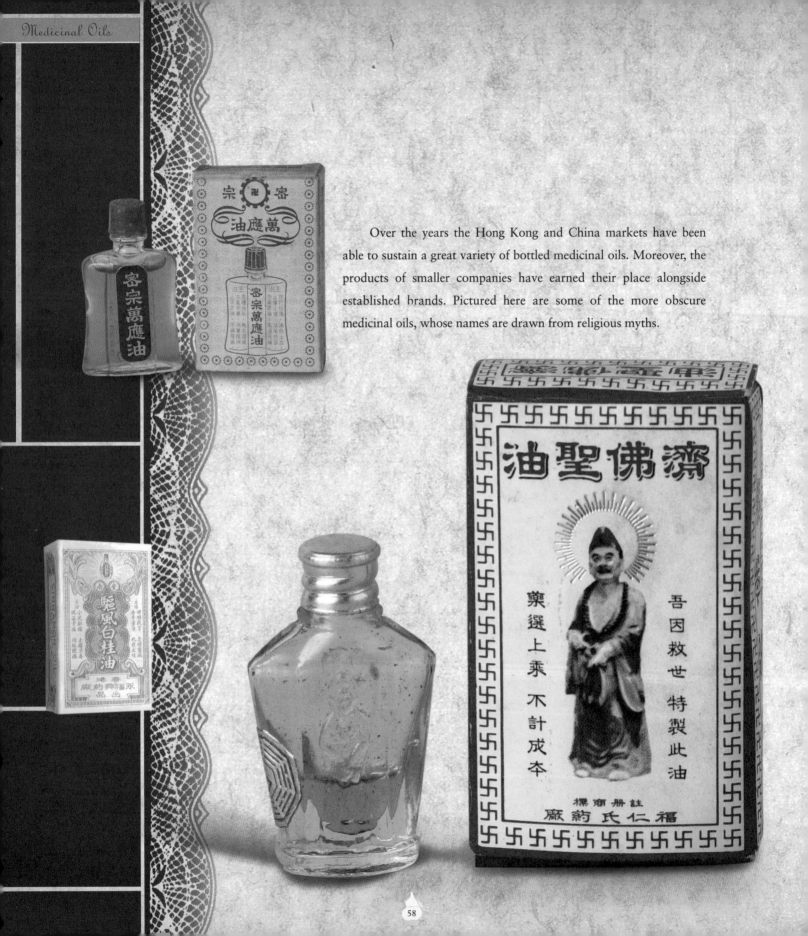

Over the years the Hong Kong and China markets have been able to sustain a great variety of bottled medicinal oils. Moreover, the products of smaller companies have earned their place alongside established brands. Pictured here are some of the more obscure medicinal oils, whose names are drawn from religious myths.

Ban Chung You

Old-style traveling theatrical troupes were prone to insect bites and an array of other ailments brought on by changes in the weather and environment, as they were constantly on the move. Furthermore, the physically energetic nature of their art meant that they were also vulnerable to muscular strains, bruises, and injuries, so the performers usually carried medicinal oil with them for emergency use. As a result, *ban chung you* 班中油 [medicinal oil for traveling performers] was produced. In the natural progression of things, they eventually put their medicinal oils on the market, and they became a popular remedy for the general public.

This colorful box of Bat Wo Tong Wah Toll Oil 八和堂華陀油, pictured below, is a wonderful example of medicine packaging at its most intriguing. Its design was based on the story of three heroes of the ancient kingdom of Shu, just one of many popular folk legends whose imagery proved highly persuasive to consumers.

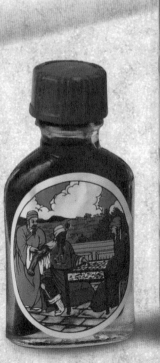

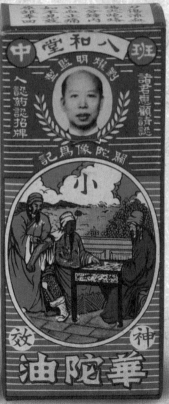

Tonic Wines

Over the centuries, jiu 酒 [wine] has been used as a conduit for thoughts and emotions and has even brought out the drinker's heroic spirit. A classic example of the latter is Li Bai 李白, the Chinese god of poetry and a legendary tippler who enjoyed three hundred cups of wine daily. Notwithstanding the great variety of wines produced around the world, China has arguably the greatest variety of tonic wines. Restorative medicines are steeped in rice wine until the soluble ingredients are released, producing remedial effects to fortify the body. Among the more commonly known medicinal wines are *san bian jiu* 三鞭酒 [which combined the genitalia of three of the following animals: tiger, bull, donkey, dog, or male deer], three snakes wine (a blend of black-striped snake, krait, and viper), rat wine, and toad wine. Other popular tonic wines include those for healing rheumatism and injuries caused by knocks and falls.

Indelibly etched in my own mind is the glass jar I saw as a youngster containing my maternal grandfather's homemade rat wine. I was truly appalled by the sight of all those entangled downy-white rat fetuses that resembled laboratory specimens. Before they had even set eyes on the world, my grandfather was already coveting these pitiable creatures as the vital ingredient of his liquor. I still remember now his contented expression as he relished his regular tonic after meals. To him it was like heaven. Later I discovered that the rats had to be selected while still fetuses in order to guarantee the wine's remedial effect. The rat infusion is added to a base of pure rice wine with additional ingredients such as the root of Chinese angelica 當歸, pseudo-ginseng 田七, safflower 紅花, and eucommia bark 杜仲. Such rice wines are said to relieve gas, rheumatic pains, and unconsciousness. Additionally rice wine is believed to activate energy flow, enhance blood circulation, and strengthen the kidneys. Little wonder that my grandfather still had a spring in his step long after he reached seventy years of age.

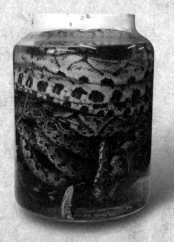

Leung Choi Shun: A Potted History

Leung Choi Shun's bone-setting practice has operated in Lanshi market on the outskirts of Foshan for more than 150 years. It is well known throughout Guangdong province for its medicinal wines, pills, and plasters. Leung Choi Shun is believed to have acquired the art of healing under the tutelage of Pun Yat Su 潘日舒, whom he later surpassed. Leung set up his business in 1805 and became extremely popular with local workers and the potters of Shiwan. Later he set up a branch in Hong Kong on Possession Street. Today Leung Choi Shun has a string of local branches operating under three brand names: Sunlight 日光牌, Five Portraits 五像牌, and Tai Chi 太極牌.

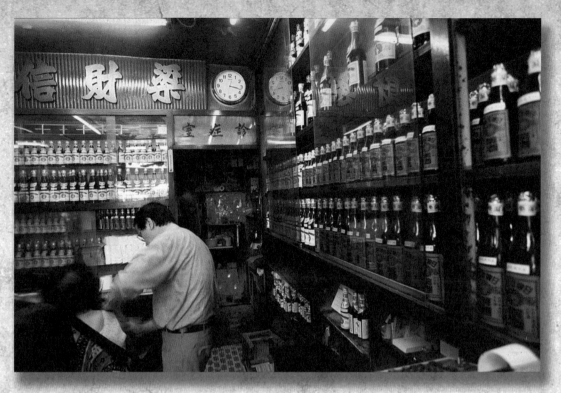

Leung Choi Shun: Bonesetter Extraordinaire

When it comes to the art of bonesetting, one name stands out: Leung Choi Shun 梁財信. For almost a century his name has been uttered with awe and respect in Chinese circles; some even claim that Leung could fuse chicken and duck legs together. To see if there were any truth to the story, I paid a visit to Leung's successor, fifty-year-old Leung Wing Sang 梁永生, who currently runs Leung Choi Shun's main store 梁財信藥廠(日牌) in Shamshuipo. During my visit Leung was busy treating patients, bandaging them, and applying medicinal oil with the firm and masterful movements that come from years of practice. Unlike those prim-looking bonesetters dressed in long gowns over a traditional Chinese jacket and trousers, the urbane Leung is bespectacled and neatly dressed in a Western suit. He is up to his ears in work, but he solicitously attends to each patient, wearing an expression that is at once scholarly and benevolent.

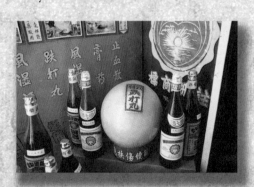

"It's utterly impossible to connect chicken and duck legs!" Leung tells me unequivocally but with a smile. "Such wives' tales stem merely from the high esteem in which people held my ancestor! After all, chickens and ducks are two entirely different species with their own distinctive DNA. How can their bones possibly knit together?" Leung's authoritative tone immediately clears any doubts I may have had.

There was, besides Leung Choi Shun, another famous bonesetter, named Lee Kwong Hoi 李廣海, who practiced in Foshan during this time. The two ran their practices amid a spirit of keen competition, and Lee allegedly experimented on chickens and ducks to prove his superior skills. When I broach the subject with Lee's grandson Kwok Siu 李國紹, he comments, "My grandfather not only excelled at bonesetting, he was also well versed in healing bullet and knife wounds. Banditry was rife in the villages and mountains, due to the chaos that reigned from the late Qing dynasty to the early years of the Republic of China. My grandfather made no distinction between the law-abiding citizens and underworld kingpins who sought his assistance. He just dedicated himself to generously aiding people in distress, irrespective of their financial situation, provided that they were injured."

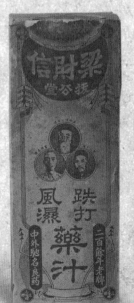
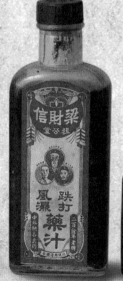

So these two celebrated bonesetters owed their great success and popularity not only to their consummate healing skills but also to their medical ethics and integrity.

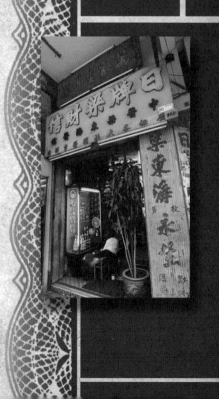

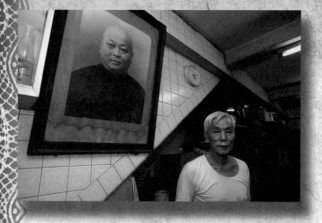

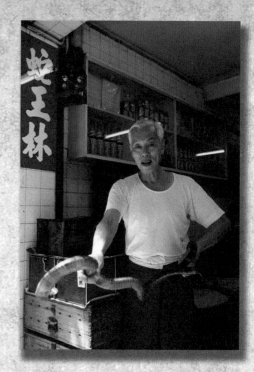

She Wong Lam: Hong Kong's First Snake Shop

For many people the mere mention of snakes is enough to make them recoil in horror, but epicures, particularly Cantonese gourmands, lick their lips in anticipation of feasting on these plump, attractive, and slithering creatures. Autumn, traditionally, is the high season for eating snakes and local gourmets go to great lengths to satiate their appetite. Today there are many snake shops in Hong Kong, and most of them have adopted the title

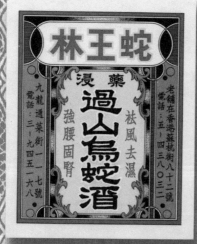

"snake king." The first shop to truly lay claim to this accolade was She Wong Lam 蛇王林 [Snake King Lam], on Hillier Street, Sheung Wan, which was established a century ago.

Longtime employee Mak Tai Kwong 麥大江 is the second generation in his family to work at She Wong Lam, following in the footsteps of his father and paternal uncle. In spite of his advanced years, seventy-two, and shock of gray hair, Mak is still a strong and healthy man, bursting with vitality. Having worked at the shop for more than half a century, he knows the snake business inside out. The founder of She Wong Lam was Lo Tai Lam 羅大林, whose ancestors settled in Xinhui, Guangdong province. As a boy Lo learned the skills of snake-catching from an old neighbor. Besides catching snakes, he bought snakes from others to sell. In Hong Kong he sold snakes under the brand name She Wong Lam, adding a second branch on Jianglan Street, Guangzhou, before the Second World War. While being a much sought-after culinary treat, a snake can also be used in its entirety to make medicine, so it is regarded by the Chinese as one of nature's most precious gifts. Particularly prized in Chinese medicine is the snake's gallbladder, which contains the essence of its entire body. There is a wide variety of snake-based medicine, of which the

best-known remedies are *she dan chuan bei mu* 蛇膽川貝末 [a powdered mixture of snake bile and the tendril-leaved fritillary bulb], snake gallbladder wines, and *san she dan chen pi mu* 三蛇膽陳皮末 [a powdered mixture of the bile of three commonly found snakes and dried citrus peel].

Mak describes the procedure for preparing snake medicine: "First the snake is thoroughly cleaned inside and out with the head, intestines, and internal organs removed. It is then steamed in a container and immersed into a jar of rice wine. Steamed snakes soaked in wine can be taken orally after one month, while raw snake can only be consumed after a year." Mak explains that the best wines take between three to five years to mature. Any wines older than this will not be effective, because the wine tends to evaporate over time, especially if the container is not properly sealed. To make *san she dan chen pi* 三蛇膽陳皮 [dried citrus peel steeped in the bile of three common snakes], one should select eight-year-old citrus peel from Xinhui. The peel is steeped in the bile of the three snakes, dried by the wind, and baked, then this process is repeated two or three more times.

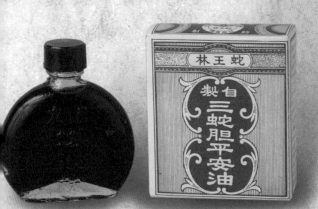

From time to time newspaper reports surface about unfortunate souls who have been poisoned or even killed as a result of ingesting snake gallbladders. Such tragedies, according to Mak, occur when there is an improper preparation of the gallbladders, such as a failure to observe hygiene standards or ignorance on the part of the consumer. He continues earnestly, "Before the snake gallbladder is fit for consumption, it has to be disinfected with alcohol and soaked in wine for up to a year. Swallowing raw-gallbladder could endanger your life!" I wondered if, in his many years of dealing with snakes, Mak had ever been bitten. "By my third year on the job, I had already started pulling out the snakes' venomous fangs. Thankfully, luck has always been on my side, and I have never been bitten. In any case, we always keep two doses of herb-based antidote in the shop in case of emergency." With his personal safety record intact, Mak has plans to retire in the near future, after a lifetime spent working at She Wong Lam.

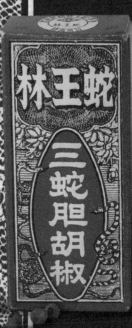

Most snake medicine is blended with plants native to China, such as ginger, citrus peel, and pepper, to bring out the remedy's full medicinal effects.

A photograph taken in 1939 shows Li Tze Fai's first shop, located on Shanghai Street, Hong Kong. The young boy crouching in the foreground is Li's son Yiu Ming.

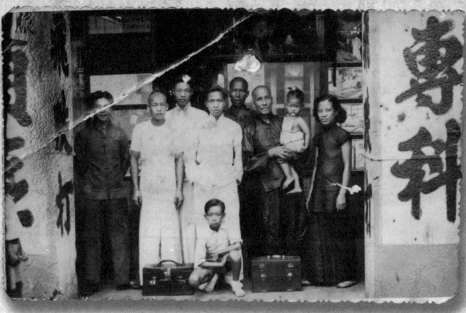

Li Tze Fai

Bonesetter Li Tze Fai 李子飛 was renowned throughout Hong Kong for his healing powers. He started out as a street performer on Hollywood Road, peddling particularly effective pills and medicinal wines that had been made according to secret formulas handed down by his forebears. His prowess was such that he was once invited to the city of Nanking to diagnose Jiang Qiyan, a high-ranking officer of the Chinese Nationalist airforce. The news that Li had helped to heal General Jiang quickly spread, and he returned to Hong Kong with a glowing reputation.

The pioneering Li was also the first bonesetter to use an X-ray machine to aid his diagnoses. Accompanied by his son Yiu Ming 李耀明, he was frequently the medical officer at sporting events held by various associations and organizations. The two were regular fixtures, for example, at competitions organized by the local soccer club and, equipped with medicine chests full of homemade remedies, they rushed about the playing fields tending to the players' injuries.

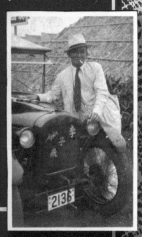

Li Tze Fai, the proud owner of a gleaming Austin motor car, is pictured here in 1938.

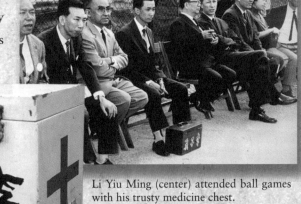

Li Yiu Ming (center) attended ball games with his trusty medicine chest.

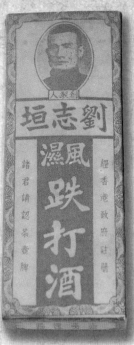

In the past there were a great many famous martial-arts masters in Hong Kong and China. Each possessed his own unique understanding of medical science and the injuries caused by physically demanding activities; some even sold their own brand of simply packaged medicine. This remained a sideline, however, as most concentrated on their bonesetting practices. Among the many medicines available were those produced by famous bonesetters, including Luk Chi Fu of the School of the White Crane 白鶴派陸智夫, Lau Chi Wun 劉志垣, and Leung Choi Shun of Foshan. Their medicines provided an excellent cure for injuries sustained by knocks and falls.

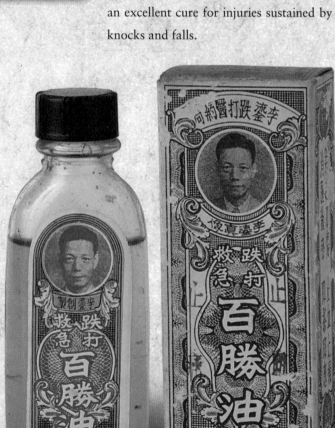

Safety First

Under the strict tutelage of their masters, young martial-arts pupils practiced their moves late into the night. In recognition of their hard work, the wives of tutors customarily prepared a large bowl of hot, fortifying porridge, to be shared among the master and his pupils. Aside from imparting martial feats, the masters taught their pupils basic medical skills for treating injuries caused by knocks and falls. Once they had learned about the structure of the human skeleton, the pupils were better equipped to heal themselves in the event of an injury. As the local saying goes, "Learning how to heal injuries caused by knocks and falls comes before the learning of martial arts."

Snakes: A Metaphor for Slackers

When snakes fatten themselves up in the autumn before hibernation, their movements become slow and languorous. The Cantonese refer to the serpent's sluggish movements as a metaphor for idlers looking for a place to avoid work. By extension, the place chosen is known as the snake's den!

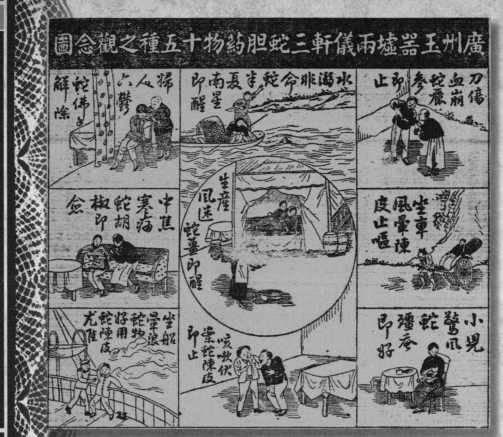

The graphics in this newspaper, which date from the early twentieth century, demonstrate the fifteen different uses of snake-gallbladder medicine.

Leung Yee Hin

Renowned for its snake-gallbladder medicine, Leung Yee Hin 兩儀軒 was founded a century ago by Yu Hoi Chau 俞凱儔 and is run today by her only daughter, Teun Fong 俞端芳. The shop was originally located in Guangzhou's jade market, and other branches rapidly followed in Nanzhan, Xizhan, and Foshan in Guangdong, and in the Sai Ying Pun district of Hong Kong.

In its heyday the shop produced a wide assortment of snake medicines, including nearly twenty types of snake powder and plasters and fifteen kinds of snake wine. After Yu closed down the branches in China and transferred the company base to Hong Kong, demand for Leung Yee Hin's snake products dwindled, as the local market began to decline. By 1958, according to medicine packaging printed in that year, the shop only produced nine kinds of medicine, based on the combined gallbladders of three snakes. At that point Leung Yee Hin had changed hands and was owned by Chu Da Jan 朱特珍, who renamed the store Chu, Da Jan Leung Yee Hin 朱特珍兩儀軒. Today the company is once again based in China.

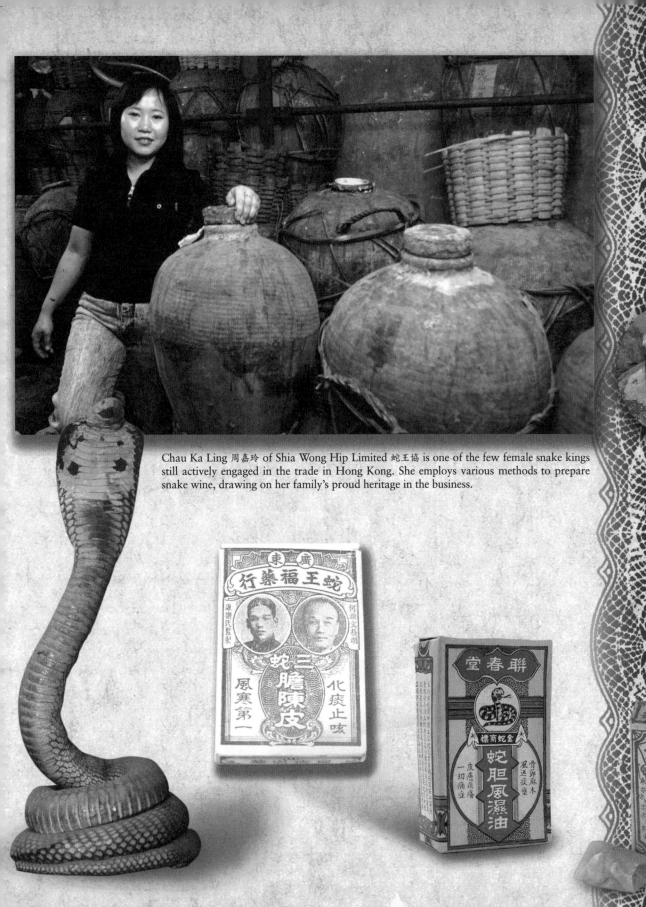

Chau Ka Ling 周嘉玲 of Shia Wong Hip Limited 蛇王協 is one of the few female snake kings still actively engaged in the trade in Hong Kong. She employs various methods to prepare snake wine, drawing on her family's proud heritage in the business.

Sealing Wine Jars

To seal a jar of snake wine, one prepares a paste by mixing pig blood and lime. The paste is then smeared onto a swab affixed to the top of the wine jar. When the mixture coagulates, it completely seals off the mouth of the wine jar, protecting the contents for up to five years.

"Nine out of ten men are impotent!"

What Poor Wretched Souls Are Men!

Long-Standing Traditional Values

Driven by a deep-rooted desire for self-improvement, Chinese men have traditionally believed in developing both a mental fortitude and a strong physique to accomplish their life's ambitions. Ultimately these goals are in keeping with the time-honored Confucian motto *Xiushen, qijia, zhiguo, pingtianxia*, ("To cultivate one's morality, put one's family in order, run the local government well, and bring peace to the entire country").

Trials and Tribulations Affecting a Man's Libido

In traditional Chinese society, male chauvinism, paternal authority, and other invisible pressures arising from one's career, family, and peers have constantly forced men to put on a brave face in public. Working hard all day every day to support their families, men frequently suffered from mental and physical fatigue, resulting in such physiological dysfunctions as impotence, premature ejaculation, spermatorrhea, and sterility. Men would try every conceivable method to recover their potency, and in traditional herbal medicine they found precisely the restorative tonics they needed to nourish the kidneys, brain, and blood. The herbal remedies were not intended so much as an aphrodisiac as a means of enhancing virility in order to successfully reproduce.

Living in Shame and Fear

The vast majority of men lived in fear of kidney complaints, impotence, and, worse still, sterility.

A Satisfying Sex Life Leads to a Happy, Fulfilled Existence

Men, in particular Chinese men, suffer a loss of face when they become impotent. Ridiculed by their partner, they lose their self-esteem and confidence. Psychological issues further complicate matters, a problem not so easily remedied by medicine.

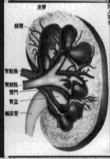

When it comes to male fertility, Chinese and Western medicine are entirely at odds with one another. Doctors trained in Western medicine interpret the kidney as an organ for distilling blood. In Chinese medical theory, the kidneys form a repository for sperm and are directly related to a man's sexual performance. Western practitioners dismiss this view as ridiculous.

Sex has long been taboo in Chinese society and was seldom discussed overtly until recent years. With the rise in venereal diseases in the early twentieth century, it became an obvious topic for discussion. From the 1920s to the 1970s, there was an abundance of newspaper advertisements for products such as "invigorators" and medicine for treating venereal diseases. Playing on men's single biggest fear, companies resorted to shock tactics and printed alarmist slogans like "Nine out of ten men are impotent" (see label at left).

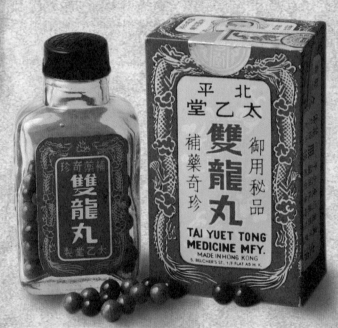

Spermatorrhea (the involuntary discharge of semen without orgasm) is a normal physiological phenomenon. According to Chinese physicians, it is symptomatic of kidney deficiencies. Being overworked, and hence prone to mental stress, directly affects a man's sexual faculty and can, in serious cases, lead to kidney complaints. In medieval times these involuntary emissions were considered a crime among the clergy, and those who found they had experienced a wet dream upon waking had to sing the seven psalms of penitence to atone for the sin they had committed!

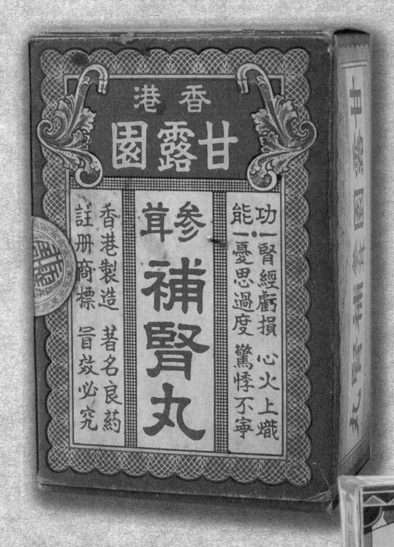

性一直是社會的禁
忌，同時是人類的
一大煩惱。

This tonic wine, specifically targeted at men, enjoyed great popularity a decade or so ago for its striking slogans that boasted of the efficacy of the genitalia of three specific animals as an aid for male vigor and potency. The wine included the genitalia of the fur seal, the spotted deer, and the Chinese dog, which were blended with numerous other medicinal ungredients, including ginseng, the hairy antlers of a young stag, Chinese cinnamon, and agalloch, or eaglewood.

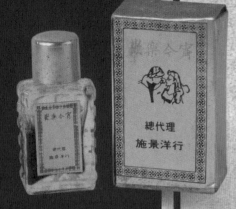

「你可以笑我無錢，但唔可以話我
唔得！」

Enjoy Yourself Tonight

When the hosts of Hong Kong's famous long-running evening variety TV show, aired on TVB Jade channel, bid its viewers goodnight with the words "Enjoy yourself tonight," they used an overt double entendre in Cantonese that exhorted couples to have fun, or, in other words, enjoy sex every night. The bottled aphrodisiac pictured here appropriated the show's sexual pun for its brand name.

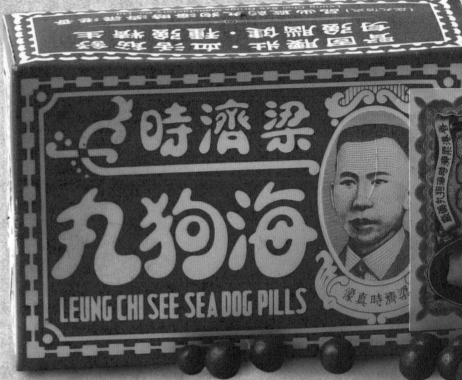

LEUNG CHI SEE SEA DOG PILLS

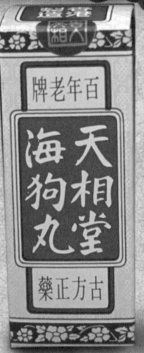

The Chinese have long believed in consuming certain animal parts to benefit the parallel part of the human body; for example, one would eat chicken legs to nourish one's legs, the brain of a pig to nourish the human brain. Naturally this concept extends to animal genitalia as well, which are thought to have an aphrodisiac effect on humans. The key ingredients of common aphrodisiacs include the genitals of fur seals, Chinese dogs, tigers, deer, or snakes. Of course, the benefits of such delicacies are more psychological than medical; but, as the local saying goes, "Those who believe shall be saved!"

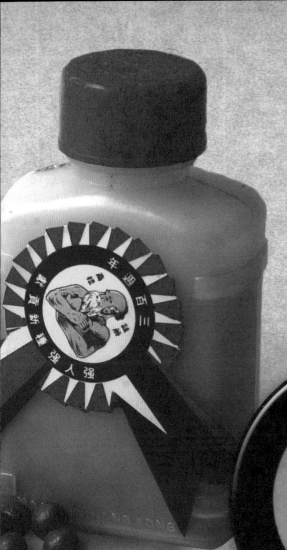

Through the ages, young men have nurtured hopes of possessing supreme staying power and sexual vigor. Few can resist the temptation to boast about their sexual prowess or to subdue their partners in bed, and most are willing to demonstrate their ability at the drop of a hat. However, poor sexual awareness, compounded by the exaggerated exploits of pornographic magazines and films, only serves to underline the gulf between men's wild claims and reality. There are those who have relied too heavily on medicine in the vain hope of conquering the female sex; it may have increased their sexual desire in the interim, but ultimately their dependence may lead to impotence.

Indian God Provides Sexual Healing

As one of the world's ancient civilizations, India is shrouded in religious mysticism, arousing awe and wonder; and in the *Kama Sutra*, the country has bestowed upon the world the secrets of its distinctive art of eroticism. Quick to spot an appealing gimmick, canny Hong Kong medicine shops hit upon the idea of using the image of an Indian god on their packaging who bears a magical lamp as an emblem of his outstanding sexual performance. Users of the love potion obviously hope that the genie with the lamp can work miracles by resuscitating a flagging sexual appetite.

In Hong Kong it was sometimes difficult to identify locally produced medicine for treating impotency by their packets alone, as they generally bore no clear indication of the contents. The trade was subject to regulations laid down by the Undesirable Medical Advertisements Ordinance, (Chapter 231), which meant that such medicine could not be referred to explicitly as an aid to male sexuality. Instead the medicine was described euphemistically or given a cryptic brand name, such as "sea dog pills" or pills for nourishing the kidneys. The seal of the Leung Chi See Sea Dog Pills 梁濟時海狗丸, pictured above, is conservative in its use of color and design, yet the nature of the medicine is revealed by the registered trademark depicting an old man cradling a baby and the phrase "A strong man produces strong offspring." Here the dual effect of the medicine—enhancing sexuality and fertility—is cleverly implied by the trademark.

The King of Curing Venereal Diseases

Pharmacist Yik On Tong 益安堂 produced thirty kinds of antidotes for attacking sexually transmitted diseases, earning him the title "the king of curing venereal diseases." From the late Qing dynasty to the turn of the twentieth century a vast number of medicines were available for curing venereal diseases. Among the more famous remedies were Wong San Tong's pills for curing gonorrhea 黃慎堂白濁丸, detoxifying medicines by Fu Yun 扶元搜毒膠 and Chat Bo Chai 七寶齋百珍花柳搜毒丸, Su Wo Tong's analgesic pills for healing gonorrhea 庶和堂淋濁止痛丸, and Fa Lau Sau Duk pills for treating venereal diseases 花柳搜毒丸。

Opium addiction was a major social problem in China in the nineteeth century. It was an invisible and indiscriminate killer, claiming the lives of all those seeking an escape from reality, whether they were high-ranking members of society or humble tradesmen. Once addicted, smokers sank further and further into depravity, with disastrous consequences: rapid physical degeneration, financial ruin, and personal upset. Some tried to kick their opium addiction through their faith or willpower, while others sought assistance from the numerous forms of medicine aimed at substance abuse. There was even a medicine—in pill form—that could be placed in opium pipes and that helped smokers by gradually reducing the quantity of opium. Depending on the degree of addiction, these pills helped smokers give up their habit. But the success of this type of medicine was questionable, since it became in effect a substitute drug and did little to manage the smoker's craving to light up.

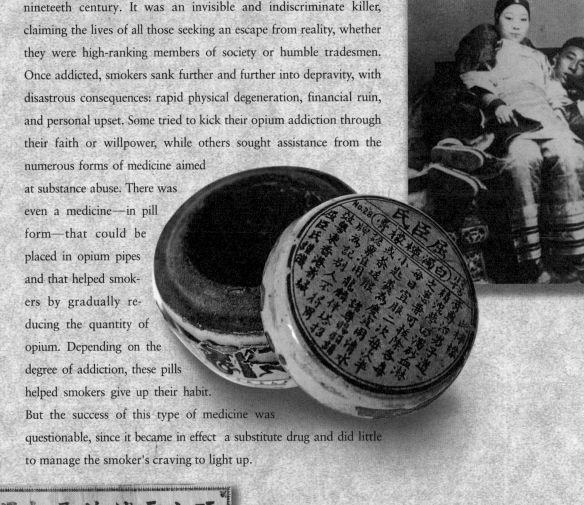

In this morally depraved society, men indulged in carnal pleasures and lingered in brothels. Incapacitated as they were, they possessed no sexual awareness and took none of the necessary precautions to guard against contracting sexually transmitted diseases. There was a dramatic increase in sufferers of gonorrhea, strangury (painful urination), syphilis, and chancre. Despite enduring indescribable pain from festering and swellings, most of them felt too ashamed to visit a doctor and instead sought to treat themselves. As a result, the market saw a rise in herbal remedies for healing venereal diseases.

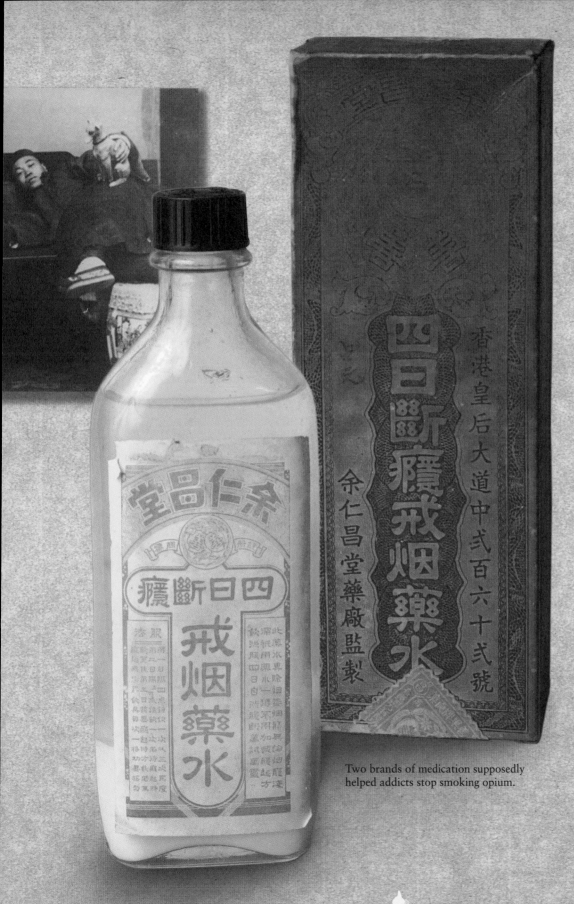

Two brands of medication supposedly helped addicts stop smoking opium.

Opium-Smoking Paraphernalia

The opium smoker's den was typically furnished with an opulent bed on which the smokers would languidly recline, an opium pipe, and a lamp. The bed was often made of the finest-quality redwood, while pipes were fashioned from precious materials such as ivory and adorned with jade, pearls, and gemstones. Pipes made of rhinoceros horn could allegedly heal the constipation caused by smoking opium. The pipe was held over the flame of the glowing opium lamp, which was also referred to as the "mind-blowing lamp," on account of its intoxicating effect.

黃中瑾
參茸婦科
安胎丸
本舖在前清康熙二年開業
調理五臟務使婦科奇效特製
驗監全有黃瑾堂
MADE IN HONG KONG

香
盧

"Women will age rapidly if they do not take health tonics."

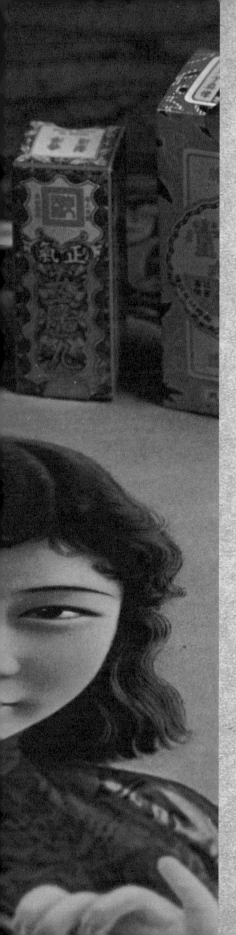

Women! What Great Strides They Have Made!

A Woman's Lowly Status in a Feudal Society

Bound by the feudal attitudes of the past, women once firmly believed that their duty in life was to bear offspring and manage domestic affairs. Their low status meant that they relied on their husbands for financial stability. From the day a young girl started to menstruate, she was prepared for her future role as a mother by the female members of the family. Emphasis was placed on the necessity of supplying a male heir to continue the family line, as well as on producing multiple offspring, since that implied great fortune.

The Importance of Bearing and Rearing Children

In the past when times were hard, women led a simple life, deprived of even the most basic comforts and proper nourishment. Their feeble physique often resulted in irregularities in their menstrual cycle, which ultimately affected their fertility rate; yet they felt too ashamed to consult a doctor on the source of these embarrassing ailments. Suffering in silence, they feared sterility most.

The ultimate objective of gynecological medicine was to regulate menstruation and to strengthen a woman's physique in preparation for childbirth. It was also important to nurse pregnant women, to benefit the development of the fetus, and to ensure the safe delivery of the baby. Among the more famous examples of such medicine are Tin Hee pills, made by Tin Hee Tong 天喜堂天喜丸, and Koo So pills, made by Tien Sau Tong 天壽堂姑嫂丸.

Modern Times Bring Women's Emancipation

With the advent of the modern era, women's status in society rose, and, thankfully, reproduction was no longer their sole raison d'être. Paying attention to one's appearance and enjoying a satisfying sex life were among the modern woman's chief preoccupations.

As women became financially independent, they formed a significant target for advertisers, and the market, then as now, was flooded with products for enhancing one's beauty and health.

Many women wanted to enhance their looks in order to appeal to the opposite sex, so medicine manufacturers began to change their traditional sales tactics accordingly, repackaging their gynecological products to appeal more to a woman's vanity than to her maternal instincts. Best-selling products of this kind included *young yum* pills 養陰丸, *pak foong* pills 白鳳丸, and Pearl powder.

"Women generally start their menstrual cycle at the age of fourteen and yet are like a candle in the wind by the time they reach twenty. Although they overcome these illnesses, they frequently fall sick throughout their life. As blood forms the crux of women's health problems, it is extremely important to nourish the blood in order to regulate menstruation." A translation of the instruction leaflet was found in a packet of *bak dai* pills, made by the Chai Seng pharmacy. These pills were used for treating feebleness and leukorrhea.

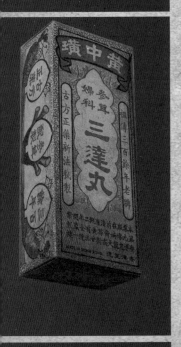

With a view to safeguarding their reproductive health, women attached great importance to preventing ailments associated with menstrual problems. Medicines of the era promised a wide range of therapeutic effects during both prenatal and postnatal stages, such as nourishing the menses before pregnancy, protecting the fetus and easing the mother's breathing during pregnancy, facilitating child delivery, dispelling chills, and removing stasis at the postnatal stage.

Tak Fat pharmacy's 德法藥房 claim that "nine out of ten women suffer from leukorrhea" was perhaps exaggerated, but it did reflect how common the problem was. According to a packet of the company's *lap chi bak dai yun* 立止白帶丸 [pills for the instant treatment of leukorrhea], "the heart controls the flow of blood, so menstrual bleeding should be reddish in color. If periods become irregular, the redness of menstrual blood will easily alter. If blood turns purplish and coagulates, it indicates menstrual disorders."

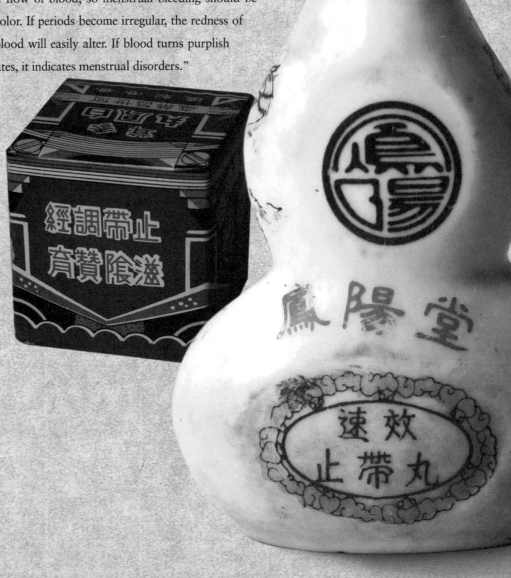

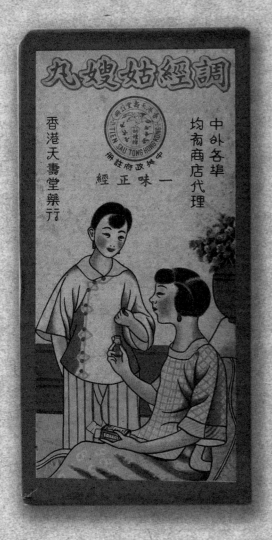

In the past young women who contracted gynecological diseases would avoid consulting a doctor out of shame, so they relied upon the experience of senior members of the family to impart medical advice. Tin Sau Tong's Koo So pills played on this theme in its name and packaging design, both of which refer to a woman instructing her daughter-in-law how to care for herself. The packaging is printed in bright, attractive colors, revealing costumes of China's early Republican period. This packaging concept stood out at the time as an example of creative and coherent design.

家姑教家嫂
大嫂教小姑
調經姑嫂丸
女界護身符

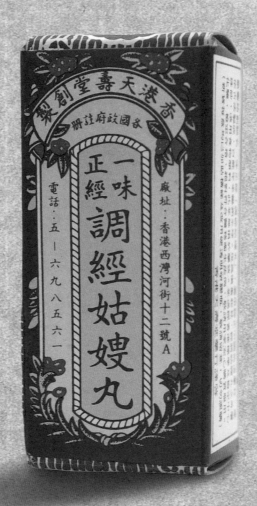

Bringing a child into the world is a joyful occasion for the parents-to-be, though few pregnancies are entirely free from worry. Among the various ways to protect the developing fetus, certain tonics and gynecological medicines were relied upon to guarantee the well-being of the mother and her unborn child.

On toi pills 安胎丸 for expectant mothers were mainly for treating movements of the fetus and abdominal pain, as well as for preventing bleeding during pregnancy and miscarriages.

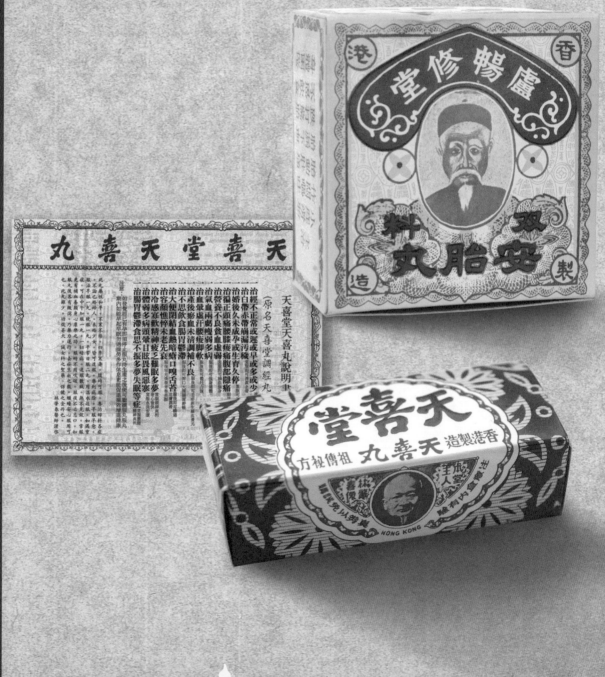

救生良藥

廣州城西方便醫院贈題之匾額

自一九七零年一月改用新仿單諸君賜顧祈為注意

敬佛氏大國居主人衷慕佛法，精修善藥所製太保安胎丸，功效卓著馳名中外，歷有年所。以廉價其惠保生安胎之靈藥也。四句題之。

香港崇佛氏藥行

太保安胎丸

用法	主治	
每服一丸，用滾水燉化飲服，加生薑兩片一齊燉服更佳。	胎動不安 慣成半產 胸膈不舒 頭痛骨痛	腰痛腹痛 孕期下血 食慾不振 精神疲倦

十二太保乃經驗安胎聖方，本藥行依照原方份量，配選上藥虔製。此丸功能養血安胎，孕婦常服，可保子母平安，誠妊娠保產良藥也。

香港製造　　　MADE IN HONG KONG

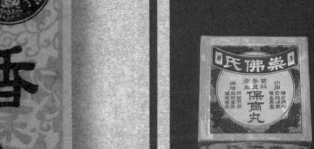

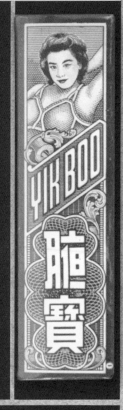

As an earthy local saying puts it, "Men stink, and women are fragrant!" Conscious about maintaining appearances and good personal hygiene, Chinese women had a real horror of sweating profusely in hot weather. To counter disagreeable body odor and the unpleasant sensation of underarm perspiration, two leading pharmaceutical manufacturers produced the antiperspirant-cum-deodorant products Ban Bo 汗寶 and Yik Boo 腋寶. The message conveyed by the packaging design, which showed a woman with one arm raised, is crystal clear.

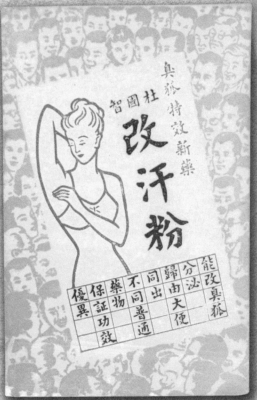

"Small pills are easier to swallow" was a well-known TV advertising slogan, but the message also signifies how Chinese medicine was reformed during the 1980s to tailor to market needs. The introduction of smaller pills heralded a departure from the traditional wax-coated bolus, often as big as a Ping-Pong ball, and they were considered just as effective. In turn the heavy iron cases containing the original pills were replaced by smaller, lighter tins and plastic bottles, which were much easier to carry around. Many companies rethought the packaging of *pak foong* pills at that time.

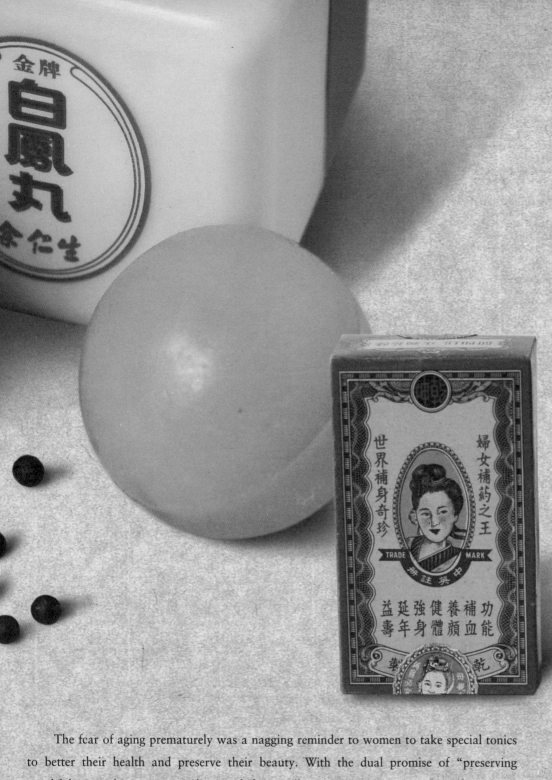

As the modern Chinese woman shook off her shackles of oppression, it was considered perfectly acceptable to embellish her looks to increase her sex appeal. Gradually women sought to strengthen their self-esteem, and they enjoyed the newfound luxury of maintaining a well-groomed appearance.

The fear of aging prematurely was a nagging reminder to women to take special tonics to better their health and preserve their beauty. With the dual promise of "preserving youthfulness and increasing vitality," *pak foong* pills were seen as capable of satisfying every woman's keenest desires.

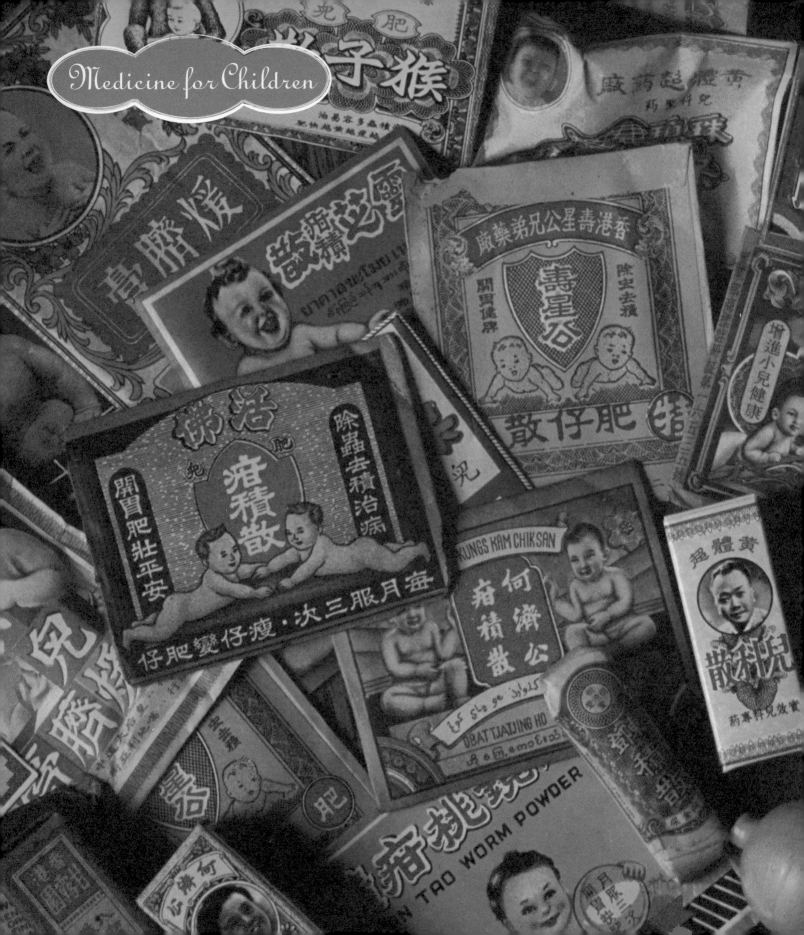

Responsible Parenting

Children are the apples of their parents' eyes. All proud parents take pleasure in watching their babies grow into plump, healthy, and lively children.

Ancient Superstitions and Folk Practices

Newborn babies contract illnesses easily, as they are weak and have an undeveloped immune system. Pinning their hopes on the healthy development of their children, Chinese parents would go to great lengths to provide them with due care and attention. In the past, however, when illiteracy was widespread, inexperienced parents often sought help from senior members of the family when their baby contracted an illness or cried constantly throughout the night. Some even believed that evil spirits had possessed their children, so they would visit a local temple to ask for magical charms or incantation water to invoke a deity who would exorcise the spirits. Without proper medical care, these children often died in infancy. Fearing that their children would not survive, some parents gave their offspring animal nicknames like A-Zhu or A-Gou, meaning "pig" or "dog," in the hope that they would grow up healthy and strong. Others would pierce a baby boy's ear and insert an earring or plead with Guanyin [the goddess of mercy] to become a foster mother and watch over the child. It was not unheard of for parents to place their children in the care of others, believing that they were better equipped to raise them, at least temporarily.

Woeful Living Conditions

Fever, colds, convulsions, crying at night, and vomiting are common infantile disorders that were merely aggravated by the unhygienic living conditions faced by Hong Kong's poverty-stricken population. It was not uncommon, for example, for a family of eight to share one bed in the early days of the colony. As a result, young children suffered from all kinds of infectious diseases, in particular infantile indigestion and small sores, and their complexions were typically sallow with ashen lips.

Cheap But Quality Remedies for Children

Among the medicinal remedies for children most commonly sold in street stalls were *kam chik saan* 疳積散 and partridge powder, used to cure infantile malnutrition from digestive disturbances or intestinal parasites and to encourage the appetite. *Po ying* pellets 保嬰丹 [baby protectors] and pearl medicinal powder were cures for infantile convulsions, twitches, and nerves. The cost of the medicine was mercifully low, ensuring that even the neediest children received relief for their ailments, and most parents kept a supply at home in their first-aid kit. Some of the era's best known brands included *po ying* pellets, made by Po Che Tong Poon Mo Um Dispensary 保滋堂潘務菴保嬰丹, Ma Pak Leung's *chat li* powder, made of pearl 馬百良珠珀七厘散, and Wang Hing Dispensary's Grand and Cheerful Partridge Powder 宏興鷓鴣菜.

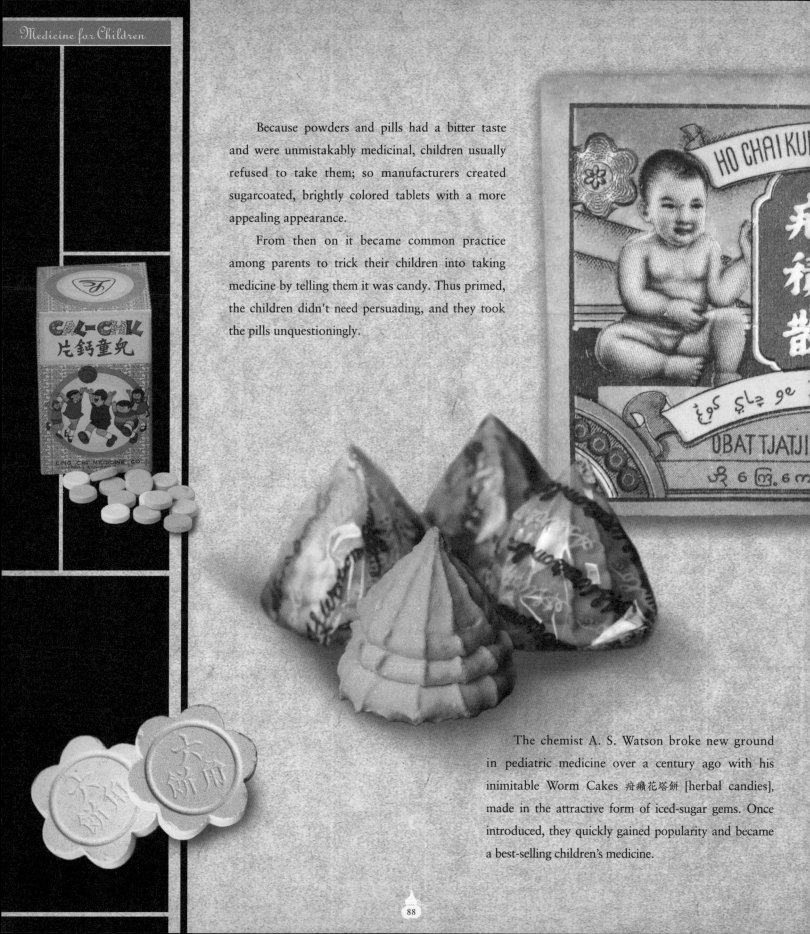

Because powders and pills had a bitter taste and were unmistakably medicinal, children usually refused to take them; so manufacturers created sugarcoated, brightly colored tablets with a more appealing appearance.

From then on it became common practice among parents to trick their children into taking medicine by telling them it was candy. Thus primed, the children didn't need persuading, and they took the pills unquestioningly.

The chemist A. S. Watson broke new ground in pediatric medicine over a century ago with his inimitable Worm Cakes 疳癪花塔餅 [herbal candies], made in the attractive form of iced-sugar gems. Once introduced, they quickly gained popularity and became a best-selling children's medicine.

A strikingly designed packet often invited poor imitations from counterfeiters. Take Grand and Cheerful Partridge Powder, for example (see below). Ever since the packaging bearing the iconic twin-baby motif was launched in the early 1930s, other children's remedies with similarly designed cases soon crowded the market. Wang Hing's packaging, however, was a classic design with a feel for symmetry and balance. The twin-baby logo harked back to one of the most enduring concepts in Chinese culture, namely, that "happiness comes in pairs."

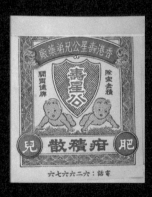

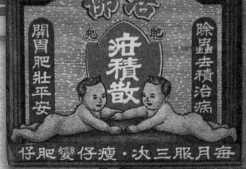

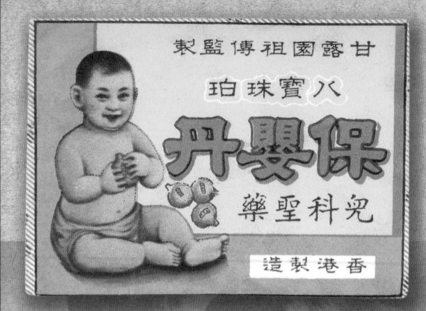

這邊廂有成功的設計和市場銷量，

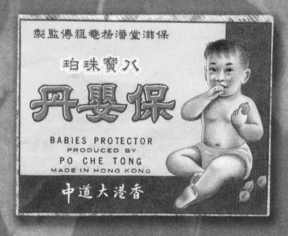

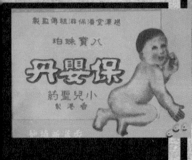

Since children were usually prescribed medicine in small doses, remedies were contained in small tins or packets, with an eye-catching and colorful design to draw the attention of parents. Thus, creative compositions became a hallmark of children's medicine, and parents further increased a product's marketability by sharing news of its therapeutic effects with others.

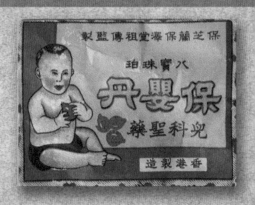

Prior to the 1970s, Hong Kong was densely populated, and the majority of people lived in appalling conditions. Undernourished children with meager limbs and sallow complexions were a familiar sight. As the perception of a healthly child was one who was chubby with fair skin, babies of Western appearance were considered to be the ideal role model. Little wonder, then, that a chubby baby was the predominant image that decorated the packaging of children's medicine, aimed at both local and overseas markets.

In contemporary Hong Kong, conversely, years of comparative prosperity have led to a rising number of severely overweight children, as parents, mindful of the past, tend to spoil and overfeed their children. Today their concerns center on illnesses associated not with malnutrition but with obesity, and they must face a whole other set of health problems.

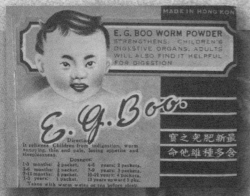

那邊廂就有抄襲模仿的出現。

最後也不分出誰抄襲誰。

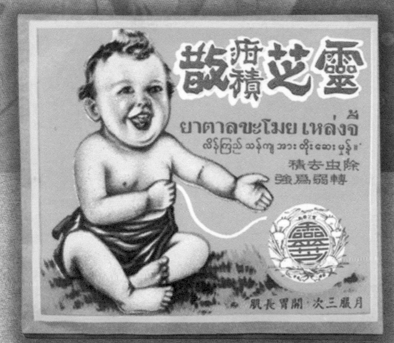

All infants were breast-fed in Hong Kong's early years. To facilitate the taking of medicine, mothers applied medicinal powder to their nipples before feeding. The same practice, conversely, could also be adopted for weaning a baby off the breast. Medicinal oil with a stimulating odor was applied to the nipples to discourage feeding, and, after repeated resistance, infants were gradually weaned from the breast.

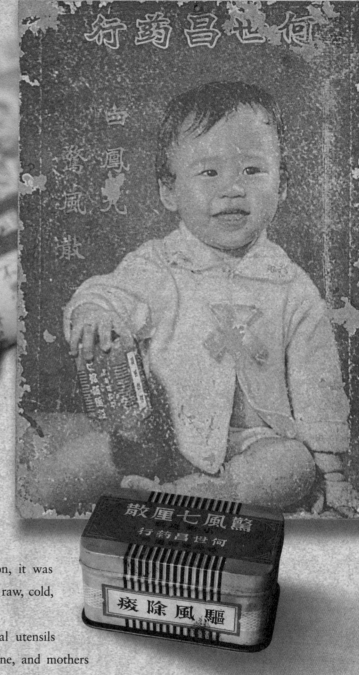

Po ying pellets were used to heal infantile convulsions, infections, persistent crying at night, vomiting, and poor appetite. The dosage depended on the seriousness of the illness, and the pellets were taken with hot water or ginger tea. While taking the medication, it was recommended that children avoid eating raw, cold, oily, hot, and fried foods.

As an added precaution, no metal utensils could be used to administer the medicine, and mothers had to be careful with their food preparation, refraining from wearing any gold ornaments. Such were the taboos and superstitions of the day.

Ma Pak Leung's *chat li* powder used the words seven *li* 厘 [*li* being a unit of weight] as the name of its medicine. Then Ho Sai Cheong medicine company 何世昌藥廠 followed suit, producing *king fung chat li saan* 驚風七厘散 [powder for healing infantile convulsions]. The two leading medicinal powders were a common household remedy for healing children.

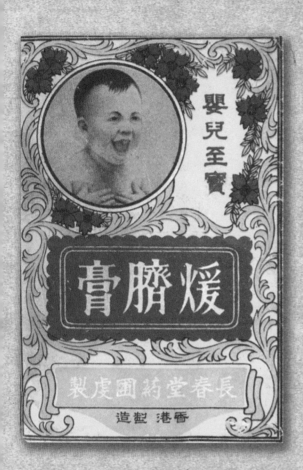

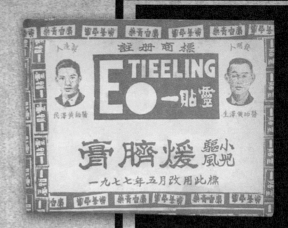

From ancient times the Chinese believed that newborn babies were delicate and vulnerable to infection, making them prone to nervousness and illness. A new occupation emerged: *tuijing po* 推驚婆 [an old woman], were hired to act as child healers.

Sadly, in a country where mass illiteracy was common, anxious but clueless parents had no choice but to leave their ailing children at the mercy of these healers. Often young patients died from the lack of proper medical care.

According to another old wives' tale, after the umbilical cord was severed from a newborn baby, cold wind could easily enter the body through the navel, causing umbilical tetanus, abdominal pain, and diarrhea. Thus navel-warming plasters 暖臍膏 were produced and placed directly on the navels of children.

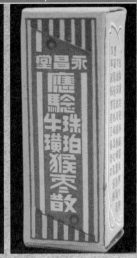

The *houzizao*, a ball of matted vegetable fiber derived from the macaque, is considered one of the three treasures of pediatric medicine, along with pearl powder and *niuhuang*, or bovine bezoar. Oval in shape and resembling the jujube fruit, the macaque bezoar can be as big as an egg or as small as a soybean and provides antipyretic, antidotal, soothing, and expectorant effects.

The Soothing Effect of Gold

For many generations gold foil was sold in some of the more traditional herbal shops, as it was thought that gold could help soothe the nerves of infants. Gold was also considered an effective detoxifying medicine but was harmful to one's health when excessive amounts accumulated in the body.

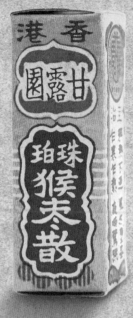

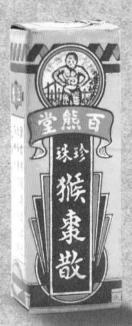

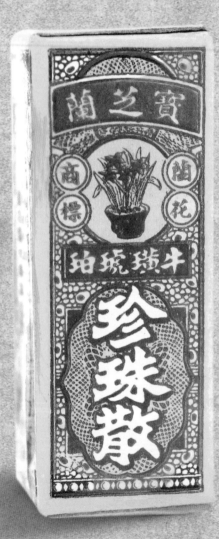

"If you don't take your medicine, insects will crawl out of your backside and bite you!" When infants were suffering from infantile malnutrition, it was common for parents to issue this kind of threat to scare them into taking their medicine.

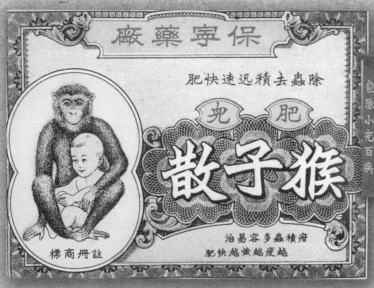

The Chinese saying "To possess both the agility and naughtiness of a monkey" was an apt reflection of parents' expectations of their children. Monkeys projected an image that was at once healthy, vivacious, clever, and naughty and were often seen on packets of children's medicine. Nor was it a coincidence that such medicine contained the precious bezoar of a monkey as its key ingredient.

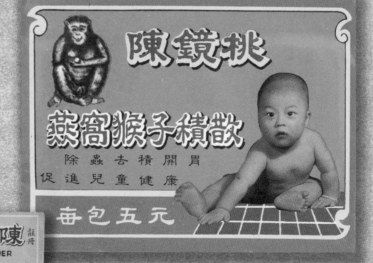

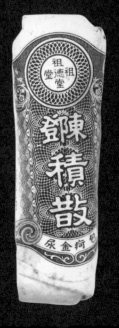

Kam chik saan was a powdered remedy for healing infantile malnutrition, effectively treating digestive disturbances and intestinal parasites. Its ingredients included medicated leaven, hawthorn fruit, malt, tuckahoe, wrinkled giant hyssop, preserved citrus peel, and licorice root. Aside from killing parasites, it was touted as strengthening the stomach and spleen. Numerous famous herbal shops produced *kam chik saan* and, as it was easy to prepare, many hawkers sold inexpensive *kam chik saan* in the streets.

Four Basic Functions of Medicine Packaging

1. Medicine packaging is necessary both to guard the contents from contamination caused by pollution and contact with moisture and air and to ensure its long-term preservation. The traditional method of coating pills with wax works well in this respect.

2. Different forms of drugs require different containers. Whatever the material, the packaging should not produce a chemical reaction with its contents, as this could affect the efficacy of the medicine or, worse still, make it unsafe for consumption.

- Crowning the medicine package is a tin lid, which ultimately seals the contents.

- The cardboard lie underneath is mounted with a piece of glass, through which the contents are visible.

- The folded guarantee coupon — typically adorned with the factory owner's portrait — acts as a buffer for the wax-coated pill.

- The wax coating forms the pill's first layer of protection against contact with air and moisture.

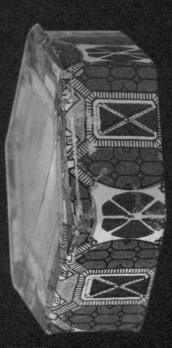

3. Medicine packages that are lighweight and easy to open are essential. Crates, chests, and cases that are simple to transport can facilitate sales and shipping overseas.

4. Distinctive packaging helps consumers identify the various brands and products in the marketplace. Needless to say, medicine that is beautifully packaged generates better sales and enhances brand recognition.

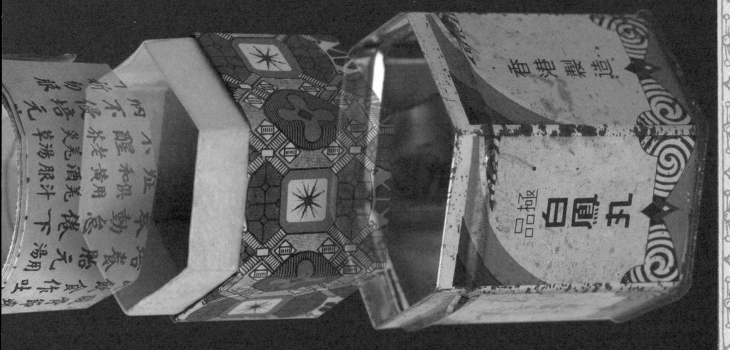

- The instruction leaflet is folded into equal halves and rolled up, acting as an additional layer of protection.

- The base of the cardboard case is constructed manually and decorated with patterned paper to enhance its overall appearance.

- The outermost layer of the medicine packaging is a sturdy tin case.

One of the oldest forms of medicine packaging, paper is widely employed because it is comparatively inexpensive and highly versatile. It is used to fashion everything from wrappers and boxes to labels, instruction leaflets, and guarantee coupons.

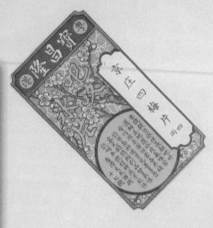

A typical sheet of Bo Cheung Lung 寶昌隆 wrapping paper from the 1960s was carefully folded so that the medicine shop's label would be presented on the surface of the packet.

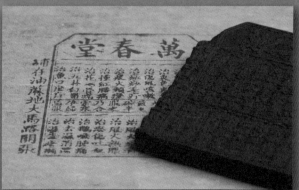

An eighty-year-old woodblock was once used to print labels. This woodblock is from the Man Chun Tong herbal shop, formerly located in Tai Ma Road 大馬路, now better known as Shanghai Street 上海街.

Humble paper and string were among the earliest materials used to wrap medicinal herbs. Today some shops still use printed white paper wrappers that are strategically folded to show the shop's name atop the package. Pills were usually wrapped in cotton paper, which produces few chemical reactions, and coated in wax to prevent contamination by air and moisture.

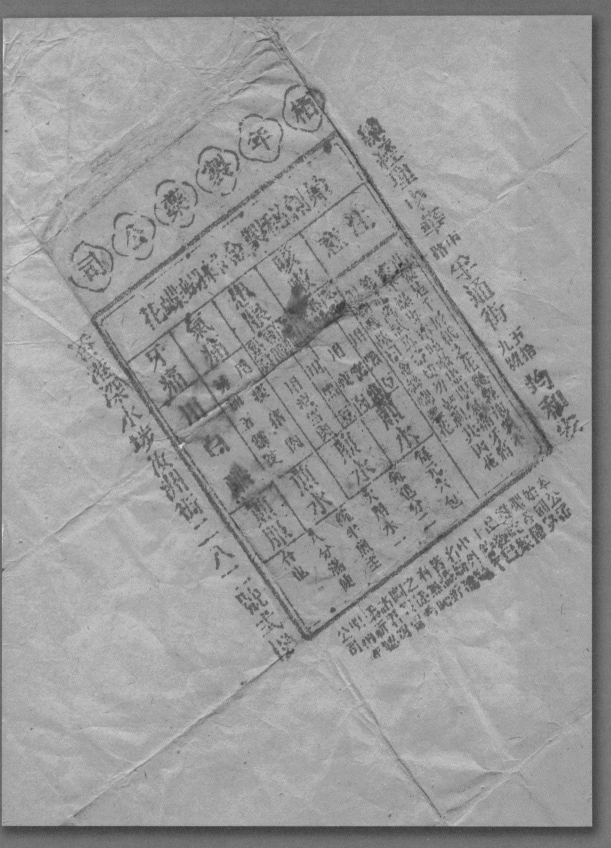

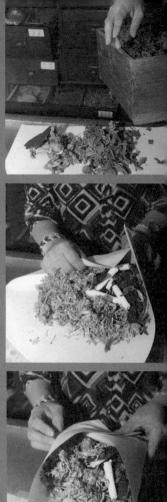

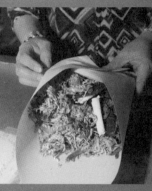

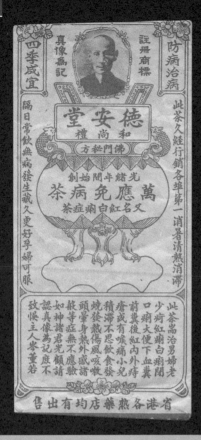

Cotton paper is typically used for wrapping pills.

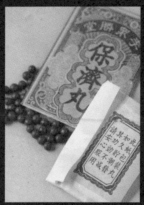

A waxed-paper packet of Po Chai Pills has a finely printed outer wrapper that dates back to the 1950s.

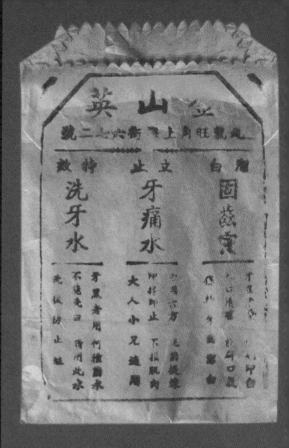

The beauty of cardboard is that it can be folded into containers of myriad shapes and sizes, bearing different graphic patterns, depending upon the kind of medicine it is designed to hold. Even so, it is not without disadvantages:

• It is only suitable for pellets and powders.

• It is not very strong and easily loses its shape under pressure.

• It is not waterproof and can become mildewed in damp conditions.

• It is not suitable for long-term preservatio, since moths may eat through it.

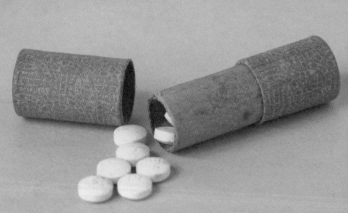

The instruction leaflet is rolled up around the glass medicine bottle for added protection.

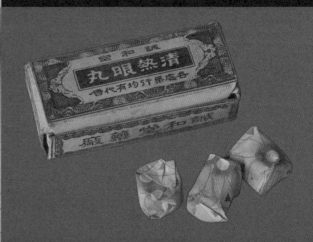

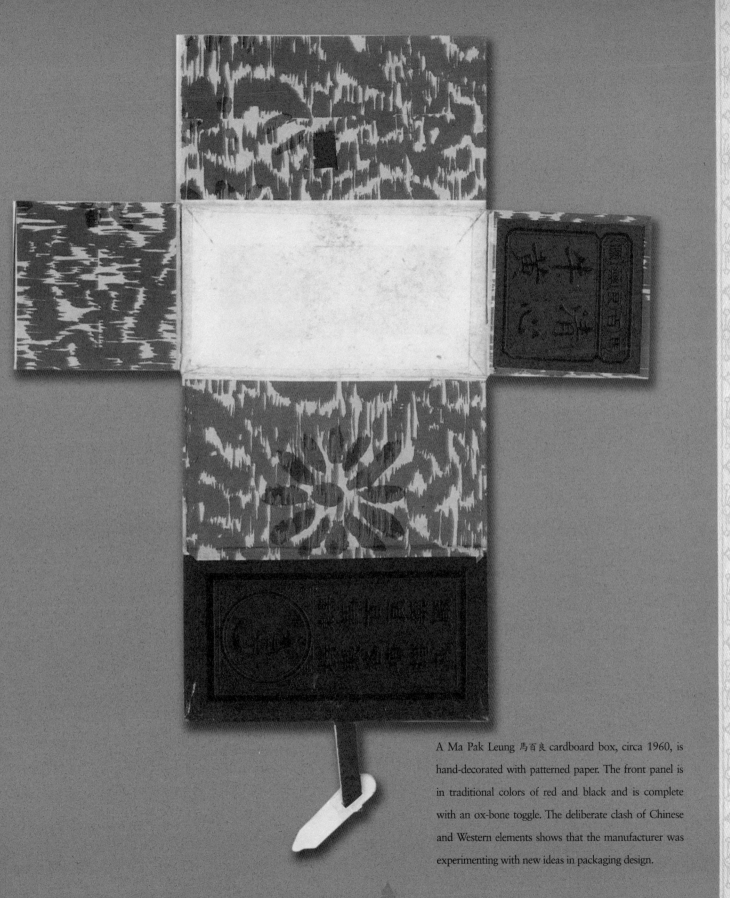

A Ma Pak Leung 馬百良 cardboard box, circa 1960, is hand-decorated with patterned paper. The front panel is in traditional colors of red and black and is complete with an ox-bone toggle. The deliberate clash of Chinese and Western elements shows that the manufacturer was experimenting with new ideas in packaging design.

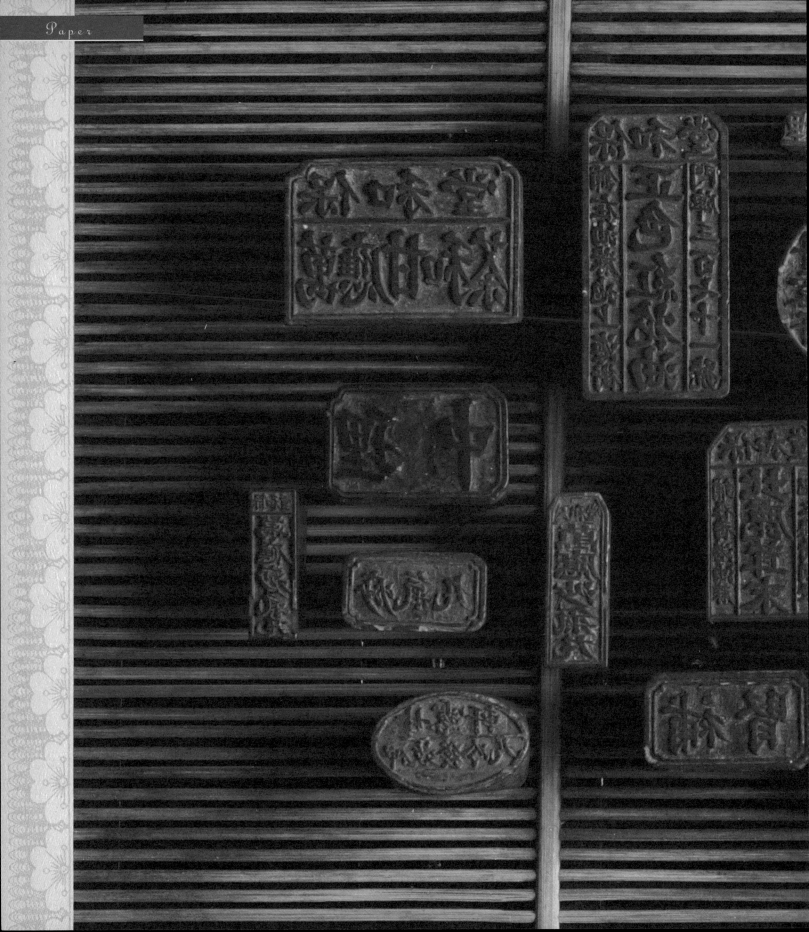

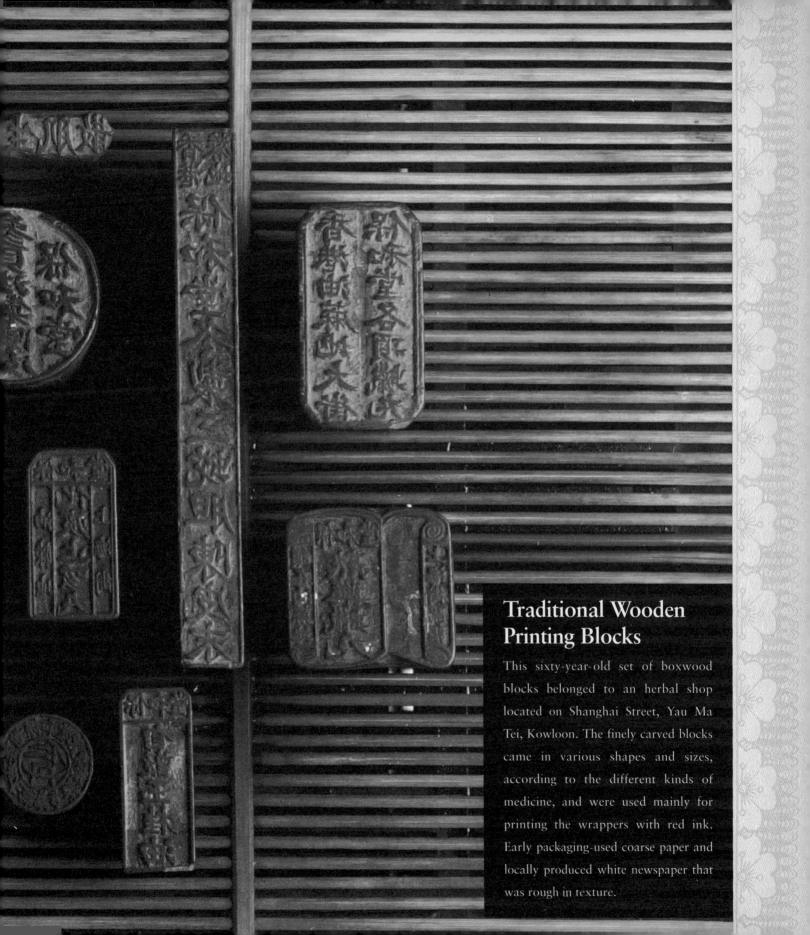

Traditional Wooden Printing Blocks

This sixty-year-old set of boxwood blocks belonged to an herbal shop located on Shanghai Street, Yau Ma Tei, Kowloon. The finely carved blocks came in various shapes and sizes, according to the different kinds of medicine, and were used mainly for printing the wrappers with red ink. Early packaging-used coarse paper and locally produced white newspaper that was rough in texture.

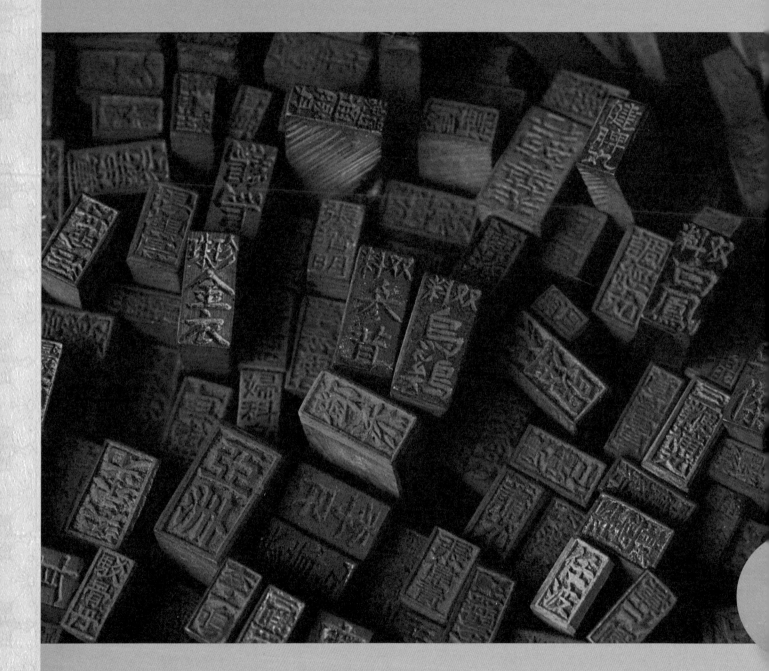

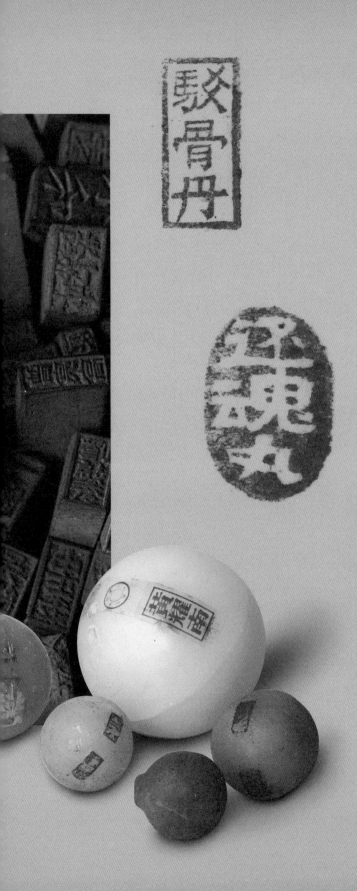

Stamping Wax-Coated Pills

Wax-coated pills were marked with labels that described their hidden contents. Wooden blocks bearing the name of the shop or medicine were generally used to this end. Usually red ink made from cinnabar was imprinted directly onto the wax shell, but in the case of rare and precious ingredients, the pills were occasionally graced with a gold stamp. Thus, even the tiniest package was transformed into an object of great beauty.

The Making of Wax Shells

Wax is an odorless, highly dense material that provides an effective barrier from water and air. In its molten state it is extremely pliable and can be molded into any required shape. The coating of pills with wax is a complicated process, involving special tools such as wooden sticks with orb-shaped attachments. Decades ago pills were coated with beeswax imported from China, but it was necessary to process the wax before use. Today industrial wax is used. The wax is melted at around 167 to 176 degrees Fahrenheit. According to Mr. Chan, a veteran of the trade, temperature control is the determining factor in coating the pills, though, with fifty years of experience under his belt, he no longer relies on a thermometer.

The size and thickness of the wax coating depend on the number of layers applied; between four to seven layers are generally used to coat a pill.

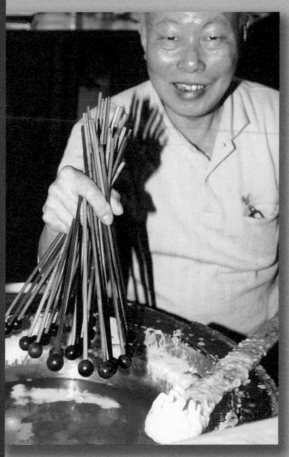

(1) Chan grasps almost twenty sticks in one hand, evenly distributing them among his fingers, a task that comes easily to one with fifty years of experience in the business.

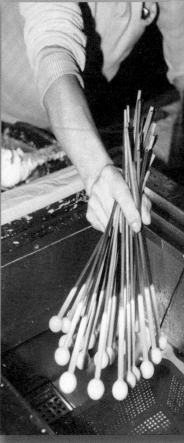

(2) He immerses the sticks in a vat of molten wax for a couple of seconds before pulling them out swiftly and plunging them into cold water. The process is repeated several times until the wax shell is formed, one layer after another.

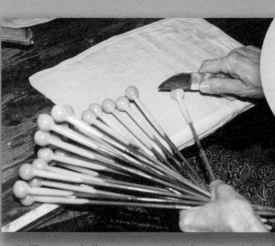

(3) The wax shell is cut across the diameter of the sphere, and an opening is made.

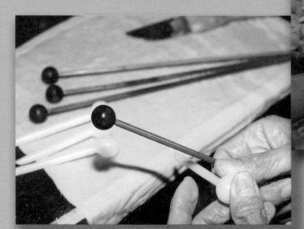

(4) The wax shells are removed from the stick...

6) Pills packed in cotton paper or cellophane are inserted into the wax shells, which are then sealed using a heated iron.

(5) ...and are placed in an oven to dry out completely.

(7) The process is completed manually by sealing off the wax containers.

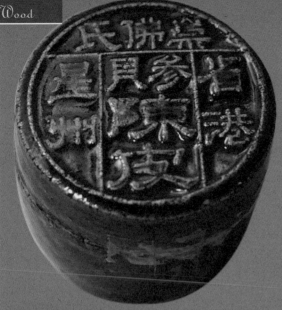

Porcelain bottles are the oldest and most commonly found containers produced in China. They were suitable for holding most forms of medicine and easy to carry around. With a cork inserted into the tapered mouth of the bottle, they formed the ideal container for long-term preservation. The names of the medicine and shop were fired onto the bottle for easy identification. Some shops would employ eminent masters to tailor-make medicine containers that could be admired and collected after use, although their popularity never rivaled that of the sumptuous snuff bottles created during the height of the Qing dynasty. Their obvious weakness is that they were easily broken, and their identifying labels tended to peel off.

The wording on the surface of this humble but classic ceramic medicine pot from the Sung Fat Sih reveals that the manu-facturer had branches in Singapore besides those in Guangdong and Hong Kong.

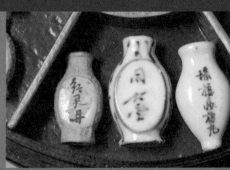

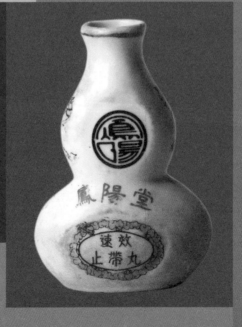

Dating from the 1930s, this medicine package from the Ho Sai Cheong Medicine Factory is a standard wooden box produced by a small factory for the medicine industry. The individual shops would affix their own labels.

This small traveling medicine chest from the Ma Pak Leung Company dates to the early Republican period.

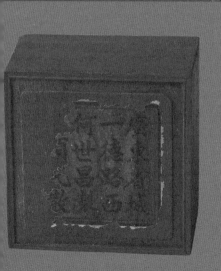

Wood is a material imbued with graciousness and elegance. Occasionally exotic and precious woods such as blackwood were used to make medicine boxes. Later boxes were made with elm wood to cut manufacturing costs. Since it was both very expensive and time consuming to produce wooden packaging of this kind, it was only produced to contain rare medicine.

These superbly handcrafted boxes were made in the same way that traditional Chinese furniture was, using not nails but sophisticated mortise and tenon joints. Printed labels were pasted by hand onto the boxes. These boxes were so delicate that they could never be mass-produced; yet, sadly, the craftsmen earned little in spite of their technical prowess, because their artistry was undervalued. Once their craft died out, medicine boxes became much more modern in design.

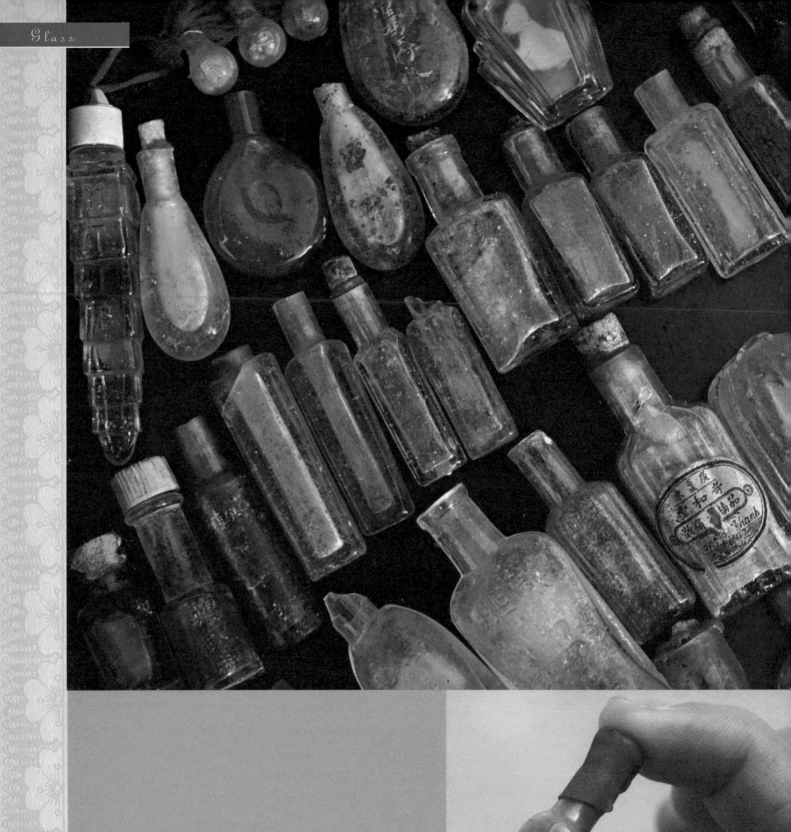

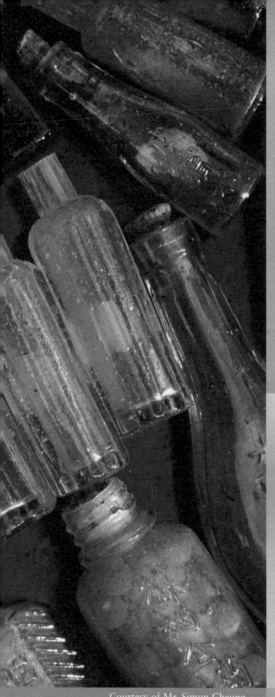

Courtesy of Mr. Simon Cheung.

This early bottle contains Ma Pak Leung's *hat li* powder. Also known as a light bulb bottle, it is very delicate and embossed with the medicine shop's name.

Traditional Chinese medicine once seemed shrouded in secrecy, as manufacturers jealously guarded the details of their healing formulas and prescriptions, which were mysterious cocktails of ingredients. Even medicine packaging gave little away, keeping the contents tightly sealed from view. With the advent of glass as a packaging material, however, medicine was suddenly on full display. In the West, glass was used for bottling medicine as early as the mid-nineteenth century, while in China it supplanted ceramic containers around one hundred years ago. Early glass bottles produced locally were of low quality because there was poor control

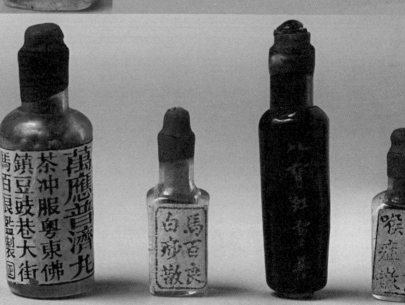

during the heating process, resulting in coarse vessels filled with air bubbles. Glass was then used for most forms of medicine, including pellets, powder, wine, and oil, but, like ceramic, it was easily broken.

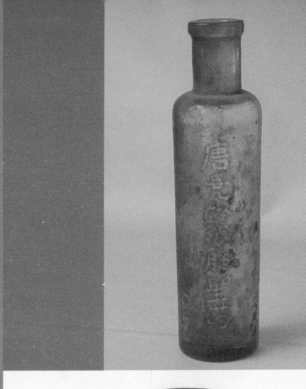

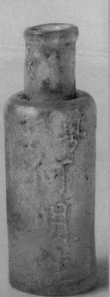

When the Chinese first produced Western forms of medicine, they adopted the foreign technique of using colored glass bottles to safeguard the medicine from harmful ultraviolet rays. The body of the bottle was frequently embossed as much for aesthetic reasons as to identify the manufacturer's name or contents. As glass bottles became more popular, the embossing technique eventually replaced paper labels, even on those of some Chinese medicine bottles.

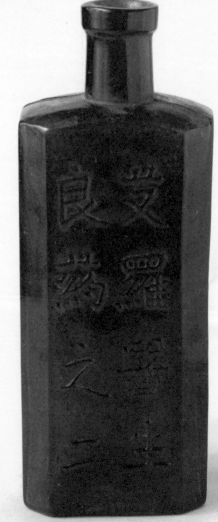

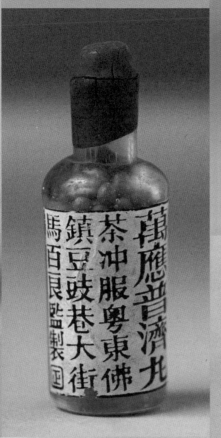

萬應普濟丸
茶沖服粵東佛
鎮豆豉巷大街
馬百良監製製

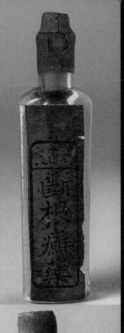

止咳痰樽

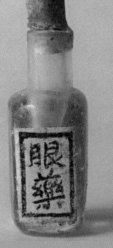

眼藥

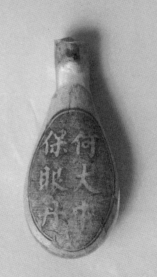

何大神
保眼丹

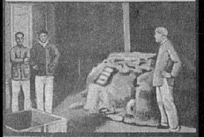

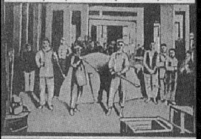

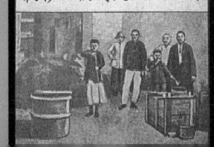

During the late nine-teenth century glass bottles came to be widely used for Chinese medicine. Paper labels were affixed to the glass bottle, just as they had been on the earlier ceramic containers. However, the labels would peel off easily in damp conditions, making the contents difficult to identify.

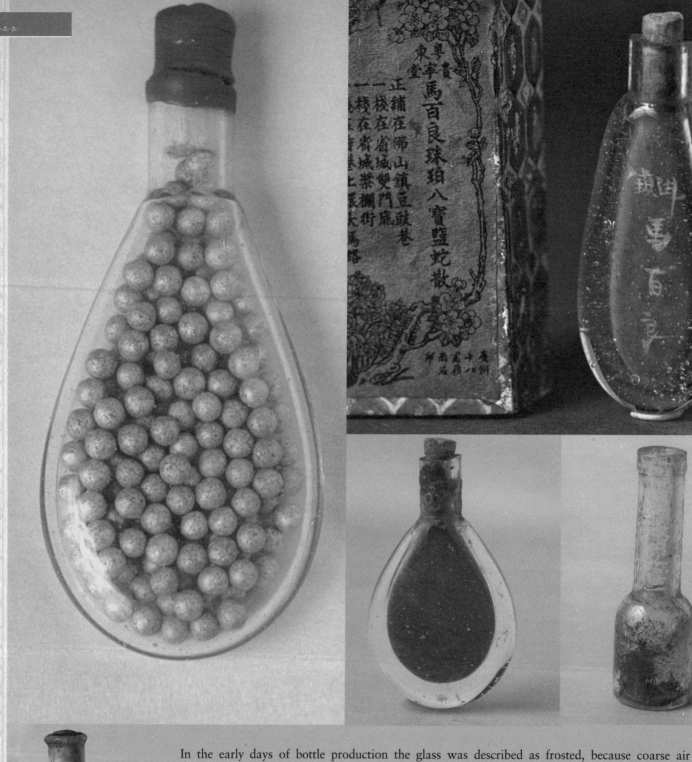

In the early days of bottle production the glass was described as frosted, because coarse air bubbles covered the surface like grains of sand. After a cork was inserted into the bottle's neck, it was then sealed off with white wax or sealing wax. This airtight stopper ensured the long-term preservation of the contents and was employed by Chinese and Western manufacturers alike.

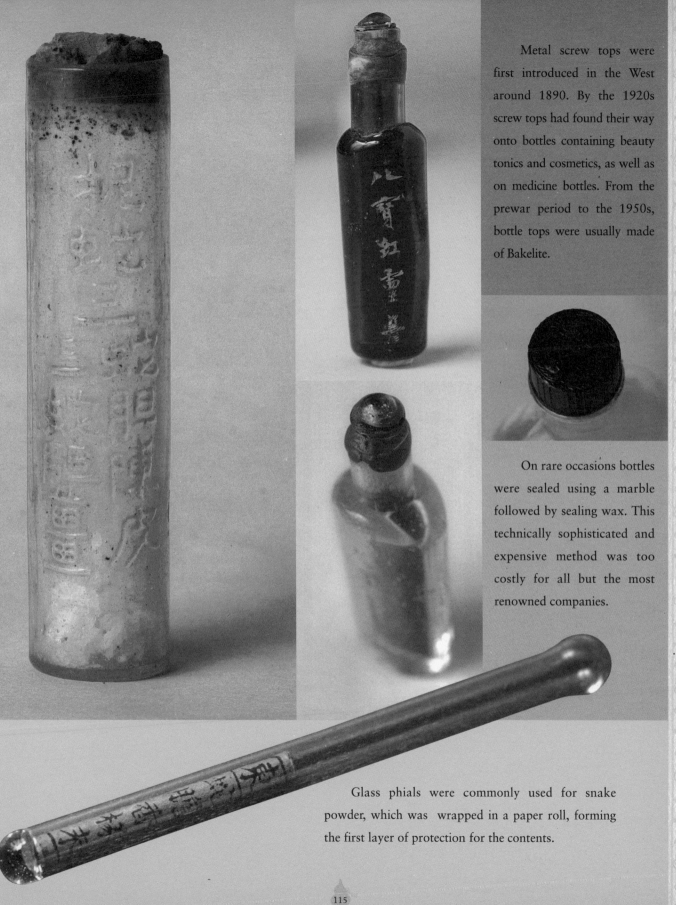

Metal screw tops were first introduced in the West around 1890. By the 1920s screw tops had found their way onto bottles containing beauty tonics and cosmetics, as well as on medicine bottles. From the prewar period to the 1950s, bottle tops were usually made of Bakelite.

On rare occasions bottles were sealed using a marble followed by sealing wax. This technically sophisticated and expensive method was too costly for all but the most renowned companies.

Glass phials were commonly used for snake powder, which was wrapped in a paper roll, forming the first layer of protection for the contents.

Metal, a solid and robust material, forms an excellent outer layer of protection for medicine containers, but its tendency to rust makes direct contact with the contents unsafe. Other disadvantages of the metal container are sharp edges, causing injury, and weight, which ultimately increases shipping costs. Over time metals like tin have been replaced by lightweight materials such as aluminum and plastic.

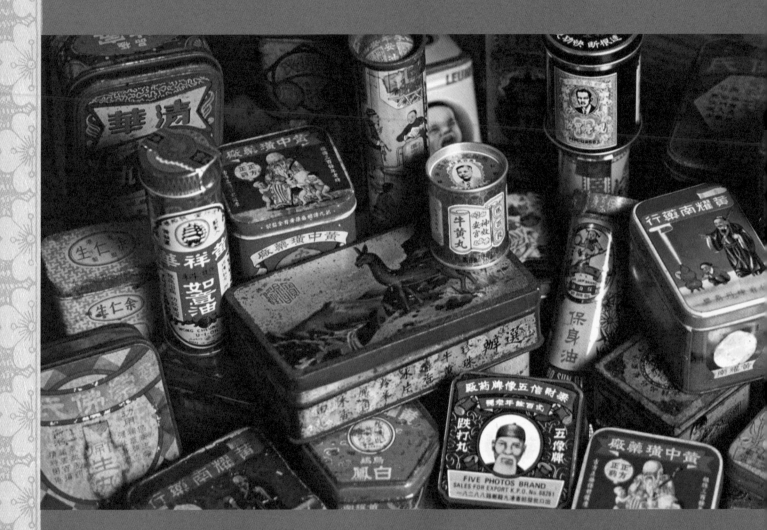

Metal containers were produced in various shapes, catering to different forms of medicine. Advances in printing made it possible to introduce more colors and intricate patterns.

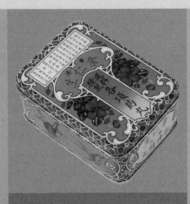

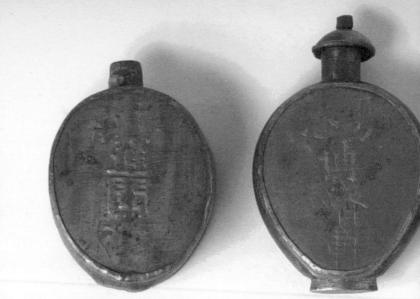

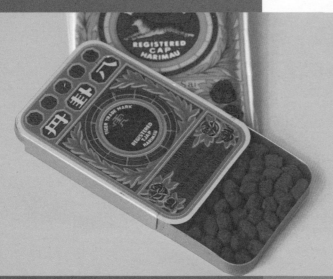

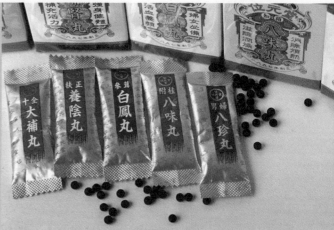

Lightweight foil packaging is easy to carry and has been used by pharmaceutical factories since the 1980s.

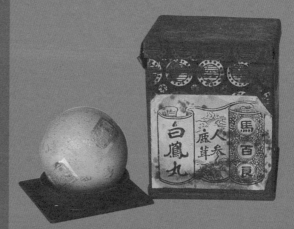

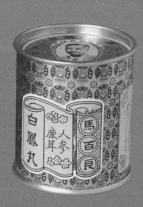

Since metal is prone to oxidation and rust, it is not ideal for containing medicine. The use of aluminum, however, solves this problem and, being lightweight, helps reduce shipping costs.

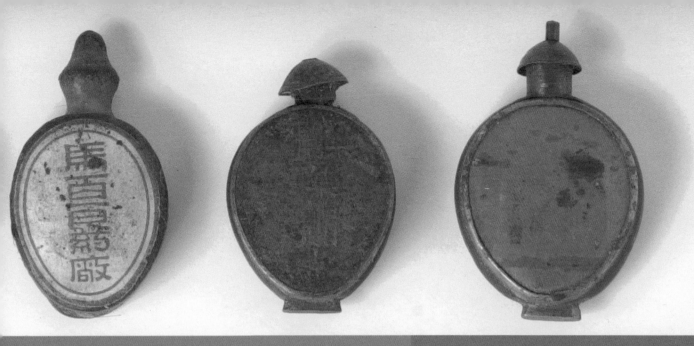

Brass Medicine Containers

The use of brass containers dates back to ancient times. Strips of brass were flattened to a moderate thickness and soldered into small bottles for medicinal powder. The brass bottles pictured are from the late Qing dynasty and the early Republican period. To extract the contents, the body of the bottle must be gently squeezed, creating internal pressure, which emits a puff of powder. This is an extremely unique and witty device, but today it is hard to find anyone versed in the skills of making such fine containers, the craft having virtually died out.

This antimony case of Po Sum On healing oil dates from the 1930s.

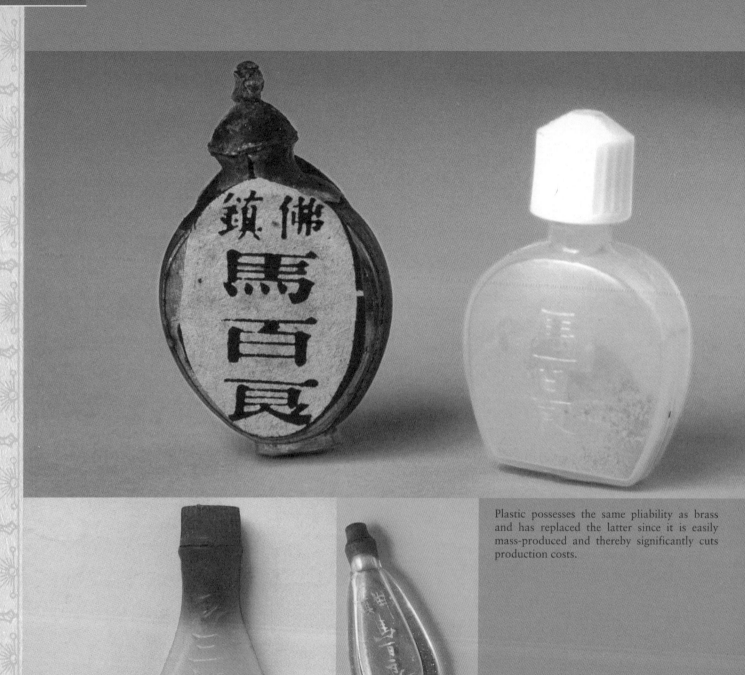

Plastic possesses the same pliability as brass and has replaced the latter since it is easily mass-produced and thereby significantly cuts production costs.

The shape of plastic bottles was initially modeled on those of early glass bottles, while fully exploiting the plasticity of the medium.

120

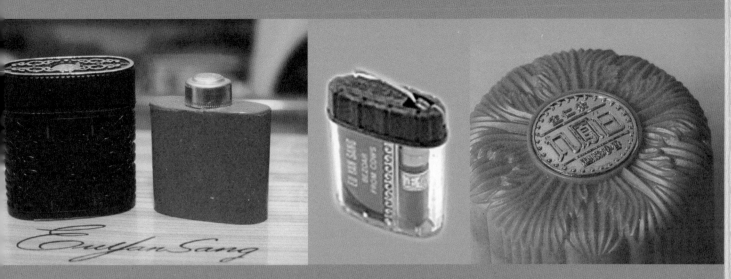

Plastic is extremely versatile, lending itself to various shapes and textures that enhance the decorative quality of the packaging. Moreover, it harmoniously blends with other materials.

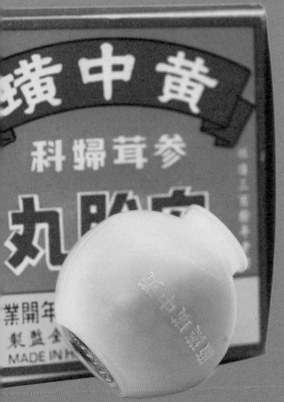

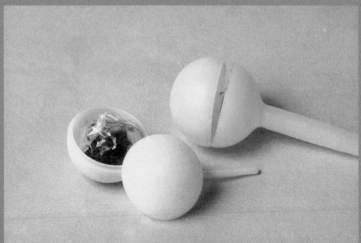

Wax coating, the most traditional form of medicine packaging, was eventually replaced by plastic in the 1980s, though some medicine factories argue that wax is superior because it is completely airtight.

Factories used different colors to distinguish packages meant for local and overseas markets.

A plastic box made to resemble jade conferred a sense of value on the medicine.

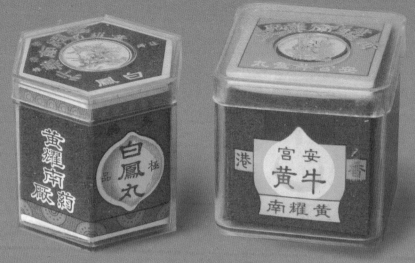

Tin cases came to be replaced by plastic containers.

As technology in the plastic industry improved, recycled plastic came to the fore, cutting production costs still further and encouraging more factories to use the material. In the mid-fifties factories started to use plastic containers for packing pills and powders. Like glass it is transparent, but unlike glass it is not so brittle and is, in fact, much lighter. Within a couple of years most manufacturers had switched to plastic medicine containers, with factories such as Li Chung Shing Tong and Ling Chi leading the way.

Of course, even plastic is not perfect. Its primary weakness is that it produces a chemical reaction when it comes into contact with medicinal oil or wine, so glass containers were retained for such liquids. Although plastic is not, perhaps, as strong as metal, it is certainly much lighter, thereby reducing shipping costs and offering a far wider range of packaging options.

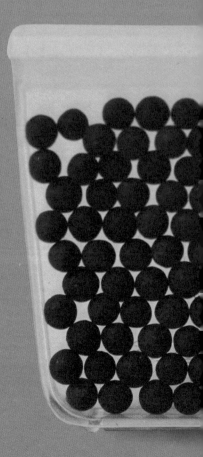

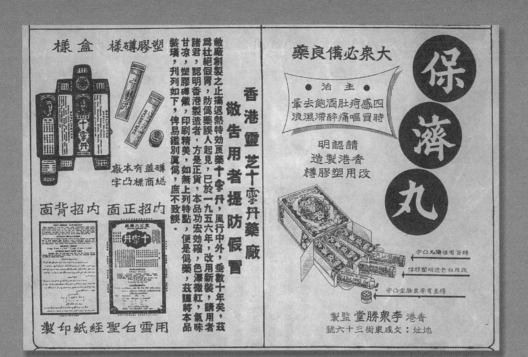

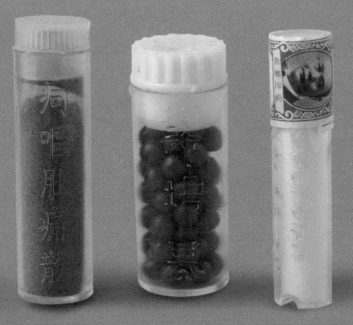

Plastic containers were in use from the late 1950s, gradually gaining in popularity over the next twenty years.

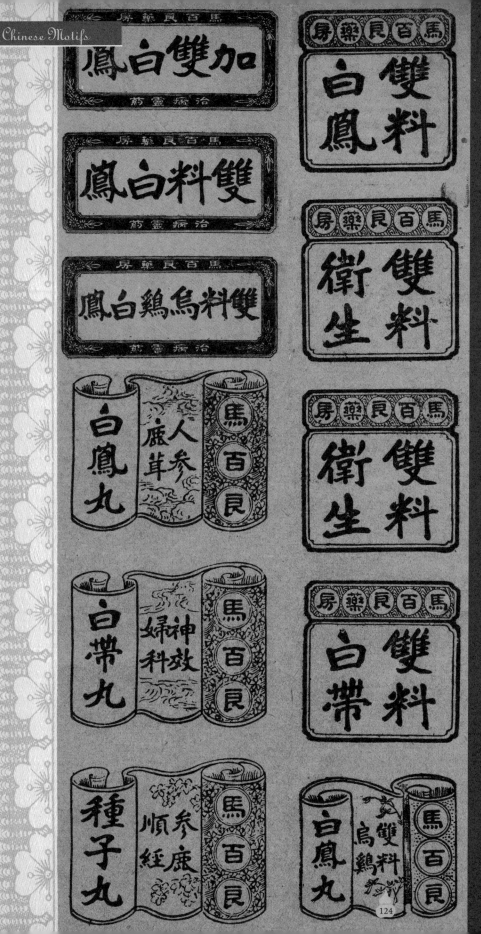

Religious beliefs have long played a role in traditional Chinese culture and art. Good health, happiness, and longevity are the ultimate goals of the Chinese. Through the ages our forebears learned to interpret these abstract concepts and incorporate them into the rituals of daily life, using totems and other auspicious objects. These symbols were unquestioningly applied to medicine packaging, too, and, coupled with China's long history of making medicine, they reflected the preservation of a profound and vibrant culture.

At the turn of the twentieth century, the Western medicine industry began to heavily influence traditional Chinese medicine in terms of packaging design. Chinese medicine packaging gradually moved away from tradition and leaned toward something that was neither strictly Chinese nor Western in appearance. Yet, on closer examination, some Chinese elements could be discerned and have become novel forms of expression in their own right.

Long ago the Chinese believed that evil spirits brought illness and epidemics, and they tried every means of warding those spirits off. In its way medicine packaging was also designed to counteract such misfortune, using eye-catching colors such as red, black, and yellow. Auspicious motifs like the dragon, phoenix, and magpie, along with tortoise and wave background patterns, were used both as a striking decorative touch and an emblem of spiritual strength. These powerful colors and images positively influenced people's perception of the medicine.

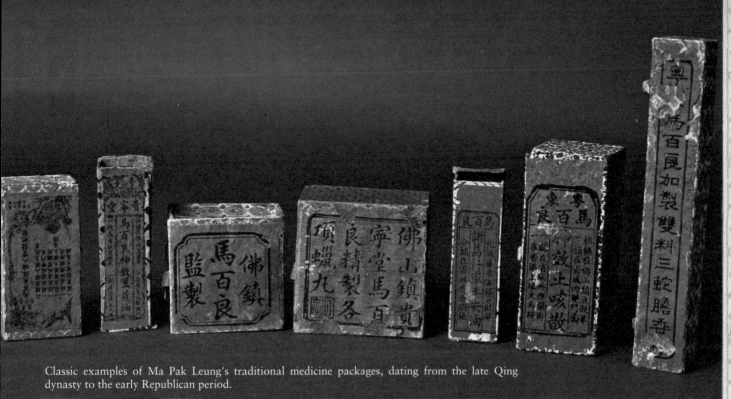

Classic examples of Ma Pak Leung's traditional medicine packages, dating from the late Qing dynasty to the early Republican period.

The Brocade Box

Medicine housed in a brocade box fastened with colorful ribbons implied rarity, elevating the status of the brand and bringing great aesthetic pleasure. When opening the beautifully decorated box, the user savored its exclusivity and was psychologically convinced of the medicine's effectiveness.

The Literary Medicine Box

Early medicine boxes were made by hand from cardboard. This painstaking process could only be produced in small quantities. Some factories used sumptuous packaging to boost sales. One of the more unique creations was a box that resembled a carrying case. It was adorned with a fine bone toggle and was used to hold precious Chinese books, giving a taste of the literati.

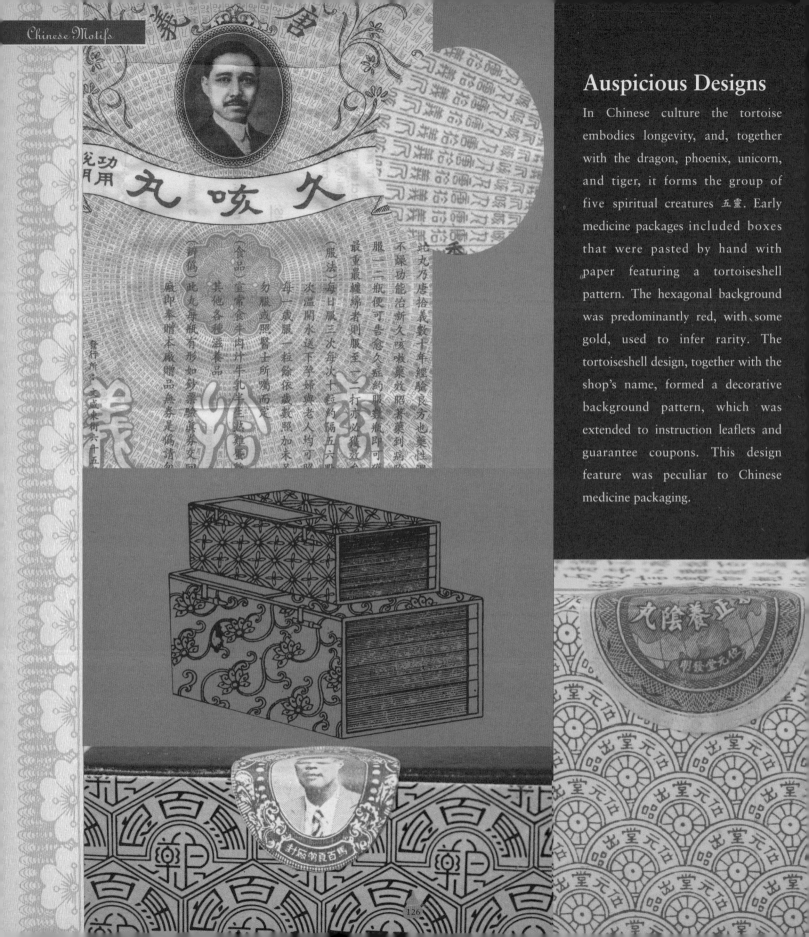

Auspicious Designs

In Chinese culture the tortoise embodies longevity, and, together with the dragon, phoenix, unicorn, and tiger, it forms the group of five spiritual creatures 五靈. Early medicine packages included boxes that were pasted by hand with paper featuring a tortoiseshell pattern. The hexagonal background was predominantly red, with some gold, used to infer rarity. The tortoiseshell design, together with the shop's name, formed a decorative background pattern, which was extended to instruction leaflets and guarantee coupons. This design feature was peculiar to Chinese medicine packaging.

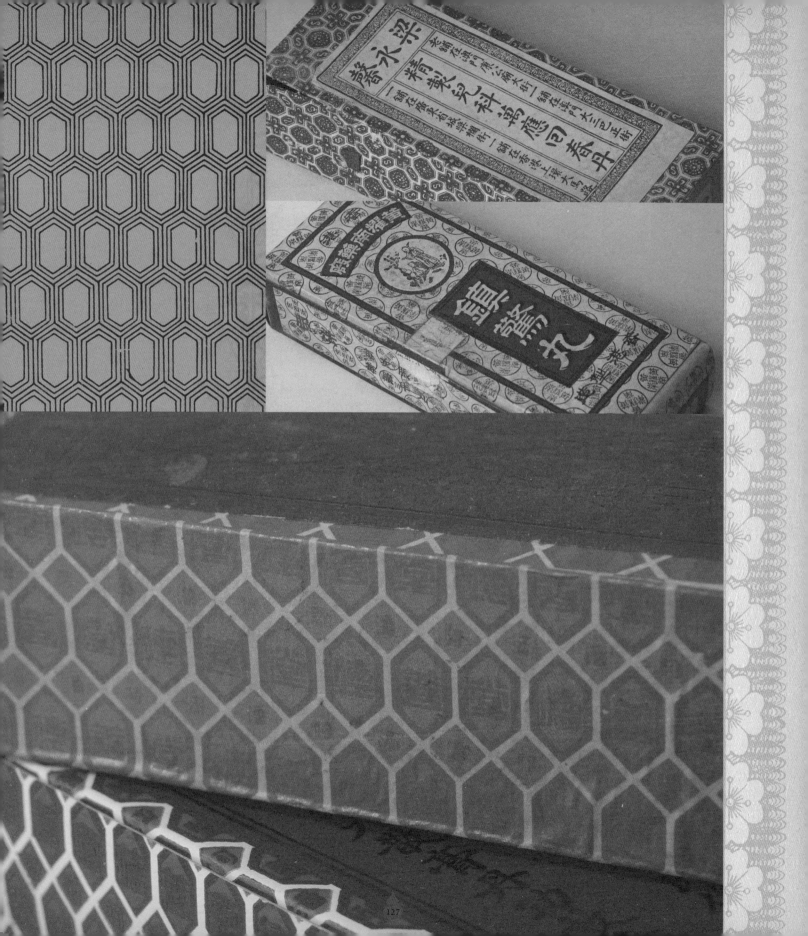

Lettering

In the early days of medicine packaging, shop names and products were inscribed on red paper labels that were stuck onto the bottles. Later on these names were directly fired onto the porcelain bottles. Some factories would use elegant calligraphy to give the medicine bottles a refined air, their aesthetic appeal making them highly collectable pieces. From the 1940s factories started to employ artists to design their medicine packages and lettering and to endow them with unique characteristics. The artists' cultivated tastes and experience contributed a distinctly personalized sense of style.

Sap Ling Tan (pictured lower right) and Sap Ling Oil are good examples of the growing success of the logo. The prominent and attractive use of the company's brand names in its print advertisements soon gained wide recognition. The complexity of Chinese characters required great ingenuity on the part of the designer, who had to work the company's name into the overall layout of the packaging in a manner that was both attractive and legible.

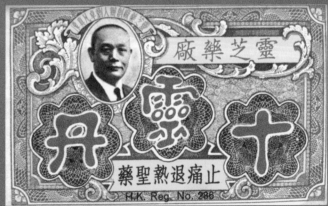

Illustrations

In early Chinese medicine packaging diagrams of body parts detailing acupuncture points were printed on the instruction leaflet to help users apply the medicine properly. Later some manufacturers employed storybook-style illustrations, rather than heavy text, to make the instructions easier to follow. This was especially useful for illiterate villagers.

From that time on most medicine packets were printed with appealing and vivid illustrations, which, besides providing instructions, went on to become an integral element of the overall design, enhancing the visual appeal of the packaging.

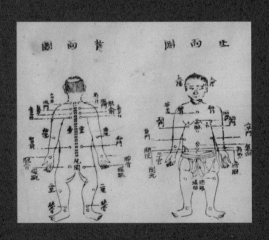

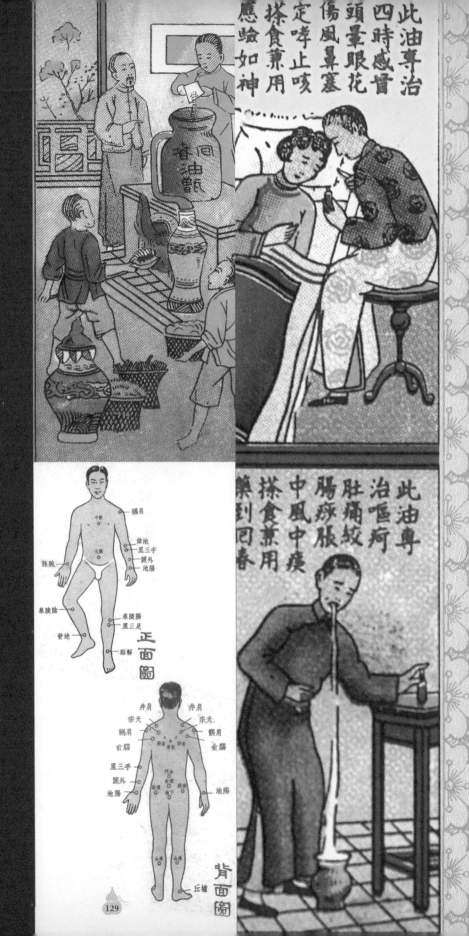

A scene depicting alchemy, which has its roots in Taoism.

Symbolism

With its ancient myths and legends, Chinese history provides people with a rich source of inspiration. Legendary figures, such as He-he 和合二仙, the gods of happiness, prestige, and longevity 福祿壽三星, a pantheon of other immortals and auspicious animals, afforded a huge diversity of symbols that could be creatively used in medicine packaging. But beyond the superstitions associated with these figures lies the true essence of Chinese culture.

A Ma Pak Leung poster from the 1950s. Note the iconic red scarf used in the Chinese propaganda of the period.

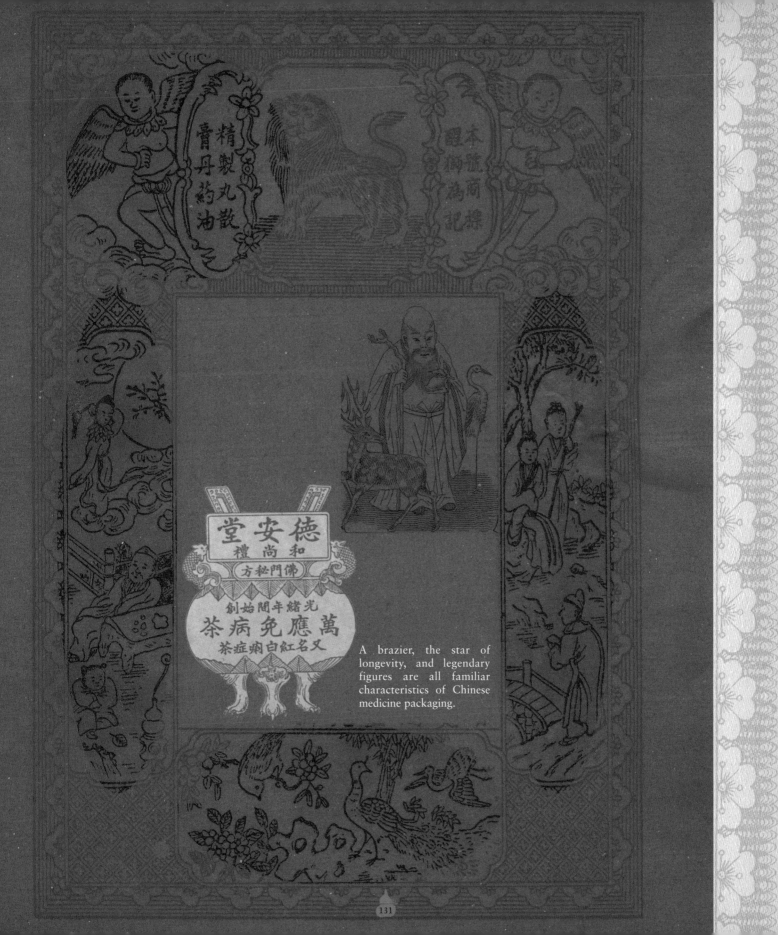

A brazier, the star of longevity, and legendary figures are all familiar characteristics of Chinese medicine packaging.

The guarantee coupon is a unique feature in medicine-packaging design. It was created as a means of thwarting counterfeiters, whose growing number of fake products threatened to damage the reputation and livelihood of genuine medicine shops. In the face of such confusion, respected businesses sought to regain their customers' confidence with meticulously designed guarantee coupons, which made for easy identification.

Typically the guarantee coupon resembled a bank note featuring the founder's portrait, the medicine's history, and often a message warning against inferior products. It shared the same design elements as the instruction leaflet, including decorative borders, background patterns, and printed type.

Eu Yan Sang's red guarantee coupon from the early republican period denounced the act of producing counterfeit medicine. It was probably printed at the shop's Canton branch, since its Hong Kong outlet did not open until 1926.

This guarantee coupon, known at the time as *fang ti* 仿帖, is from the late Qing/early republican period.

1999年2月　HK

This Tong Yeu Ling guarantee coupon dates to the 1920s. Though the paper is coarse, it is carefully printed with the founder's portrait, the company's products, and the place of origin.

Ma Pak Hang 馬百行, a medicine shop of the 1960s, was frequently mistaken for another shop, Ma Pak Leung. Its guarantee coupon was printed using both the letterpress and engraving methods and was embossed with the shop's logo.

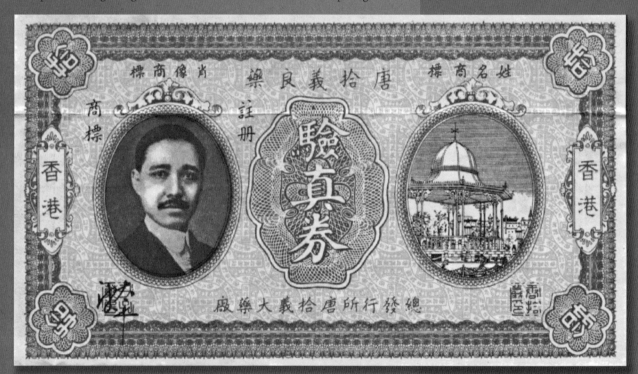

As advertised in the book *Ren Jian* 人鑑, published in 1917, this exquisite Tong Sap Yee guarantee coupon from the 1960s was printed in the style of a bank note to guard against forgery. This successful design was later adopted by other medicine shops.

This rare guarantee coupon for Sap Ling Tan was produced in 1956. It was printed on art paper with a thin enamel coating, an advanced process at the time. Finely printed with two different background patterns, it has a pronounced tactile quality. Because the production costs were high, however, this version had only a limited print run.

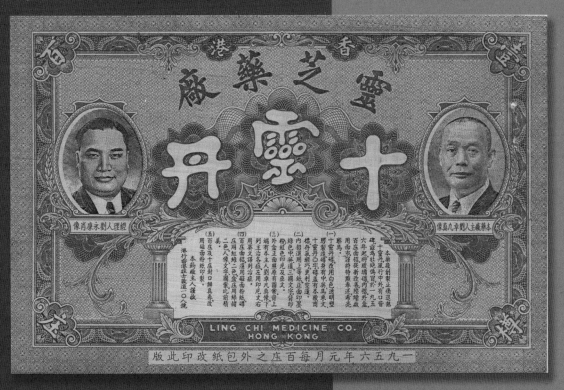

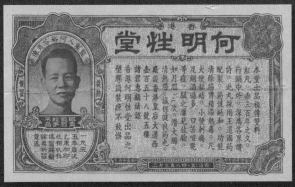

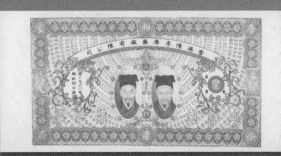

Instruction leaflets, or *fang dan* 仿單, formed an important part of medicine packaging, providing useful information such as the medicine's benefits, directions for use, and contents, as well as the company's background, objectives, and contact and registration details. Some manufacturers printed their packaging with celebrity endorsements and certificates of overseas registration. In addition to registered trademarks, founder's portraits, and illustrated diagrams, others pictured the factory building itself as a way of underlining their status. Medicine intended for export was contained in packaging printed with the relevant language on the back.

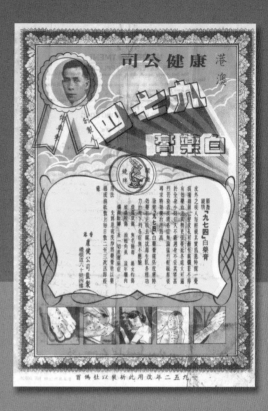

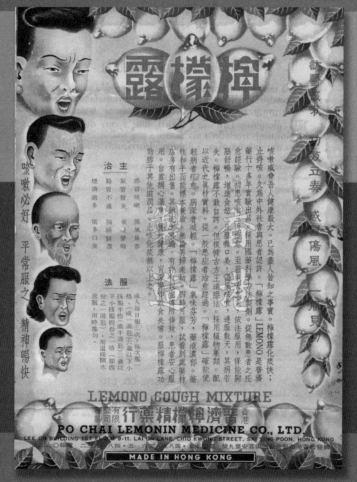

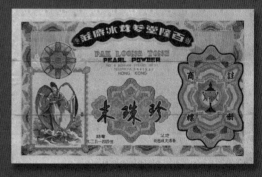

By the 1960s most monochrome instruction leaflets had given way to full-color printing. Fine paper was imported to replace the traditional rice paper and cotton paper formerly used. With manufacturers hiring in-house teams specifically to design their packaging, the aesthetic appeal of the instruction leaflets soon began to improve.

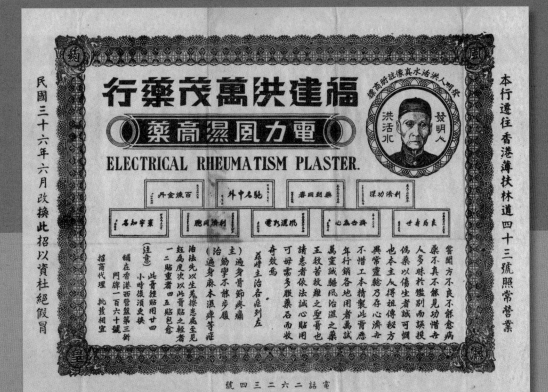

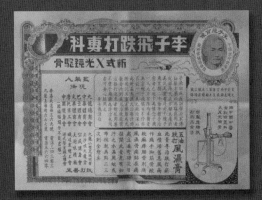

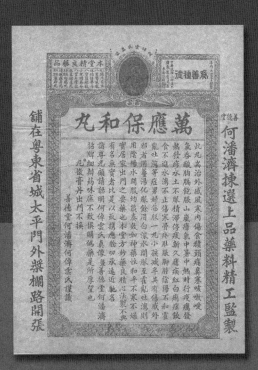

酒藥性了馮名馳下天
神通可效病百婦男治

Border Designs

During the Qing dynasty, medicine-instruction leaflets were sometimes printed with a hexagonal border in the shape of a house, just like those that commonly appeared on property deeds of the period. Since the Chinese equate the ownership of land with wealth, it is easy to understand why the pattern was widely used on land deeds. By extension, medicine, a matter of health, is considered equally worthy of such a contract, so the appropriation of this decorative style seemed particularly apt.

These contracts and deeds span different periods of the Qing dynasty.

The coastal ports of China saw a big influx of Western medicine, which had a significant impact on the domestic medicine market. Both local and foreign doctors trained in Western medicine set up clinics and produced their own remedies, sometimes mixing Western and Chinese medicines. In order to gain a competitive edge, their packaging reflected a Westernized style.

Soon after the British colony was established, Hong Kong started to issue bank notes, which in the eyes of the public were considered as credit-worthy as property deeds. In this light, medicine packaging incorporated border designs like those of bank notes to serve as a guarantee to consumers, raising both the value and the status of the medicine. The borrowing of decorative borders after the manner of bank notes is another design element peculiar to Chinese medicine packaging.

An advertisement in *Ren Jian*, published in 1917, shows a Tong Sap Yee guarantee coupon with a design imitating that of a bank note or stock certificate. A similar advertisement from Tong Yeu Ling appeared in 1922, showing that the design was popular in the early Republican period among Chinese doctors practicing Western medicine. These attractive borders not only raised the outward appearance of the medicine but also formed protection from forgery.

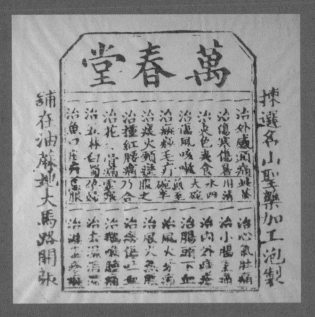

An early Instruction Leaflet, printed with a hexagonal border in the shape of a house.

Stock certificates and bank notes were among the first documents to use decorative borders; the medicine industry later followed suit.

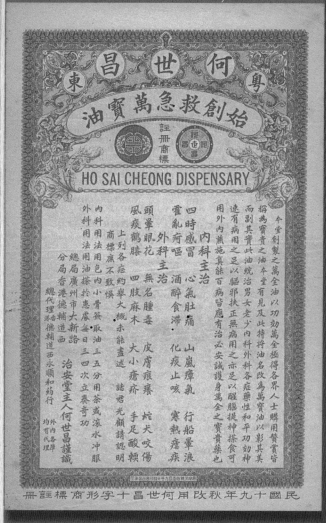

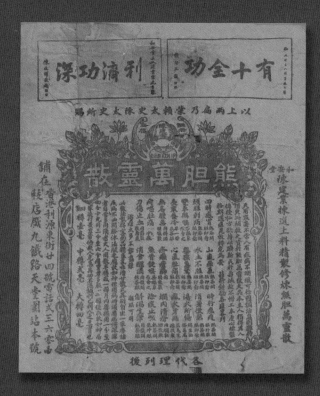

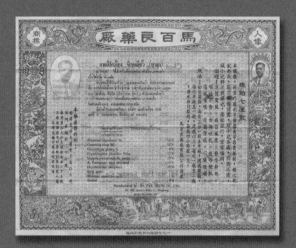

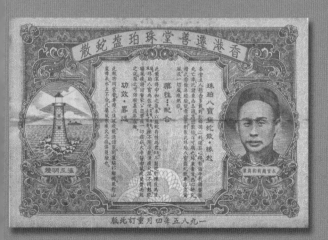

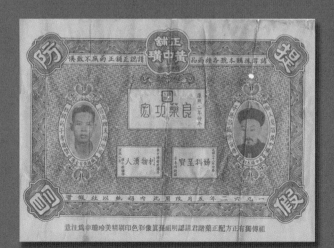

On this box of Chan Li Chai Pak Foong Pills, dating from 1952, there are four seals, of both round and rectangular shape. One of them features the Kowloon clock tower in Tsim Sha Tsui and bears the words *made in Hong Kong*. This was not merely a sealing label but also a guarantee of the place of production, which instilled consumer confidence.

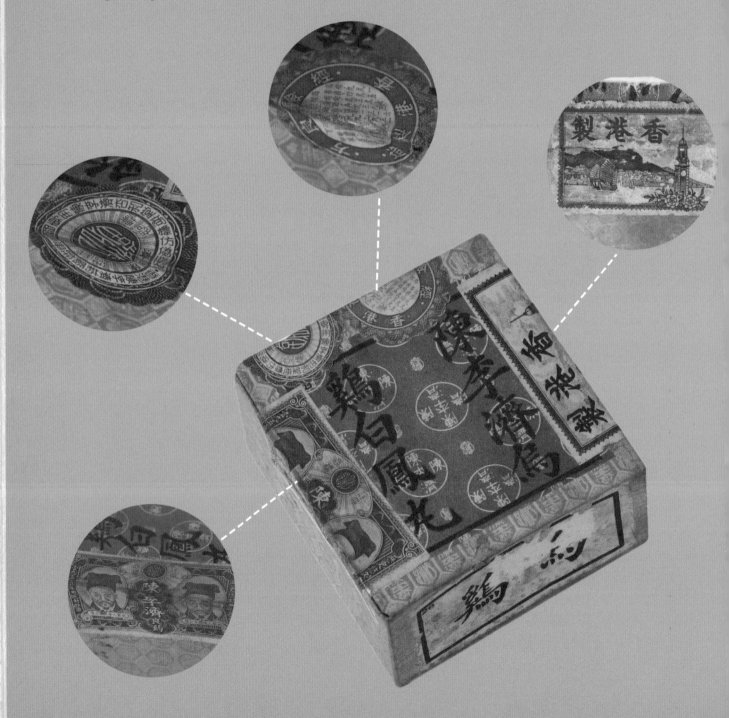

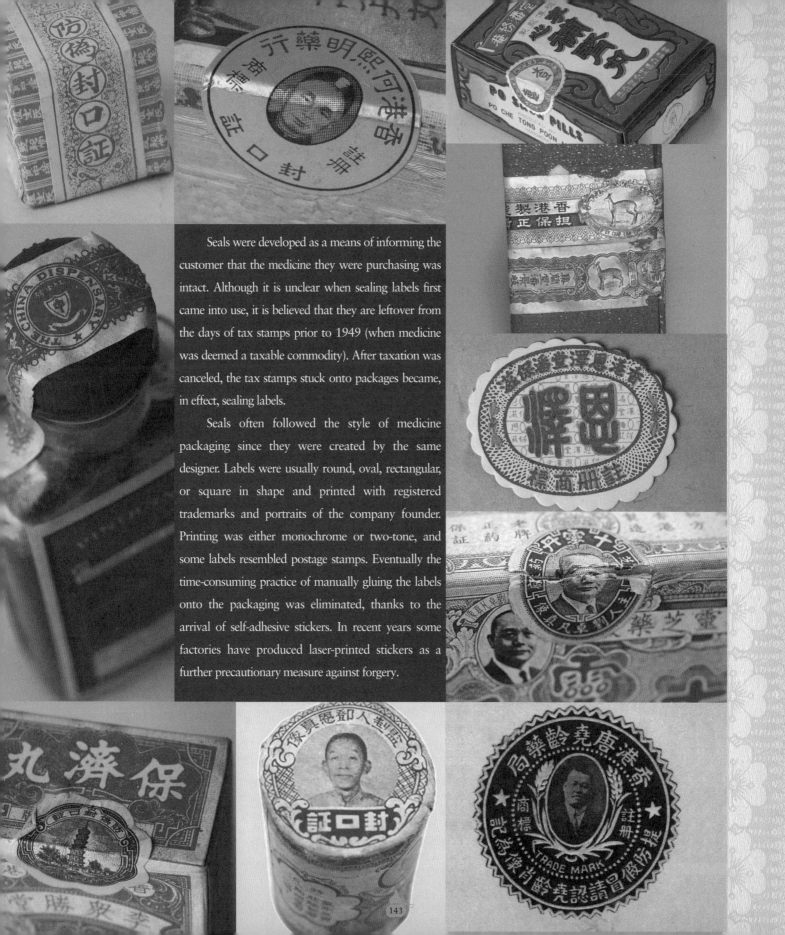

Seals were developed as a means of informing the customer that the medicine they were purchasing was intact. Although it is unclear when sealing labels first came into use, it is believed that they are leftover from the days of tax stamps prior to 1949 (when medicine was deemed a taxable commodity). After taxation was canceled, the tax stamps stuck onto packages became, in effect, sealing labels.

Seals often followed the style of medicine packaging since they were created by the same designer. Labels were usually round, oval, rectangular, or square in shape and printed with registered trademarks and portraits of the company founder. Printing was either monochrome or two-tone, and some labels resembled postage stamps. Eventually the time-consuming practice of manually gluing the labels onto the packaging was eliminated, thanks to the arrival of self-adhesive stickers. In recent years some factories have produced laser-printed stickers as a further precautionary measure against forgery.

Registered trademarks are important in medicine packaging, because they make a brand instantly recognizable. The portrait of a company's founder was a common logo, but more often than not the trademark was a combination of text and image.

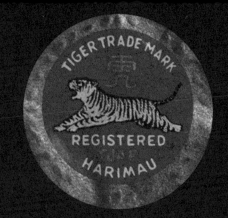

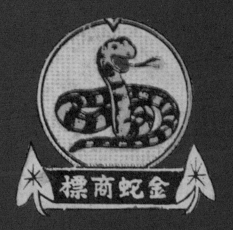

Most trademarks tended to reflect the personal preference of the manufacturer, the tiger used on Aw Boon Haw's Tiger Balm packaging being a classic example. The legendary figures and auspicious animals of folk tales were also very popular, giving the trademarks a uniquely Chinese flavor. Some medicines for healing rheumatism and injuries from falls used images — including deities, religious figures, and famous temples — that led to a direct association with the martial arts. All these trademarks are united in their use of figurative images to enhance brand recognition.

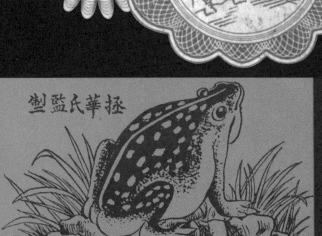

Early portrait trademarks were not photographic images but simple line drawings. As photography took hold in China and printing methods improved, medicine manufacturers began to apply photographic portraits as trademarks. The earliest photo-portrait trademark is dated 1917, though the use of the photo portrait probably dates back to the reign of Pu Yi 宣統 (1908-1911). In the 1920s and '30s, many large medicine factories adopted the photo portrait as their trademark; however, realistic images were considered taboo, so they would come up with outline sketches instead. Portrait logos were periodically updated when the company founder grew older or consumer trends changed.

Portraiture as Trademark

"Identify the portrait; beware of forgery" was a common exhortation. With the proliferation of counterfeit medicine, the owners of reputable medicine companies needed to show their faces as a precautionary measure against forgery.

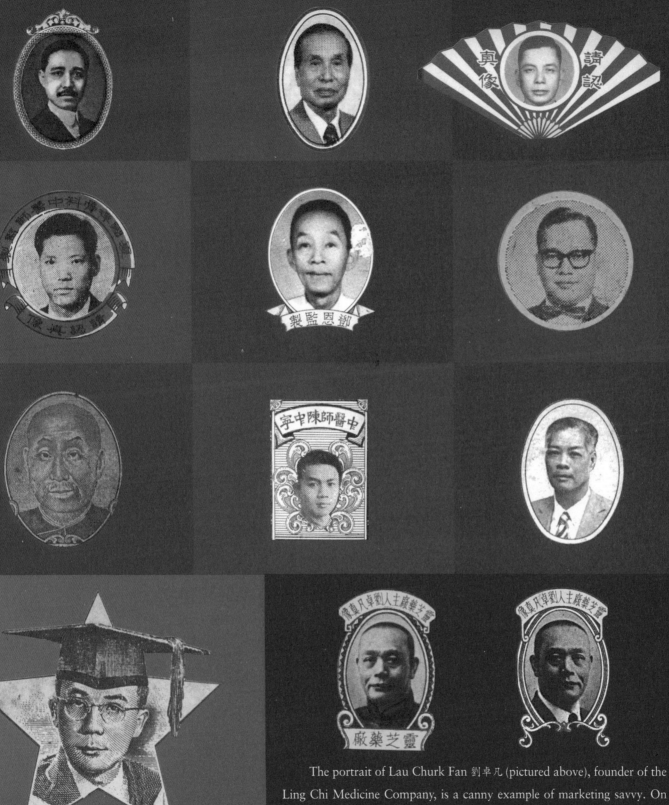

Whether portrayed in the traditional Chinese scholar's cap or in the mortarboard and gown of the West, the company founder hoped to present an enduring image of authority and credibility.

The portrait of Lau Churk Fan 劉卓凡 (pictured above), founder of the Ling Chi Medicine Company, is a canny example of marketing savvy. On the same medicine packet Lau is pictured in both traditional Chinese and Western costume, gaining the trust of the older, local community while at the same time winning over devotees of modern Western beliefs.

Beware of Imitations

Besides the existence of fake medicine, there were products that closely imitated those of renowned brands. Unsuspecting customers were easily fooled by these knockoffs, which greatly affected the good name and sales of bona fide products. In Hong Kong those disturbed by counterfeiters took legal steps to prevent the malpractice.

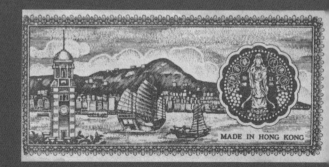

MADE IN HONG KONG

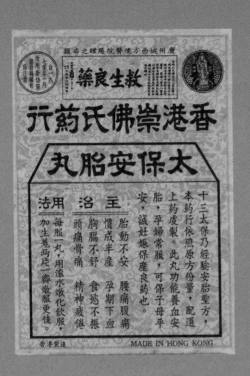

Pictured from left to right on previous page are packages of Sung Fat Sih Kidney Protection Pills (1970s) 崇佛氏補腎丸 and Chan Li Chai's Si Chi Yat Mo Pills 四製益母丸 (1950s). From their almost identical packaging, it is clear that one copied the other.

- Though the shape of the packets are different, the outward appearance and the design elements, from the print types to the logo and colors, closely resemble one another.
- The patterned background of the instruction leaflets is basically the same, using similar paper, albeit different colors.
- The seals are printed with the same basic design of the Tsim Sha Tsui waterfront, complete with clock tower and Chinese junk; the layouts, however, are reversed.

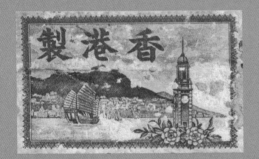

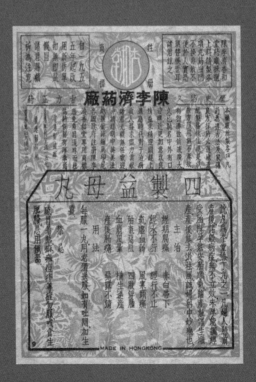

Since its creation more than seventy years ago, Wang Hing Partridge Powder has hardly altered its packaging design. Over the years the symmetrical image of infant twins has been retained, while the color has changed from red to blue and slight amendments have been made to the decorative borders.

Partridge Powder

Unfamiliar perhaps to today's younger generations, *partridge powder* 鷓鴣菜 was once a household name and was commonly used to treat children's ailments. The company's founder was Cheung Sze-wan 張思雲, a native of Shun Tak, Guangdong province 廣東順德, and the personal doctor of Sun Yat Sen. During the 1920s and '30s, Cheung witnessed his country in chaos with children often suffering from malnutrition and intestinal parasites. To alleviate these ailments, he invented *partridge powder*, a highly effective medicine that soon gained popularity not only in China but in Southeast Asia and North America as well. In 1949 the Cheung family moved to Hong Kong, where it continued the business. When Cheung Sze-wan died in 1959, his daughter Chi-shan 張紫珊 took over the business. She is now more than seventy years old yet continues to work hard, upholding her father's objectives to "benefit the country and its people and preserve children's welfare." In 1966 Wang Hing reopened its factory in Wuhan 武漢 and resumed production of *partridge powder* on the mainland.

The first generation of packaging was both crudely printed and illustrated.

The second version's colors improve, although the two red babies still appear rather outlandish.

In the postwar era the illustration was refined, and the babies were changed from red to blue. In 1947 the wording "Wang Hing Partridge Powder" was embossed on the pack as an antiforgery measure.

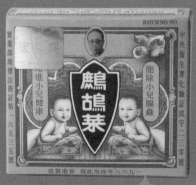

In accordance with new laws governing the advertisement of Chinese medicine in Hong Kong, the slogans on the pack had to be amended in the 1980s. Exaggerated claims that the medicine could cure a hundred pediatric ailments were replaced by one overall promise to improve children's health by eliminating parasites. In the packaging of the 1990s, a portrait of the founder replaced the brand name Wang Hing.

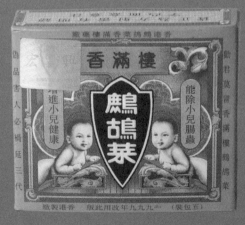

In 1999 the brand name was changed to Heung Mun Lau 香滿樓, and a laser-printed label showing the former brand name, Wang Hing, was affixed on the pack.

Genuine

Successful brands have long fallen prey to forgery. In spite of costly preventive measures taken by medicine companies, the efforts have generally been in vain, as an abundance of counterfeit products continues to cause confusion. With advances in computer technology, it has become easier to manufacture imitation medicine with packaging so convincingly made that it is frequently difficult to tell the fake from the genuine article.

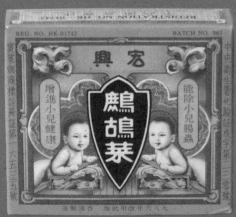

This packaging was used in 1986.

Fake

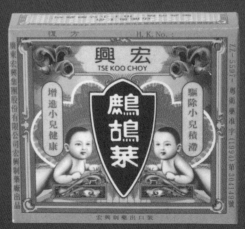

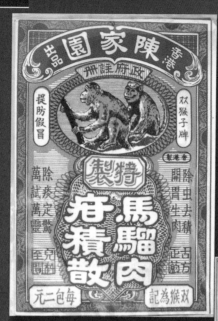

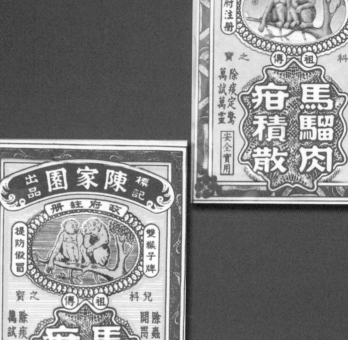

Imitation: The Sincerest Form of Flattery?

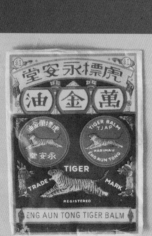

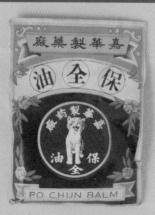

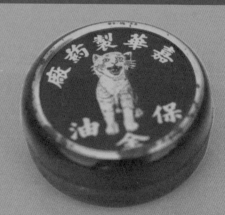

From Pak Fah Yeow 白花油 [white-flower embrocation] and Bak Fah You 百花油 [hundred-flowers oil], which are close homonyms in Cantonese, to Tiger Balm and Po Chun balm 保全油, these products are confusingly similar. Po Chun balm's choice of a cat motif in lieu of a tiger was by no means a coincidence.

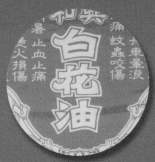

In the late 1980s labels were silk-screened.

The 1980s saw the bottle cap change from the original blackish blue to blue. Because the supply of Bakelite is limited, the bottle top is now made of plastic.

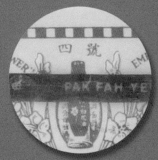

In 1970 a red plastic strip was added to seal the Pak Fah Yeow packet.

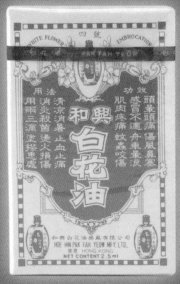

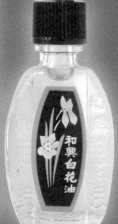

In the 1990s the brand name was embossed on the outer packaging.

The phrase Man Ying Pak Fah Yeow 萬應白花油 [all-purpose embrocation], pictured below, was printed on bottles in the 1960s. Hoe Hin Pak Fah Yeow 和興白花油 [Harmony and Prosperity brand embrocation], pictured above, was used after the law changed.

Pak Fah Yeow's Leak-Proof Bottle

During its seventy-year history, Pak Fah Yeow's packaging has remained essentially the same. However, the widespread occurrence of fake goods has led to efforts to counteract forgery through subtle improvements in the packaging design. For example, the shape of the glass bottle is registered.

The factory continues to use glass rather than plastic because the latter tends to erode. Over the years, research has been conducted on how to prevent leakage. Resistant to heat and cold, the Bakelite cap has close contact with the mouth of the bottle, thus preventing leaks. With a thin piece of pliant cork inside the cap, the mechanism works perfectly.

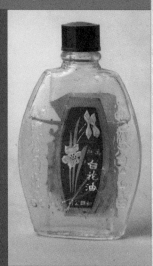

Decorative Borders

Ornamental borders were a common feature of medicine-packaging design, embellishing everything from the outer wrappers to the instruction leaflets and guarantee coupons, and were frequently coupled with scrolling acanthus-leaf patterns, which gave highly elegant results.

The borders were not only decorative but also served as an extra precaution against forgery, since great efforts were required to produce such intricate designs. At the time any defects, such as uneven lines, were very visible after duplication, but with today's advanced printing techniques, it is easy to reproduce such complex patterns.

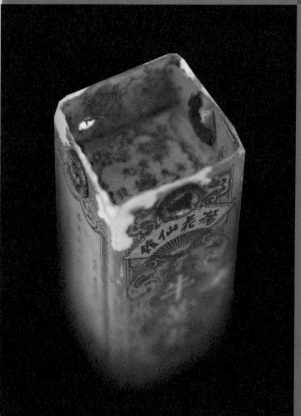

Punching Holes to Seal Packages

Kum Lu Yuen 甘露園 and Chu Hwa Sen Koon 橘花仙館 were among the first companies to punch holes in their packaging as a measure to prevent forgery. As early as 1945, Kum Lu Yuen started to apply this method to packs of *on kung ngau wong* pills 安宮牛黃片 [pills for cooling down excessive heat]. Once the box was torn open, it could not be reused. This new and complicated device increased packaging costs and thus discouraged profiteers from faking the medicine. During the 1950s and '60s some counterfeiters recycled medicine boxes from pharmacies for use in their illicit trade. In response the medicine manufacturers widely adopted the practice of punching holes in their packaging, as illustrated by this box of Chu Hwa Sen Koon On Kung Ngau Wong Pills (left), produced in 1950s.

Private Detectives

Tempted by the lucrative profits of selling fake medicine, some pharmacies colluded with the counterfeiters and tried every means to induce unsuspecting consumers to buy their fake goods.

In the early days of medicine production factories would send their employees to pharmacies to carry out inspections. Later private detectives were hired. Financial rewards were given to those who reported the illicit trade in counterfeit medicine, but, despite every precaution, these efforts were largely to no avail.

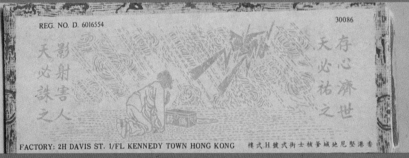

Uttering Curses

A more unorthodox method used by Chinese medicine manufacturers to impede counterfeiters was to print curses on their packaging. The threat of divine retribution or of one's descendants perishing may sound somewhat drastic, yet it was in keeping with the local belief in heavenly justice. Some manufacturers felt that if they wanted to protect their livelihood and reputation, they were left with no choice but to adopt this method as a psychological deterrent.

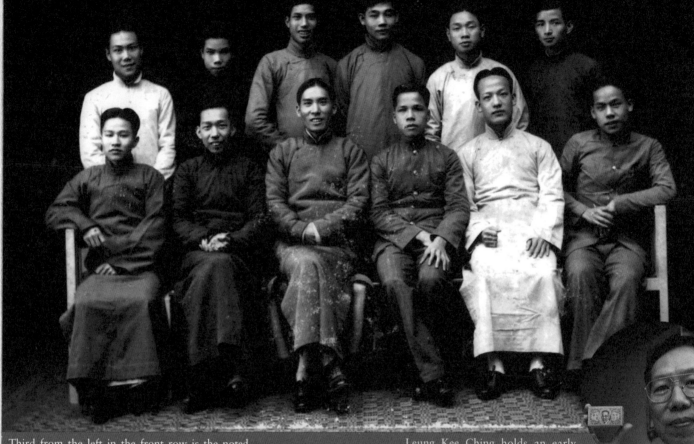

慈航美術學校二屆畢業留影 姤芄

Third from the left in the front row is the noted art teacher Ma Ci Hong 馬慈航.

Leung Kee Ching holds an early package designed by his father.

The King of Medicine Packaging: Leung Chi Mui

Following in the footsteps of his famous father, Leung Chi Mui 梁枝梅, the ambitious young Leung Kee Ching 梁其正 started out in life designing medicine packaging. However, because his clients continually poached his creative ideas, Leung Kee Ching switched careers and is now content to run a photo shop. He took time out from managing his busy shop to speak about his father and the design business.

Leung Chi Mui, wi the given name Leur Cheung Hang 梁象僬 was born in 1910 in Canton He was a native of Sunhu Guangdong province. His fathe owned a joss stick shop calle Tak Ming Chai 德明齋, located Canton. Complaining that th incense packaging sold by h father looked old-fashioned, youn Leung took the initiative to re design the wrapper. He enrolled the Ci Hong art school 慈航美術 校 to attend a one-year art cours and graduated in 1937, whereupo he adopted the alias Chi Mu after a heroic figure living i Guangdong in the 1930s.

156

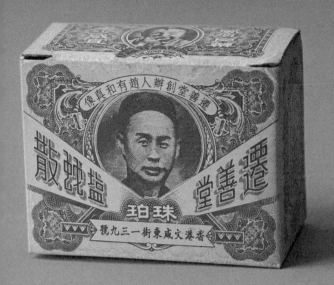

to provide the complete range of packaging from outer wrappers and instruction leaflets to trademarks and guarantee coupons. They could command a high fee, charging extra for intricate designs. As forgery was rampant, medicine manufacturers would pay any price for complicated designs that would foil the counterfeiters. At the time offset printing was in its prime, but crimson and brown were the colors most commonly used in medicine packaging. By the 1970s, however, when Western medicine started to gain widespread acceptance by local residents, it signaled the downfall of the Chinese-medicine market. In light of this trend Leung's clientele shifted to factories producing plastic toys for export and metal products.

"The word *designer* has only become a fashionable term in the past twenty years," Leung Kee Ching explains. "Back in my father's day the job was considered a lowly one, and designers were called painters or artisans at best." His father was skilled in *gong-bi* 工筆, a highly sophisticated Chinese painting style that benefited him when he worked on complicated designs. Leung Kee Ching recalls the packages his father designed for some of the more established medicine brands, among them Li Chung Shing Tong Po Chai Pills, Chi Shin Tong salty snake powder, Wong Lo Kat Herbal Tea, and Po Chai Lemonade. He still remembers vividly how Wong Lo Kat sent tons of herbal tea to his home when they tried to engage his father to design their packaging.

In 1952 Leung Chi Mui came to Hong Kong alone, to get away from the changing political climate in mainland China. There he continued his work as a designer of medicine packaging, since many medicine factories had also relocated to the city. He made a decent living with his fine skills and was able to support his large family back in Guangzhou.

Leung Kee Ching arrived in Hong Kong in 1963 and was reunited with his father, under whom he apprenticed. He remembers that they received a lot of medicine-packaging assignments all at once and were often required

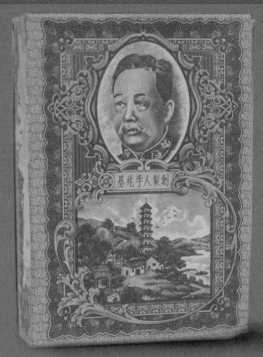

From 1964 to 1967 the elder Leung was also employed by the Culture Publishing House 文化出版社, where he produced illustrations for textbooks. He then opened the Chi Mui studio 枝梅畫院 and offered painting classes. He died in 1968.

Today some of the packages designed by Leung Chi Mui are still in use. His highly stylized work is indicative of the design genre governing the period when he was active. Little wonder he was hailed the king of medicine packaging.

This instruction leaflet is a classic example of the more intricate designs that incorporated scroll patterns and contour portraits on a decorative background and fancy borders.

Scroll Patterns

According to Leung Kee Ching, Canton was heavily influenced by European design during the 1930s. He recalls that his father, Leung Chi Mui, learned from books on European art that he had borrowed from his teacher Ma Ci Hong. Decorative borders were prominently featured in Shanghai's art deco-style calendar posters, and Leung's added scrolls of acanthus leaves, a motif seen in the Baroque architecture of the West, became part and parcel of the overall style. From then on scrollwork was commonly used on medicine packs, enveloping cameos and the name of the shop or medicine.

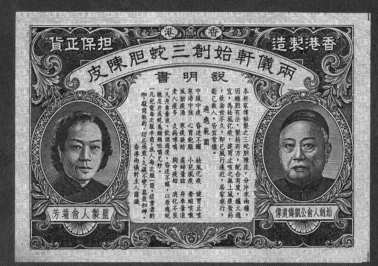

Creating Borders

Attractive borders were a key element of medicine-packaging design. First the designer would create one quarter of a border and then produce its mirror image on the opposite corner by photographic means. The process was then repeated until four symmetrical corners were complete.

Contour Portraits

In the age of the letterpress, tonal range was represented by lines of varying thickness. A contour portrait was made by using a photo to produce the initial blueprint. With tiny brushes and fountain pens the experienced artist then drew on the blueprint with great patience until a vivid portrait emerged.

Patterned Backgrounds

The process of creating background patterns was similar to that of producing fancy borders. The shop's logo or name was repeated four to eight times to form one unit; the units were then cloned continuously to make an overall pattern, which was widely applied to instruction leaflets, packets, and wrapping paper.

Leung Chi Mui used a large working table measuring four feet by five feet on which Chinese brushes, fountain pens, and ruling pens for straight lines were strewn. In early designs ink was used, but it was later supplemented with acrylic and poster colors. Artwork, especially the most intricate designs, was enlarged up to twice its original size, then reduced to its actual size by photographic means. At the time, color separation was done manually, each color requiring a separate piece of artwork. Consummate skill was needed to produce the various layers of multicolor designs with total accuracy.

The Asiatic Lithographic Printing Press and Kwan Wai Nung

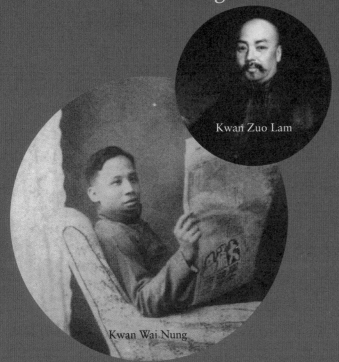

Kwan Zuo Lam

Kwan Wai Nung

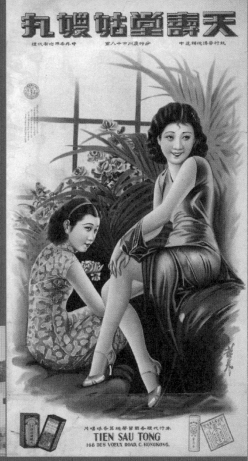

The Asiatic Lithographic Printing Press (ALPP) 亞洲石印局 should not be overlooked when studying early developments in Hong Kong's design and printing history. It was founded by Kwan Wai Nung 關蕙農, who involved most of the members of the Kwan family in the business. Kwan was an accomplished painter, as was his grandfather, Kwan Zuo Lam 關作霖 (also known as Lamqua 啉呱), who was a student of the famous British painter, George Chinnery, and widely recognized for his China-trade paintings in the mid-nineteenth century.

Kwan was art director of Hong Kong's leading English daily, the *South China Morning Post*, from 1911 to 1915, when he established the ALPP. Chinese-medicine packaging was a major source of Kwan's business at the time, calling for his full attention from design through production. The ALPP's clients included Wong Cheung Wah, Tin Hee Tong, Tien Sau Tong, Tiger Balm, and Chan Li Chai.

Early on, besides using chromolithography, the ALPP introduced advanced printing machines from Britain and Germany, applying innovative techniques to become the leading printing house of its time. Kwan lived up to his name, king of calendars, by creating many calendars of pinup girls, which served as sound promotional tools and represented state-of-the-art design pieces.

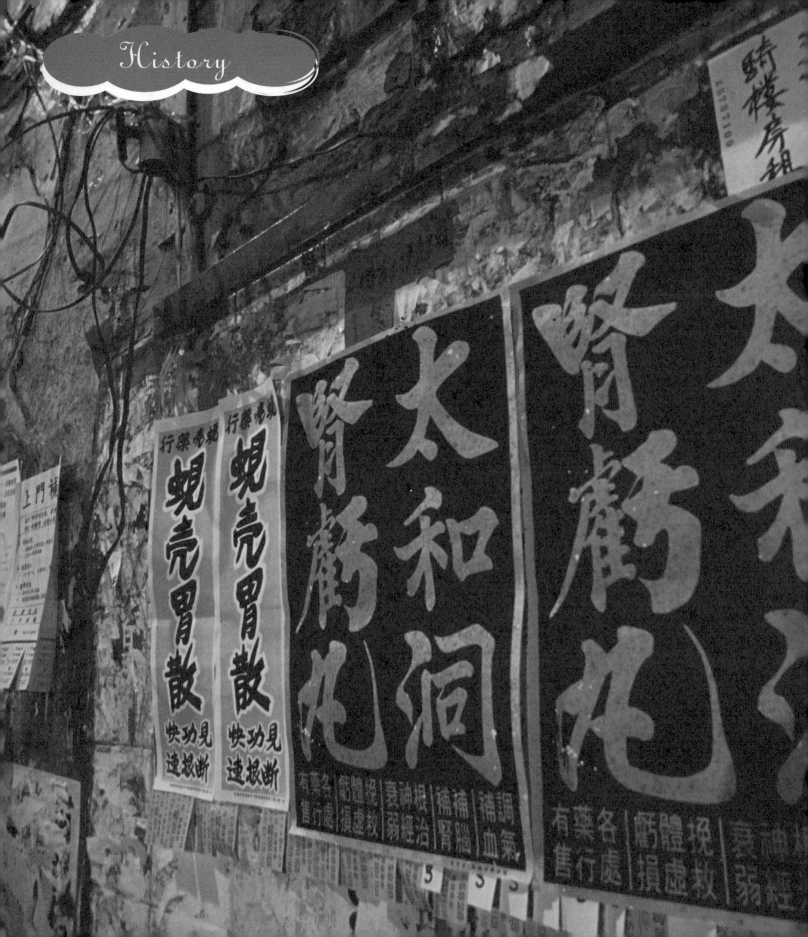

Quaint Customs of the Medicine Hawker

I have often admired the enterprise and ingenuity of past generations, particularly the creative ruses employed by itinerant vendors who once traipsed all over the Chinese countryside, drumming up interest in their products. From the outset promoters of medicinal goods took their trade to the streets, targeting humble passersby with entertaining acts. Dozens of old photographs survive, depicting comic scenes of hawkers in Hong Kong's streets and lanes.

As a child, I remember hearing a stout middle-aged man speaking in an unfamiliar Chinese dialect, parading the streets and attracting a large crowd with his compelling sideshow. An old man would step forward and pay to drink wine, mixed with the gallbladder of a freshly dissected snake. The hawker would then sing the praises of the medicinal wine, made from a secret prescription handed down by his forefathers. He drew many customers, who were somewhat dubious despite their suffering from rheumatism and copious sputum. The real scene stealer, though, was a strong man who encouraged his partner to smash a rock in half with a mallet on his bare chest. This event was merely the prelude to a captivating performance that elicited wild clapping and screams from the crowd. Eventually these quaint publicity stunts were replaced by advertisements from medicine manufacturers, which were played on the radio and television as well as placed in newspapers.

Traditional Chinese medicine serves as a sound barometer of Hong Kong's history, constantly adapting to the outbreak of epidemics and sweeping social changes. Similarly, the methods used to promote medicine have evolved in response to societal changes, not least of which are the mixing of Chinese and Western cultures and the growing consumer awareness that has erupted in the wake of mass media.

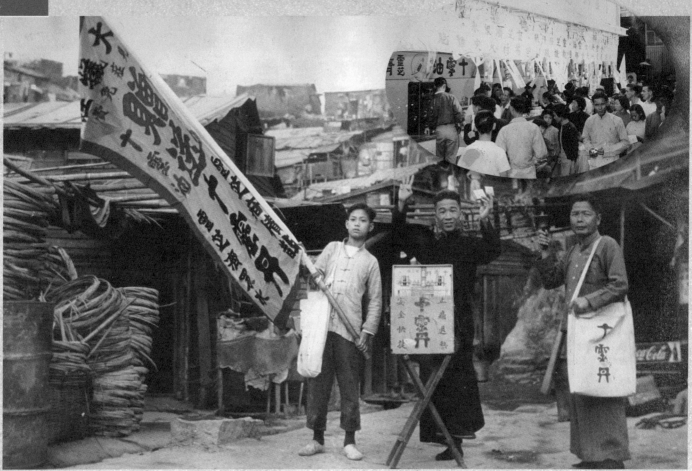

Tsang Hong and his team promote medicinal products in Hong Kong's squatter areas. Without gongs or drums to create a buzz, he had to rely on his skills as an orator and standard-bearer.

Tsang Hong's Life on the Road

According to an old Chinese saying, "traveling on the high seas or galloping on horseback increases the risk of danger by thirty percent." For Tsang Hong 曾康, a lifetime spent wandering around China selling medicine has proved even more hazardous. At seventy-eight years of age, Tsang still radiates power and vitality. Though retired since 1997, he is occasionally called back to work for the Ling Chi Medicine Company Limited 靈芝藥廠 and is the last surviving veteran of the trade known as *chu kong* 出江.

As Tsang explains it, *chu kong* was a means of spreading propaganda throughout Chinese villages and towns before the war. In the 1920s and '30s there was a proliferation of Chinese medicine shops in Guangzhou and Foshan, resulting in a vast supply of products and fierce competition. To corner the market some of the larger medicine manufacturers set up itinerant teams of hawkers to market their medicinal products in the most remote settlements in China.

Leaving his hometown in Panyu while still young, Tsang had to make a living despite having received only a rudimentary education. Like his cousins he traveled far and wide during the 1930s and '40s, shouldering heavy cloth banners and a small medicine chest. "At first I was really proud of myself, carrying that big banner, but later I found it really exhausting," Tsang recollects, in a voice made husky from years of shouting slogans. It was common to see teams of five or six carrying large, colorful flags printed with the name of the shop or medicine, beating gongs and drums, and crying out to draw the attention of onlookers.

Chu kong involved three tasks: bearing flags, arranging medicinal goods on the ground for sale, and putting up promotional posters in the streets.

Itinerant vendors usually sold their wares during festivals or village fairs, when there would be a captive audience. Tsang scouted the streets for suitable spots to stick posters, renting wall space from local residents. The hawkers had to comply with various rules and regulations, chief of which was a ban on poster-sticking at schools, temples, and ancestral shrines.

Through hard work Tsang was eventually promoted to supervisor of his public-relations team. When asked what bizarre experiences he encountered on the road, he recalls the claims of fellow hawkers that they came across evil spirits while traveling in Sichuan province. Although Tsang has not personally experienced such perils, he did cross paths with a fierce thief once, who pointed a machine gun at his team and wounded two of them. After all these years Tsang still shudders at the memory. Trying to remain composed, he remembers pleading with the thief to let them go, saying "We're just medicine sellers, going about our work. Give us a break!" The proceeds of their sales had already been deposited in the bank, so they suffered no financial loss. However, he still considers himself lucky to have escaped unhurt.

As further evidence of his thrilling and eventful life, he cites a shipwreck and the emergency landing of his propeller-driven plane, which was being flown in stormy conditions. He says, "On both occasions I thought I was going to die, but somehow I lived to tell the tale."

When the Ling Chi Medicine Company Limited moved to Hong Kong in the 1950s, Tsang formally abandoned the perils of his itinerant lifestyle. Instead, he hawked the shiny fungi *ganoderma* in Hong Kong's resettlement and squatter areas and occasionally approached local drugstores to work as their agent. Information was easily disseminated in a compact city like Hong Kong, but poster-sticking soon lost its efficacy as a promotional tool. Similarly, vendors who arranged their wares on the ground were largely supplanted by commercial fairs and expositions. Selling village to village may be obsolete nowadays, but if you come across an old man enthusiastically touting Sap Ling Tan in the far-flung corners of Hong Kong, you can be sure it's Tsang Hong, a living relic of *chu kong*.

With their displays of medicinal products and wall-painting skills, China's itinerant vendors were the earliest advertisers in the trade.

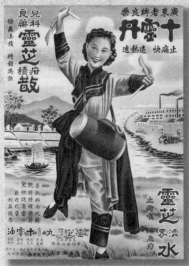

A 1950s poster shows a young female folk dancer playing the flower drum.

Tsang will never part with his cloth medicine bag, which he has kept over the years as a rare memento of the *chu kong* trade.

Chan Yat Biu and Golden Eagle

A Rare Double Act

At over ninety years of age, Chan Yat Biu 陳日標 is probably Hong Kong's oldest street vendor, and, together with his trusted friend, a monkey named Kam Ying 金鷹 [Golden Eagle], he forms a most unusual partnership.

Having survived a brief separation, Chan and Kam Ying remain upbeat and are content with their lot. Their familiar hand gestures have long captured people's hearts.

Chan and his late son in a trademark clouded by sadness and regret.

As a child, I saw Chan and his companion every Wednesday in the San Po Kong district, selling assorted products rain or shine. When I passed by, I greeted him with the words, "Hey, it's the Monkey King!" Old Chan and his monkey simultaneously raised their right hands in salute, their mischievous movements and mutual understanding prompting much amusement in the neighborhood. Like others of his generation, Chan sold *kam chik saan*, used for healing infantile malnutrition. To this day he depends on the small income he earns from this activity and has to work every day to make ends meet. When asked about his business, his answer is always the same: "All sweat and no gain."

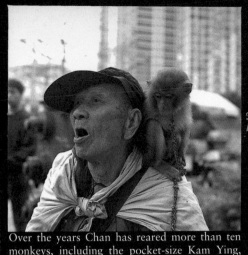

Over the years Chan has reared more than ten monkeys, including the pocket-size Kam Ying, who jumps on his master's head upon command.

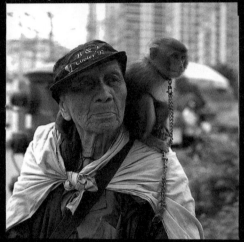

Chan and Kam Ying perform a comic act as they roam the streets.

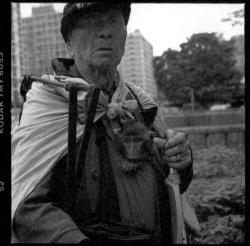

Long ago people believed that monkey saliva was a remedy for indigestion and malnutrition. During the hawker's show onlookers placed a biscuit in the monkey's mouth, pulled the biscuit out, and brought it home for the child to eat. Today the practice is discredited as nonsense and, of course, unhygienic.

Today Chan is the only street vendor who uses a monkey to attract customers, but the practice was once a common form of entertainment, adopted by hawkers stationed in Hollywood Road in the Central district and Temple Street in the Yau Ma Tei district. Having outlived his peers, Chan is the only one left still trading in the medicinal powder.

Since arriving in Hong Kong at the age of twelve, with no relatives and no skills to speak of, Chan had little choice but to become a street vendor. At a young age he quickly acquired the knack for survival on the streets and created a witty banter with earthy cries of "Pears so big they make your mouth water!" and "Sweet hemp-seed soup to make your kids grow up strong and healthy!" Long years spent hawking have made Chan's voice raspy and deep. While the old man bears most of life's hardships with grace, he still mourns the loss of his beloved second son, a trained doctor who died prematurely from pneumonia. All Chan has to remember him by is a photograph of them together, which he uses as his trademark. After his bereavement, Chan came to regard his pet monkey as his closest ally, and the two have been inseparable ever since.

Last year, however, Chan made headlines when Kam Ying was detained by the authorities because the old man did not possess a license for the monkey. The incident was widely reported in the media and won sympathy from the public as Chan appeared to lose his appetite for life. In the end, man and monkey were reunited and, basking in the glow of happiness, Chan even patched up a misunderstanding with his fifth son. It was a blessing in disguise.

Today Chan continues his trade whatever the weather. During holidays he works at a flea market, accompanied by his fifth son and Kam Ying. His presence warms the hearts of passersby, who often stop to inquire after his business, and is a throwback to the long-forgotten personal touch.

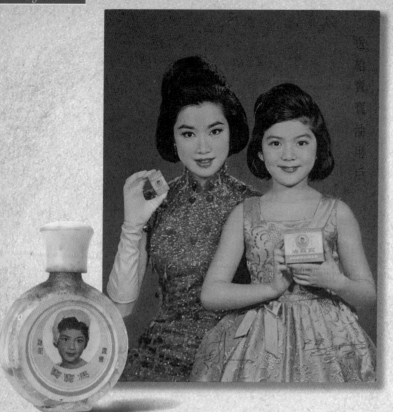

The Effects of Stardom

In the 1950s the people of Hong Kong led a simple life, the cinema and Cantonese opera being their main sources of entertainment. Noting the immense popularity of screen idols and opera stars of the era, pharmaceutical companies, such as Hoe Hing Pak Fah Yeow Manufacturing Limited, courted celebrities in the hopes of gaining endorsements for the company's products. Linking a celebrity's name with a product was enough to spark a consumer frenzy among doting fans keen to use the same medicine brand as their favorite idols.

To further promote brand recognition, a medicine company might send lavish floral tributes to celebrate film premieres, and inside the theater seat covers and screen curtains would be emblazoned with the company's name to garner widespread publicity. Celebrity endorsement was a successful means of raising a company's profile and one that to this day remains an extremely common marketing tactic to entice consumers.

Bobo Oil

Hailed as the Shirley Temple of the East, Petrina Fung Bobo 馮寶寶 won great fame and popularity as an appealing child star in the 1950s and '60s. Sensing a novel marketing opportunity, her canny father Fung Fung 馮峰, who was also an actor, used his daughter's image to plug the medicinal oil of a Chinese opera troupe, naming it Bobo oil, the first Chinese medicine to be endorsed by a child star.

Kwan Tak Hing

The character Wong Fei Hung 黃飛鴻 was immortalized on screen by Hong Kong actor Kwan Tak Hing 關德興, who played the role of Wong in more than a hundred movies in the eponymous series. Portraying an upright hero who excelled in martial arts, Kwan was actually a famous actor of Cantonese opera, proficient in boxing and martial arts. A medicinal wine for healing bone injuries was named after him in tribute to his martial-arts prowess.

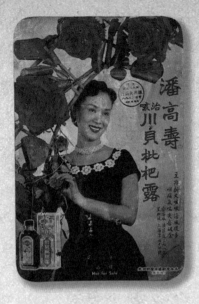

Poised and elegant, Pak Yin 白燕 was one of the most sought-after Cantonese stars of the 1950s and was approached by the famous Poon Goor Soe medicine factory 潘高壽 to pose for its calendar.

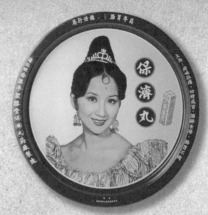

Brimming with youthful energy, Nancy Sit Gar Yin 薛家燕 graced this calendar plate to promote a well-known medicine brand.

Television Advertising

With the advent of glorious Technicolor, advertisements produced for television were suddenly rich and informative, having a direct and far-reaching impact not only on people's values but also on their mode of consumption. Local medicine companies took the lead in publicizing their products on the screen, first in the form of photographic stills and later by filming actors and creating cartoons. Despite the growing influence of television, however, advertising lacked immediacy and was still bound by practices found in the print media, both in terms of content and creative concepts. So, armed with big budgets, pharmacies began hiring advertising companies to conceive new ideas that would be visually striking and have catchy jingles that would become enduring popular tunes.

Advertisements for Pak Fah Yeow were featured in Cantonese movies during the 1960s.

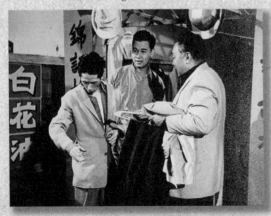

In the 1970s the Wai Yuen Tong medicine company 位元堂藥廠有限公司 launched a highly successful campaign for its main product, Young Yum pills 扶正養陰丸, enlisting famous actors Sum Sum 森森 and Leung Sing Po 梁醒波 to appear in the commercials.

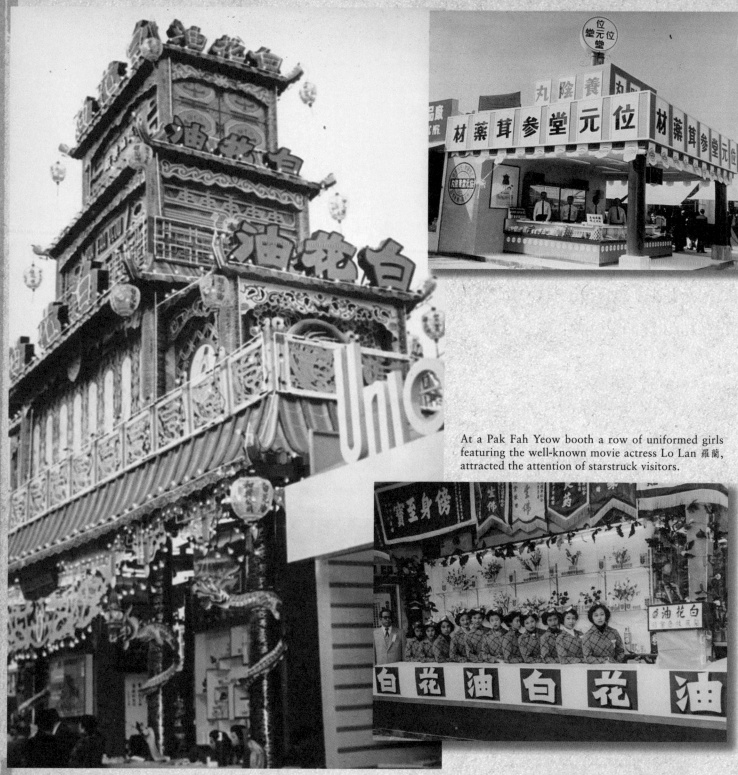

At a Pak Fah Yeow booth a row of uniformed girls featuring the well-known movie actress Lo Lan 羅蘭, attracted the attention of starstruck visitors.

During the 1960s Pak Fah Yeow pulled out all the stops to construct exquisite stalls for the Hong Kong Products Expo. At night the illuminated booths were a riot of dazzling colors.

Hong Kong Products Expo

Launched in 1938 and organized by the Chinese Manufacturers' Association of Hong Kong (CMA), the Hong Kong Products Expo (HKPE) is a renowned fair that promotes the external trade of Hong Kong's products and fosters development in the industry. Boasting the support of Hong Kong manufacturers and the active participation of local residents, the HKPE has traditionally been a large-scale, open-air retail exhibition, attracting visitors to booths displaying a wealth of fascinating products. In the past the dearth of local entertainment meant that families would flock to the HKPE, with its varied program of pageants and performances, seeing it as an ideal chance to dress up and have fun. The Miss Exhibition Pageant, in particular, was always a showstopper and set a precedent for the local beauty contests that followed.

By the 1950s the HKPE had attracted the participation of local medicine manufacturers, who seized the opportunity to promote their wares. Among them Hoe Hin Pak Fah Yeow Manufacturing Limited, and Ling Chi Medicine Company Limited spared no expense in erecting grand and ingeniously designed stalls, which offered visitors fancy souvenir packs containing medicine samples. The companies also nominated female representatives to participate in the Miss Exhibition Pageant and invited famous stars to attend as an additional draw.

Li Chung Shing Tong participated in a dragon dance at the Hong Kong Festival.

Female employees of Li Chung Shing Tong graced a float during a parade at the Hong Kong Products Expo.

Taiwanese starlet Teresa Tang became involved with the Pak Fah Yeow Charity Fair and was twice elected queen of the fair. On the strength of this title she gradually established herself as a popular singer in China, Hong Kong, Taiwan, and Japan, enjoying great fame until her untimely death in 1995.

A scene at the present-day Hong Kong Products Expo depicts the Po Sum On stall.

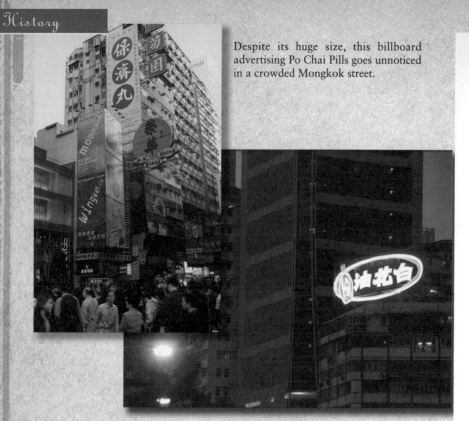

Despite its huge size, this billboard advertising Po Chai Pills goes unnoticed in a crowded Mongkok street.

In the mid-1960s the makers of Pak Fah Yeow installed a giant neon sign outside the famous Gordon Building in Causeway Bay.

Posters and Billboards

Street posters were one of the earliest forms of publicity in China, along with martial-arts demonstrations and hawking. The name and location of a medicine shop were carved on wooden boards and printed onto coarse paper to form posters that were strategically placed on street corners as a not-so-subtle inducement to customers to buy the product. Though color printing had emerged, it was costly, and, with so much waste, most manufacturers adopted monochrome or two-color printing to save money. During the 1950s and '60s the streets were typically plastered with posters in eye-catching colors like black, yellow, and red. In the dimly lit streets after nightfall the posters provided a welcome jolt of color.

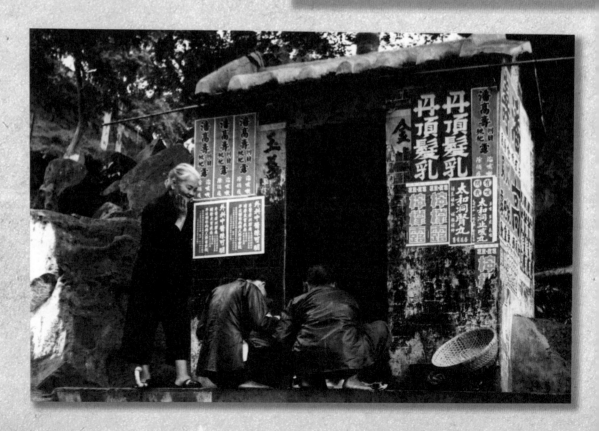

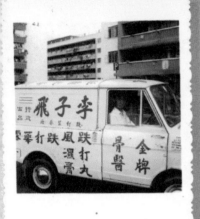

This 1960s van bears the name of the famous bonesetter Li Tze Fai 李子飛.

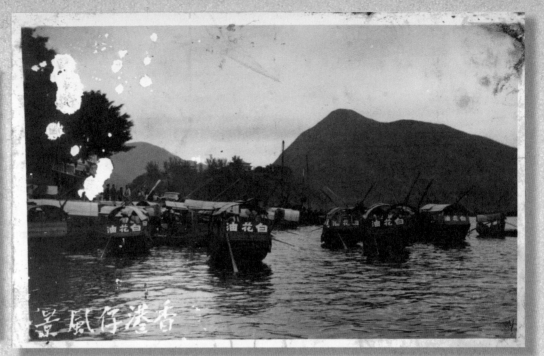

In the 1950s Pak Fah Yeow led the way by advertising on sampans and fishing boats berthed in the Aberdeen Typhoon Shelter.

Trams have long offered up their livery to advertisers. Today the No.120 tram is exclusively reserved for the promotion of medicinal products.

Pak Fah Yeow advertised not only on vehicles plying urban routes but also on buses on the once remote outlying island of Lantau.

Publicity on the Move

Public transport has long provided an effective means to display commercials to ensure a larger audience. In Guangzhou in the 1920s, when herbalist Tong Sap Yee was called out to tend his patients, he set off on his rounds with his sedan chair covered in advertisements for his practice.

Trams, which have been running in Hong Kong for nearly a century, were one of the earliest forms of public transport on the island and bore medicine advertisements right from the beginning. Likewise, on ferries plying the waters between Hong Kong, Macau, and mainland China, itinerant hawkers would put up posters and wax lyrical about their products. Buses and taxis followed suit, keen to increase their source of income, medicine manufacturers being among their main clients.

Newspaper Advertisements

From the beginning newspaper advertisements have influenced our lifestyle and shaped our spending habits. Advertisments for Chinese medicine were among the earliest to appear in the region's Chinese and foreign-language newspapers, exceeding other products in terms of coverage and volume and providing some publications with their main source of revenue.

In the early twentieth century newspapers proved a fierce battleground for Western and Chinese medicine. The former set aside huge budgets for promotional campaigns to break down traditional Chinese barriers to foreign products while opening up a new era in sales strategies. In response, traditional Chinese medicine companies placed yet more advertisments in the hopes of saving their declining businesses. These promotional materials often emphasized the long history of the manufacturers, who wanted to enhance their credibility.

Not unlike traditional street posters, Chinese advertisements used bold type to drive their message home, and illustrations made an appearance after the Second World War. Some borrowed expressions from Western advertisements, but they were out of step with the general tone of Chinese promotions and were therefore counterproductive. As a rule, publicity for Chinese medicine served to promote the products and notify the public of changes in packaging and of legal proceedings.

In the 1930s a witty advertising campaign devised by Leung Pui Kee, the well-known founder of a medicine company, ran in various Guangzhou newspapers over four consecutive days. Cashing in on Leung's popular public persona, the newspaper coverage of the first two days served as a teaser, generating enough interest to keep readers guessing. On the third day the news took an unexpected comic turn, proclaiming that Leung Pui Kee had caught a cold. By the fourth day it became obvious that the reports were part of a novel and humorous advertising campaign, because Leung had reportedly made a speedy recovery upon taking a dose of his own medicine.

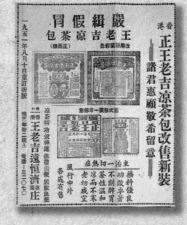

Chinese-medicine advertisements were normally placed in the margins of a newspaper, easily catching the reader's eye.

Leung Pui Kee

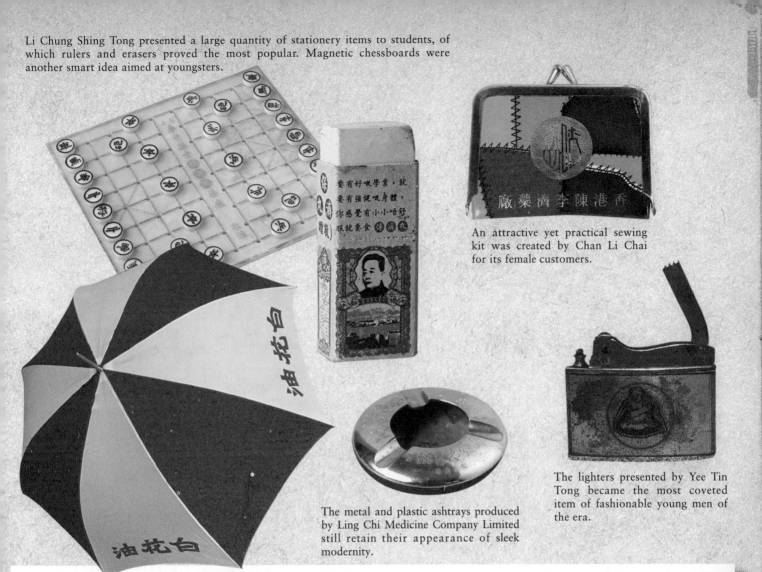

Li Chung Shing Tong presented a large quantity of stationery items to students, of which rulers and erasers proved the most popular. Magnetic chessboards were another smart idea aimed at youngsters.

An attractive yet practical sewing kit was created by Chan Li Chai for its female customers.

The lighters presented by Yee Tin Tong became the most coveted item of fashionable young men of the era.

The metal and plastic ashtrays produced by Ling Chi Medicine Company Limited still retain their appearance of sleek modernity.

Promotional Gifts

Gifts played a significant role in the promotion of medicinal products. Manufacturers presented corporate tokens to agents, salespeople, and long-standing customers for two main reasons: as a mark of gratitude for their continued support and to strengthen business ties.

Exquisitely produced calendars were among the most popular giveaways in Shanghai and Hong Kong during the early twentieth century. An increasing variety of promotional gifts followed, including small medicine samples, distributed to passengers on ferries and at railway stations, as well as paper fans and bags. The gifts were generally practical items, such as umbrellas, pens, lighters, and toothpick holders. Later, novelty items started to appear, like cups, board games, and toys. Li Chung Shing Tong, for instance, targeted children with smart stationery sets.

Hong Kong Herbal Shops

A copper pestle is used to pound medicine into powder.

The cleaver, an essential tool in Chinese herbal shops, is used to slice processed medicine.

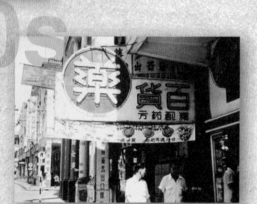

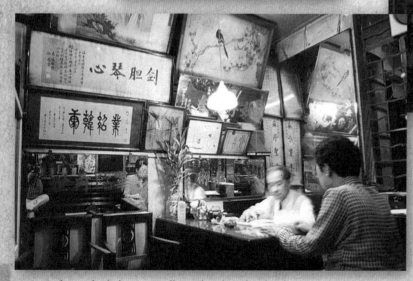

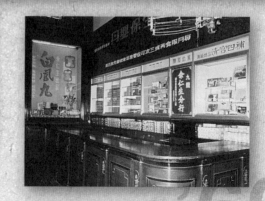

An in-house herbalist is usually on hand in the shop to provide diagnoses; the old furniture and commemorative plaques produce an air of antiquity.

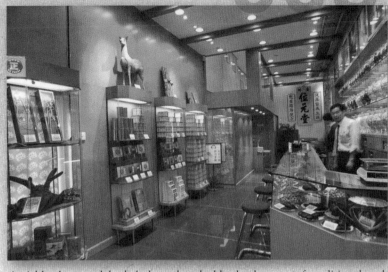

A richly decorated herbal shop cleverly blends elements of traditional and modern design.

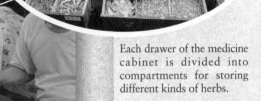

Each drawer of the medicine cabinet is divided into compartments for storing different kinds of herbs.

The high ceilings of older herbal shops provide ample space for the traditional Chinese medicine cabinet's one hundred drawers 百子櫃.

A planing tool was converted from a wooden stool.

Decor of a Traditional Chinese Herbal Shop

Most old-style herbal shops serve customers out front, while the rear of the premises serves as an abode. Typically the shop is decorated with old redwood furniture and plaques presented by patients, resulting in an elegant and solemn setting, imbued with a rich antique flavor. Behind the shop's long wooden counter lies row upon row of drawers filled with different herbal ingredients, making for an impressive spectacle. An old practitioner dressed in his robe feels the patient's pulse attentively and with a few deft strokes writes a prescription on a small piece of paper, which is then handed to the dispenser for collection. Blessed with an excellent memory, the dispenser can swiftly gather the prescribed herbs from among the numerous drawers and weigh them with a Chinese steelyard. The shop's most commonly used implements lie at the far end of the counter: a cleaver, a stone mortar and copper pestle, and a milling boat for grinding processed medicines into fine powder.

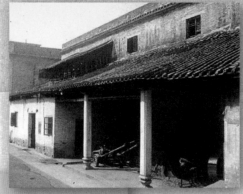

Foshan: The Birthplace of Traditional Chinese Medicine

The majority of traditional Chinese medicine shops originated in Foshan and Guangzhou, the former credited as the birthplace of traditional Chinese medicine. As far back as the Ming dynasty, Foshan was a prosperous and populous town where there was emphasis on handicrafts such as textiles and pottery. Furthermore, its prime location on the fringes of the Pearl River Delta meant that Foshan enjoyed convenient transportation links by land and sea, emerging as a significant distribution center for commodities.

The earliest Chinese medicine shop on record in Foshan was Liang Zhong Hong 梁仲弘蠟丸館, a shop selling wax-coated pills, which opened some four hundred years ago during the reign of Ming-dynasty emperor Wanli (1563-1620). From then on, numerous famous Chinese herbalists set up their healing centers there, producing medicine as a sideline. The period spanning the mid-Qing dynasty to the early republican period is regarded as the golden age of traditional Chinese medicine, with the presence of more than a hundred medicine shops, big and small.

Foshan **Guangdong**

Macau **Hong Kong**

■ Medicine factories set up branches in Hong Kong and Macau during the nineteenth century.

Medicine made in Hong Kong was distributed to Southeast Asia, Europe, and the United States.

■ Chinese medicine was distributed to various parts of Guangdong province.

When Hong Kong became a British colony and a free port, certain medicine shops on the mainland took advantage of their close proximity to the territory by setting up branches and joint corporations to sell and distribute their products to overseas markets. One typical example was Wong Lo Kat, which established a branch in Hong Kong in the late nineteenth century. Other well-known businesses, like Ou Ka Chuen and Ma Pak Leung, relocated their bases to Hong Kong, in 1901 and 1904 respectively.

An export pack of Sap Ling Tan is printed in Thai to sell in Thailand.

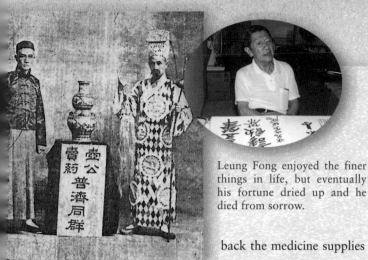

Leung Fong enjoyed the finer things in life, but eventually his fortune dried up and he died from sorrow.

Leung Kwok Ying and His Son Leung Fong

Hailing from a poor family, Leung Kwok Ying left school early to work as a newsagent, traveling between Hong Kong and Guangdong province. At the time there was a great demand in Hong Kong for traditional Chinese medicine, but since most major medicine shops were located in Guangzhou and Foshan, Hong Kong residents had to rely on friends and relatives to bring back the medicine supplies they craved. The proliferation of counterfeit medicine in the colony only made matters worse. Thus, Leung hit on the idea of approaching well-known medicine shops and offering their products for resale in Hong Kong. Using his name as a guarantee for the imported goods, he met with such a favorable response that in 1914 he changed the name of his shop to Leung Kwok Ying Newspaper Bureau and Dispensary 梁國英報藥局 and significantly expanded his retail business. His vast product range included plasters, pellets, pills, and powders, produced by renowned medicine manufacturers like Li Chung Shing Tong, Leung Yee Hin, Leung Choi Shun, Po Che Tong, and Tin Hee Tong. The shortage of Western medicine after the outbreak of war in Europe enabled Leung to prosper in the trade of Chinese medicine, and he further diversified his services to include dry cleaning and the sale of homemade soap, in place of imported foodstuffs that were difficult to come by.

Like his father, Leung Fong was also an astute businessman. He established a medicine store on a busy street corner in Wanchai and rented out the exterior of the building as advertising space for medicine products, such as Sap Ling Tan and Po Sum On healing oil. Having inherited his father's entrepreneurial savvy, Fong publicized his medicine on ferries, befriended scholars and connoisseurs, and even published his own magazines and comic books. Aside from satisfying his yen for art and literature, these publications also carried his medicine advertisements. Leung's quick-witted ways and flair for business were also demonstrated when, in response to the territory's shortage of Western wines, he set up a bar selling mixed Chinese wines—the first of its kind—which was welcomed with open arms. However, like most local residents, Leung saw his amassed fortune dwindle as a result of the punitive currency-exchange system imposed during the Japanese occupation. Another blow precipitating his downfall was the rising popularity of Western medicine. By this time the former business giant resigned himself to his fate, as he was forced to close down one branch after another. Ten years after Leung's death, only three small branches of Leung Kwok Ying Pharmacy remain in the care of his relatives and partners.

The Leung Kwok Ying Newspaper Bureau and Dispensary in Des Voeux Road, Central, was an important landmark in the early twentieth century.

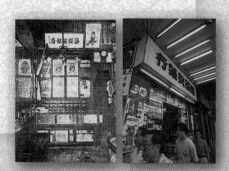

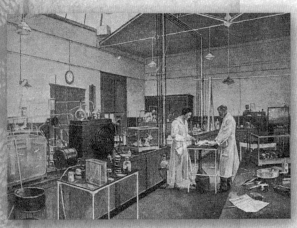

Herbalist at the street stall offering Chinese medicines for rare and recurring diseases.

The Rivalry Between Western and Chinese Medicine

The West's gunboat diplomacy of the mid-nineteenth century forced China to open its doors to trade, establishing five treaty ports strategically situated along China's southeast coast. Foreign powers wasted no time enriching themselves through rampant mercantile activities, while passing off unwanted foreign goods on the Chinese. In the wake of this prodigious commercialism, there followed an influx of Western missionaries, who set up medical schools, hospitals, and clinics. They brought unfamiliar practices to the region, based not on diagnosis by studying the pulse, acupuncture, or herbal treatment but on anatomical knowledge and advanced surgical procedures.

For more than a thousand years the Chinese people had placed their trust in the curative powers of herbalists. These specialists used traditional methods of medicine production, and patients had remained loyal from generation to generation through the centuries. But by the nineteenth century the situation had begun to stagnate, and the refusal of Chinese herbalists to change with the times enabled Western medicine companies to gain a foothold in the market. However, traders of Western medicine realized that although their remedies were fast and effective, they still needed to break down the traditional values of the Chinese. To achieve this they spent huge sums of money on advertising.

In a bid to attract Chinese customers, many early Western medicinal products had strange names—usually a transliteration of the English into Chinese—with slight changes in their pack-aging for the local market. In the face of stiff competition all kinds of costly gimmicks were used to tap into the Chinese market.

The transliteration of Western brand names into Chinese characters was extremely common, often causing confusion. New Chinese regulations stipulated that medicine packaging should avoid vague or abstract terms and provide clear information on the actual curative effects and properties of the medicine.

A 1920s instruction leaflet is illustrated with a picture of a German laboratory, displaying the kind of advanced medical equipment traditional Chinese herbalists could scarcely have imagined.

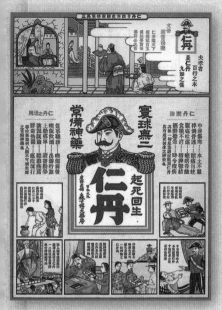

The Japanese secured a large share of the Chinese market with universal remedies such as Jintan 仁丹. An insert printed with a tale about filial piety was meant to appeal directly to traditional Chinese values.

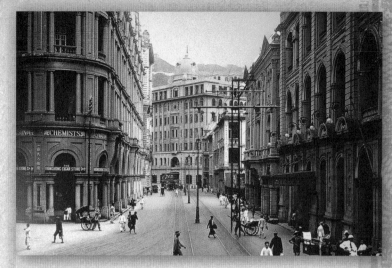

In the early twentieth century Watson was located in Des Voeux Road, Central, on a site now occupied by Alexandra House.

In Hong Kong the rivalry between Chinese and Western medicine persisted for a long time, and the Chinese found themselves facing a dilemma. On the one hand, they craved foreign goods but were bound, on the other, by a sense of national pride. Some Chinese-medicine manufacturers even exploited the predilection for all things foreign by repackaging their products with a Westernized appearance, in the hopes that their floundering businesses could be revived. The fact that there was already a strong demand in mainland China for antibiotics and injections only served to tip the scales further in favor of Western medicine.

A. S. Watson & Co.

The first western medicine shop in Hong Kong was A. S. Watson & Co. (Watson's) established in 1841. Originally aimed at foreigners residing in Hong Kong, the company went on to manufacture and market both Western and Chinese medicine products to the local Chinese. By 1885 it had already gained wide exposure through advertisements in the Hong Kong newspaper, *Circulation Daily* 循環日報. Watson set up outlets in Tianjin, Shantou, Manila, Fuzhou, Hankou, Macau, and Beijing and was considered a pioneer among Western enterprises dominating the Chinese market. Its trademark was a dragon-and-unicorn motif in red, yellow, and black and demonstrated the chemist's shrewd marketing ploy of using a favorite Chinese emblem to win local customers.

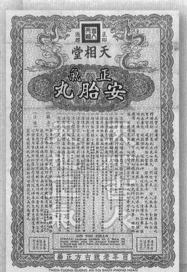

Eventually, in the interest of public health, instruction leaflets contained in medicine packages conveyed all of the necessary information regarding their contents with absolute clarity.

With close inspection one can easily discern that Watson's trademark, a combination of the dragon and unicorn, is neither strictly Chinese nor Western, but a blend of the two distinct cultures.

A shop sign extolling the virtues of a traditional Chinese medicine shop: passion, trustworthiness, and righteousness.

Tales of Old Medicine Shops

Behind every celebrated medicine shop lies a fascinating and often poignant story. Marked by the passage of time, these shops bear the traces of the blood, sweat, and tears of erstwhile Chinese entrepreneurs, the heady rise and fall of age-old clans, and the herbal-medicine business itself. Pausing to reflect on the massive changes in their industry, those in the trade are at once mournful at its passing and proud of its fine heritage.

Goodwill Rewards the Faithful and the Needy

Through thick and thin the Chinese have shown enduring faith in traditional herbal medicine and the notable curative effects of its myriad remedies. Despite the air of mystery that clung to old medicine shops, with their secret formulas and prescriptions handed down through generations, people were impressed by the knowledge and skill of discerning herbalists and trusted implicitly their ability to heal. The founders of most old Chinese medicine shops were scholarly practitioners who possessed an in-depth knowledge of traditional medicine and who lay great store in following a strict code of medical ethics and showing goodwill to others. They were also generous philanthropists, who provided free medical care and medicine to the public in times of need.

The Struggle to Uphold Family Traditions

More often than not the medicine shop is a family business, handed down from one generation to the next, and each one specializes in its own products, which have been made for the past few hundred years. Today people tend to view these centuries-old concerns as stuffy, convention-ridden institutions that fail to stay abreast of the times. In truth, the shop owners have all struggled to strike a balance between reform and tradition. Understandably, they are unwilling to turn their back on their family's long-standing success and good name but recognize, with heavy hearts, that change is inevitable in the face of continually evolving market conditions and fierce competition.

Keeping It in the Family

Nowadays traditional medicine shops are confronted both with the disillusionment of the older generation and a dearth of worthy successors. To keep their businesses alive, some have abandoned the convention of handing down property to their male successors and have allowed female family members to inherit the business. Without doubt, these women have had to work particularly hard to overcome prejudice and to win the respect of their more conservative peers.

Chan Lee Chai: Charity Begins at Home

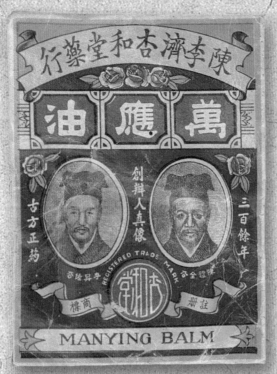

The exquisitely packaged Manying Balm 萬應油 [all-purpose embrocation] was produced in the 1940s. The paper pack was varnished for both a glossy finish and protection against moisture.

Century-old dried tangerine peel is one of Chan Li Chai's rarest products.

The famous Chan Li Chai medicine factory 陳李濟 was founded in Guangzhou more than four hundred years ago, during the Ming dynasty. Its origins can be traced back to a chance encounter between two boat passengers: merchant Chan Lai Chuen 陳體全, who had left his money behind on the boat, and the upstanding Li Sing Jor 李昇佐, who returned Chan's package after a long wait at the pier. Chan was so overjoyed at the recovery of his lost property that he nurtured a friendship with Lee and, out of gratitude, offered to invest half of the recovered funds in Li's medicine store.

The two became partners and created a new name for the shop, Chan Li Chai, which incorporated both their surnames and a joint pledge to lend charitable assistance whenever they could. The two founders agreed that the shop should be jointly managed by their descendants, that profits should be shared evenly among the

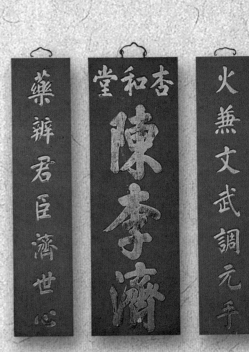

two clans, and that the two clans could not intermarry. These ancestral instructions have been carried out to the letter ever since.

Of the two leading pharmacies that once dominated the Chinese-medicine market, Beijing Tong Ren Tang 同仁堂 in the north and the Guangzhou-based Chan Li Chai in the south, it is the latter that boasts the longer history. For more than four centuries, Chan Li Chai's unique heritage has been attributed to the adherence to strict principles governing the complex art of medicine production: the use of the finest quality herbs and the most ex-

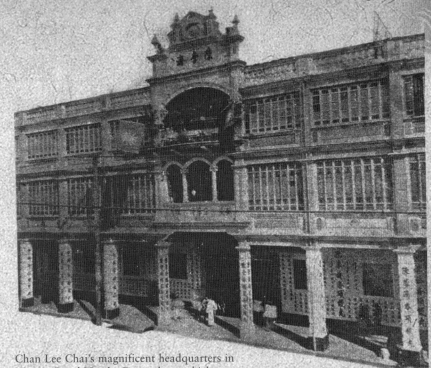

Chan Lee Chai's magnificent headquarters in Momin Road North, Guangzhou, which was destroyed during the Japanese invasion.

perienced medical practitioners. Furthermore, guided by their ancestors, the company's successors continued to provide free medical care and medicine during festivals and in times of disaster.

The medicinal products made by Chan Li Chai were obtained from rare and valuable ingredients and were used not only by the general public but by Qing-dynasty emperors. The Emperor Tongzhi 同治, who was healed of his flu with Chan Li Chai's renowned Zhi Feng So He pills 追風蘇合丸, conferred the title of Heng Wo Tong 杏和堂 upon the shop to honor its mastery in the art of healing. The title eventually formed the pharmacy's registered trademark. And each year a consignment of the shop's most prized remedy, the century-old *chen pi* 陳皮 [dried tangerine peel] was sent in tribute to the Empress Dowager Cixi.

In the 1920s Chan Li Chai set up a shop and factory in Hong Kong with a staff deployed from the Guangzhou branch. The Hong Kong branch enjoyed full autonomy, handling every stage of production in-house, from the purchasing and processing of herbs to the packaging and printing of the finished product. Today most of the processing once done by hand is carried out by machines, increasing the company's output and ensuring consistent quality levels.

This photo of the packaging section of the Hong Kong plant before the Second World War illustrates the "bed-board industry," whereby wooden boards used as packing tables during the day were reversed to form makeshift beds for workers at night.

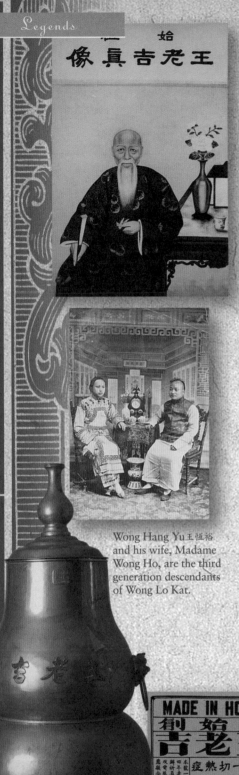

Wong Lo Kat:
Every Cloud Has a Silver Lining

Herbal teas, a product native to southern China, were originally imbibed as a means of quenching thirst and countering the ill effects of the region's long, hot, and humid summers. Particularly popular were the herbal drinks produced by Wong Lo Kat, the so-called King of Herbal Tea 涼茶大王, who founded his business nearly two centuries ago in Guangzhou. The company's first Hong Kong branch opened in 1896 to the rear of Man Mo Temple.

The origins of Wong Lo Kat's business are legendary. Wong Lo Kat 王老吉, whose real name was Wong Chak Bong 王澤邦, was born in 1813—a troubled time marked by raging epidemics and failed harvests. Many fled with their families to higher, cooler places to escape disease, and Wong, a farmer, was among the refugees.

On his way up a hill Wong had a dream in which a Taoist priest presented him with a remedy. When he awoke, he found he was grasping a piece of paper bearing the actual prescription. Convinced that he could use it to cure the diseases sweeping his hometown, he descended from the hill and asked an herbalist, Auyeung Cheong 歐陽昌, to prepare the prescription, even selling his one and only cow in exchange for a portion of the required herbs. In another dream the Taoist reappeared and directed him to take the herbs and obtain a gourd from an old man: the gourd was later used as Wong Lo Kat's trademark.

They were healed. The grateful patients nicknamed the drink Uncle Kat's Herbal Tea 吉叔涼茶, earning Wong instant celebrity. As a result, he was summoned to the palace by Emperor Xianfeng to take up a senior position at the imperial hospital, where he was handsomely rewarded for his efforts. He returned home in a sedan chair, basking in the glory of his success.

In 1853 he opened his first herbal-tea shop in Jingyuan city, Guangzhou, and named it Wong Lo Kat. After nearly two centuries this old medicine shop is in the hands of Wong Lo Kat's great-great-granddaughter, the cheerful Kin Yi 王健儀.

Wong Hang Yu 王恆裕 and his wife, Madame Wong Ho, are the third generation descendants of Wong Lo Kat.

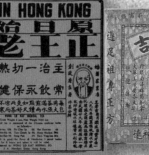

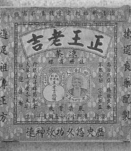

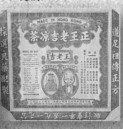

The offspring of Wong Yu Hong 王豫康 are pictured here. Seated first on the right in the front row is Wong's daughter, Kin Yi, who now runs the company.

Wong Lo Kat handed over the business to his three sons before his death. Under their management the business grew, but the herbal teas had to be sold in paper packs, because demand for their products was greater than their supply. During this period indentured Chinese workers heading overseas took packs of Wong Lo Kat Herbal Tea with them for health reasons, and pretty soon demand for the product flourished in Chinese communities abroad, and even foreigners became hooked on the tea.

The third generation heralded Wong Lo Kat's heyday, as the head of the family managed to steer the company through a series of domestic disputes over finances and drew up new plans to maintain the thriving and highly profitable business. After the first Hong Kong shop was established on Chik Street, the business flourished and other branches opened in quick succession. Since Hong Kong was a free port, Wong Lo Kat's herbal products produced further profits and recognition from overseas sales.

Today Wong Lo Kat is a large enterprise with an even wider share of the market. To stay ahead of consumer trends, it has revamped its packaging and embraced the worldwide craze for health drinks, creating new products based on ingredients like Chinese water chestnuts, carrot juice, sugar-cane juice, and loquat syrup.

The business has flourished under Wong Kin Yi's direction, but the problem of counterfeiting has long cast a dark cloud, much to her dismay. "I registered my brand many years ago in over ten countries, but still imitations appear on the market and the situation is particularly bad in Southeast Asia. What can I do?" Despite filing lawsuits against offenders, Wong Lo Kat's herbal prescriptions, in keeping with ancestral instructions, have been printed on their tea packaging from the outset and as such are accessible to the public, enabling anyone to produce herbal drinks based on the same ingredients. But Wong has stern words for these interlopers: "Our unique drinks have been produced according to a centuries-old recipe, with great care taken over the entire process, from the selecting of herbs to the packaging of the teas. Those producing counterfeit drinks do so with no regard for people's health and should be condemned!"

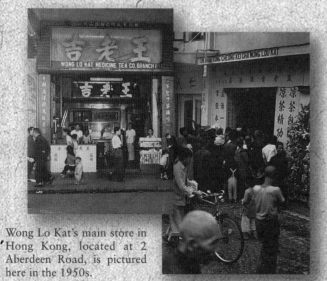

Wong Lo Kat's main store in Hong Kong, located at 2 Aberdeen Road, is pictured here in the 1950s.

This Wong Lo Kat branch is located in Macau.

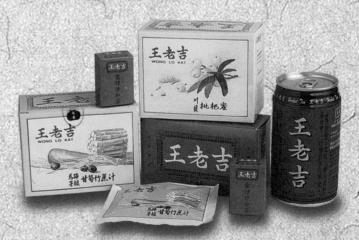

Instant herbal powder and canned herbal tea are among the company's wide variety of health-drink products.

Li Chung Shing Tong: A Household Name

Most Chinese families keep a ready supply of traditional medicine at home in case of illness, and Li Chung Shing Tong's well-known product, Po Chai Pills, are sure to be among the assorted contents of every bathroom's medicine cabinet. Given their effective relief of colds, seasonal malaise, and digestive disorders, it is easy to see why Po Chai Pills have gained widespread acceptance among those residing in southern China's typically hot and muggy climes.

The story of how Li Chung Shing Tong 李眾勝堂 was founded is another popular Chinese myth and over the years has

sprouted two similar versions. In the first the company's founder and devout Taoist, Li Siu Kee 李兆基, dreamt of the Taoist deity Lu Dongbin, who granted him the prescription for an herbal remedy. Upon waking, Li amassed the essential ingredients according to his vision and developed Pu Chai Pills 普濟丸, to be given to the needy. The second version focuses on the friendship between Li and an old monk who regularly visited Li's herbal-tea shop in the village. The monk welcomed Li's offer of free herbal tea and presented the shopkeeper with an ancient herbal prescription in return for his kindness and upright conduct. He advised Li to use the medicine to help the needy. While the authenticity of the two accounts remains uncertain, it is clear that the remedy brought Li both fame and fortune.

Founded in 1896, Li Chung Shing Tong's flagship store, located at an ancestral temple in Foshan, was a large-scale operation that boasted nearly a hundred workers. Among the items it produced were Pu Chai Pills (later renamed Po Chai Pills 保濟丸), Shing Wo Oil 勝和油, Po Wo tea 保和茶, and *tung kwan saan* 通關散. A second branch was later set up in

Guangzhou. Li Siu Kee was a charitable man who regularly rewarded the villagers who frequented his shop. He also established a school that provided a free education to those who had dropped out.

In 1937 Li's son, Chi Ho 李賜豪, fled with his family to Hong Kong as the Japanese began to encroach on Foshan. The following year Li Siu Kee died and was mourned by numerous villagers, who lined both sides of the road during his funeral procession.

In the 1950s Li Chi Ho bought a large quantity of land to establish a Hong Kong base for Li Chung Shing Tong Limited. From the 1960s to the 1970s he became an active member of the community, joining Tung Wah hospital's board of directors and participating in the spectacular parades organized for the 1973 Hong Kong Festival and the annual Hong Kong Products Expo. Li Chung Shing Tong has always been a firm believer in the value of publicity. One of its most memorable and enduring campaigns featured the catchy jingle "With Po Chai Pills near, the sick have no fear," a popular refrain that spanned nearly two decades and became enshrined in Hong Kong's collective memory.

The company's present incumbent, Li Wai Neng 李偉能, is meticulous in observing the most rigorous hygiene standards at the factory in order to guarantee the quality and safety of its traditional Chinese remedies and has invested heavily in the resources needed to meet stringent international controls concerning medicine production.

Tong Sap Yee: The End of an Era

Tong Sap Yee's trademark shows a mustachioed Tong dressed in Western clothing. The East-meets-West image reflects the company's combination of both Western and Chinese medicines.

Though the Tong Sap Yee medicine shop was finally forced to close in 1997—due to strict new government regulations—the founder's two sons, Tong Fei Chow 唐非洲 and his younger brother,

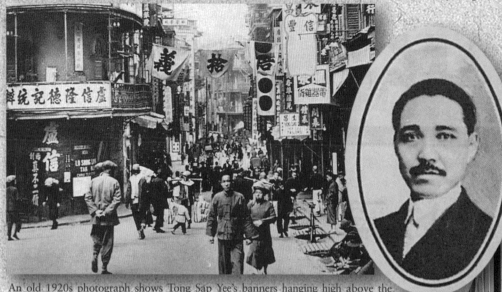

An old 1920s photograph shows Tong Sap Yee's banners hanging high above the junction of Bonham Strand and Hillier Street on Hong Kong Island.

Tong Fei Chow and Tong Chat Chow in the company's office.

Tong Chat Chow 唐七洲, still work in a small 1970s-era office, handling correspondence and answering telephone calls. This leisurely life is a far cry from the "good old days" when they worked under the continual strain of running a medicine company. Fei Chow glances with admiration at his father's framed photo and is only too happy to recount the history of Tong Sap Yee.

Born in Sanshui, Guangzhou, Tong Sap Yee (real name Tong Chun Chi) 唐振之 was the son of a businessman. A graduate of Liangyi hospital, Tong was one of the few doctors trained in Western medicine in those days, and he started his career by setting up a clinic in Xiajiufu, Guangzhou, specializing in healing pulmonary tuberculosis. Fei Chow recalls with pride that his father cured Guangdong's provincial chief, Long Jiguang, and, in a show of gratitude, Long presented Tong Sap Yee with a commemorative plaque testifying to his great skill. This greatly enhanced the doctor's reputation, and soon after his clinic swarmed with patients.

In 1915, however, Guangzhou suffered serious flooding, forcing inhabitants to flee and leaving others destitute and homeless. This sudden turn of events took Sap Yee to Shanghai, where the potential for business appeared more promising. He left his clinic in the hands of his nephew and went with his wife to start a new life in Shanghai. Aware that among the city's rich and powerful there were many suffering from lung troubles, he invested heavily in advertising and charged deliberately high consultation fees. His expensive prices had the desired effect and patients were lining up at his door. With the money he

earned, he set up Tong Sap Yee pharmacy 唐拾義藥房 on Sanma Road in 1924 and two years later built the flagship store on Aiduoya Road, renaming it Tong Sap Yee and Sons Medicine Company 唐拾義父子藥廠.

Among Tong's best-selling products was his brand of malaria pills (also used to heal colds and fevers), because they were an inexpensive yet remarkably effective cure. He capitalized on the success of this remedy by developing various new kinds of medicine that catered to the needs of the market, and he amassed a great fortune. He was credited with bringing about several breakthroughs in medicine production: the invention of a pill-rolling machine, created by his nephew Tong Lai Shou 唐禮壽, improved both the quantity and quality of the pharmacy's output; and major reforms in the workplace protected and safeguarded his employees. In 1938 Tong's third son, Ou Chow 唐歐洲, received his medical degree from Berliner University and took over the business in Shanghai. He formulated rules and a proper administrative system for the factory, strengthening financial management and staff welfare. Tong Sap Yee was one of the few Chinese-funded pharmaceutical factories to implement Western-style management.

Tong Sap Yee died in Shanghai in 1940 at the age of sixty-five, after a lifetime of performing good deeds. He founded the Weide School [a school for safeguarding morals] and Boai Hospital [a fraternity hospital] in his home village of Sanshui, Guangzhou.

Li Chung Shing Tong and Tong Sap Yee medicine shops are located on opposite sides of Bonham Strand.

A promotional placard was displayed by dispensary agents.

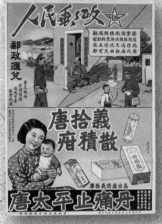

A Tong Sap Yee poster was displayed in China during the 1950s. In the past medicine was frequently distributed by mail.

The grandiose pharmacy Tong Sap Yee was located on Aiduoya Road, Shanghai, in the 1930s.

Tong Sap Yee's Great Ambition Revealed in the Names of His Children

Tong Sap Yee had ten sons and eleven daughters by six wives, of whom only six boys and ten girls survived. The names he chose for his sons were extraordinary: Ya Chow, Ou Chow, Mei Chow, Fei Chow, Chat Chow, and Kau Chow, meaning Asia, Europe, America, Africa, seven continents, and nine continents respectively, reflecting Tong's aspiration of expanding his business globally. In naming his daughters he drew on some of China's most beloved scenic areas, including Xinglin, Guilin, and Jilin.

His son Chat Chow feels a mixture of helplessness and anger at the decline of the family business. Despite their attempts to abide by the government's prescribed regulations and hire qualified pharmacists—which they fully support—Tong feels that the new controls were rushed through prematurely. Unprepared and running low on funds, the pharmacy fell short of the harsh demands urged by the government, leaving most family members so dispirited that no one was willing to take over the business. Tong Sap Yee finally closed its doors before the actual implementation of government regulations, a sad and gloomy end for such a distinguished family business.

Tin Hee Tong: Blessings from Above

In this typical family portrait Tin Hee Tong 天喜堂 founder Lam Siu Chun 林肇春 appears dignified and stern, yet there are traces of a smile touching the upturned corners of his mouth and a twinkle in his eye. The proud father of seven sons, all born in the space of a decade, Lam was regarded with deep admiration by his peers and was considered truly blessed.

According to Chinese tradition, giving birth to a son means everything, so the classic photo of Lam Siu Chun surrounded by his seven sons is a model family image, representing the hopes and ambitions of every Chinese household.

Lam's daughter-in-law, Lam Tong Kat Lam 林唐吉林, who presently runs the business, points to the efficacy of Tin Hee Tong's medicine as evidenced by the founder's fecundity! The medicine in question, originally called *tiu king* pills 調經丸, which were for relieving menstrual discomforts, was later renamed fertility pills 多仔丸, and, aside from being a cure, they nourished the blood and dispelled bodily toxins.

Tin Hee Tong was founded by Lam Siu Chun in 1904. An old myth, however, posits that the company was founded during the Boxer Rebellion, when an old maid who had taken flight from the imperial palace met Lam by chance in Shanghai, where she sought refuge and conferred upon him a secret formula to assist reproduction. Lam, still childless at that time, encouraged his wife Liu Kwan Ying to take the medicine, which had been prepared according to the prescription. Within the year his wife was pregnant; more surprising still was the fact that she gave birth to seven boys in quick succession. Believing his good fortune to be heaven-sent, Lam felt compelled to use the medicine to benefit the masses. He set up a medicine store called Tin Hee Tong in Shanghai, producing the aforesaid *tiu king* pills. Eventually two factories were established, on Jiangya Lane in Guangzhou and on Hollywood Road in Hong Kong, and the medicine won acclaim for its remarkable effects.

A photograph of the entire Lam family, taken in the 1930s. Seated in the center of the middle row is the matriarch, Liu Kwan Ying, with her daughter-in-law, Lam Tong Kat Lam, at her far left.

When I comment on the exquisite packaging of Tin Hee pills 天喜丸, Lam Tong Kat Lam explains that her father-in-law was really particular about packaging. "He hired someone especially to design the glass bottle, and the name Tin Hee Tong decorated both the bottle and lid. Counterfeiters would have to spend a lot of money and effort if they were to produce imitations." Once she sought advice from a senior member of the family on replacing the glass bottles with plastic. He replied with a question: "Haven't you seen perfume from Paris in plastic bottles? No, never. The value of premium packaging lies in the glass bottle so the fragrance won't leak out!" His answer enlightened Tong Kat Lam. Since then, Tin Hei Tong has used glass bottles for their medicine packaging.

Once a renowned and flourishing business, Tin Hei Tong today occupies just small premises measuring no more than one thousand square feet in an old building in Sai Wan Ho, Hong Kong, which combines the workshop, packaging facility, and retail space under one roof. Since 1983, when Lam took over the family business, she has never taken a day's leave and manages everything single-handedly, but she openly admits that at age seventy-five, her health is deteriorating. Her husband died three years ago, and because all her children live overseas, she can only count on the support of a few aging employees. In 1997 the economic crisis that affected most of Southeast Asia dealt the business another serious blow, and recent government proposals to regulate traditional Chinese medicine have given her yet further cause for concern. She says, "We

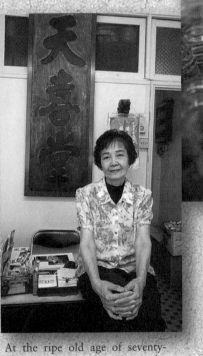

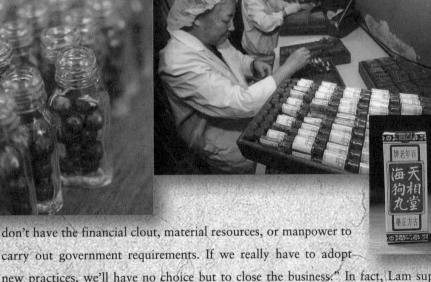

don't have the financial clout, material resources, or manpower to carry out government requirements. If we really have to adopt new practices, we'll have no choice but to close the business." In fact, Lam supports the regulation of traditional medicine as a means of boosting public confidence but confesses that she doesn't always comprehend the government's intentions. She merely bows to the inevitable and says, "My ancestors will not judge me harshly. They know that I have done everything possible to preserve Tin Hee Tong's heritage up till now, in spite of all the difficulties."

At the ripe old age of seventy-five, Lam Tong Kat Lam, the present head of Tin Hee Tong, still worries about the future of her business.

Wai Yuen Tong: Keeping One's Promise

Wai Yuen Tong 位元堂 was first established in 1897 with a store at 44 Jianglan Street, Guangzhou, as a wholesaler of herbal medicine; the business was later expanded to include a shop in Hong Kong in 1930. The entire operation moved its base to Hong Kong in 1952. Unlike other medicine shops, Wai Yuen Tong was a cooperative run by different families who held meetings to decide important matters. The original document, which set out the terms of the joint venture, still survives and bears witness to the long-standing principle that successive generations would provide medicine for the needy.

From the beginning the Lai family has been a major partner in Wai Yuen Tong. The family's natural successor, Lai Chung Men 黎中岷, a devoted Taoist, had no interest in business matters, however, and since no other family members were willing to manage the company's affairs, the responsibility fell to Lai's wife. Wisely she prepared herself

Unlike the dimly lit interiors of Chinese medicine shops, the decor of Wai Yuen Tong's main store, on Nathan Road, is bright and modern while it retains traditional elements.

The packaging of Young Yum pills may have changed over the years, but it retains a look of sober elegance.

Lai Siu Tong 黎兆棠 was a former partner of the Wai Yuen Tong business.

for the challenges ahead. At first many shareholders did not trust her, because she regularly traded on the stock market, and they feared that she would gamble away their investment. She says, "There was nothing I could do to allay their fears but promise that business would be profitable without their needing to pump further capital into the venture." Lai still recalls how her heart pounded when she made that promise to the shareholders. She continues, "I could feel the mental burden of having to live up to my bold assertions." This would not be the first time she overcame stress.

Her first attempt at reform was met with strong objections from the shareholders, who angrily rejected her plans to change the medicine's packaging, claiming it would bring infamy upon the company. Anticipating their negative response, however, Lai did not back down. Instead, she faced them bravely and said, "Just give me a chance!" After heated debate, the shareholders finally relented on the issue, but it was only the prelude to bigger battles.

Although she considered the company's packaging outdated, Lai was sensitive to the fact that drastic changes could be detrimental to the customers' loyalty to the brand and that they might even suspect the newly packaged products of being fake. Thus, she only made minor changes to the packaging on a trial basis. "People soon got used to the changes, and within a few months business grew! Although there was some decline in the Southeast Asian market, local profits more than compensated for the losses." Not content with her achievement, she pressed ahead with the second round of her reforms.

First Wai Yuen Tong adopted expensive Japanese technology to produce unique tin packaging that would be difficult to counterfeit. As the second part of her management strategy, Lai abandoned television and print advertisements and concentrated instead on direct sales. The move to set up booths in department stores and chain stores was warmly welcomed by customers. She also favored a more democratic approach to business, empowering employees to speak out to the management if they felt the quality or appearance of the medicine was compromised in any way. "I have always subscribed to a sense of responsibility and purpose," adds Lai, who is justly proud of her initiatives and firmly believes that the guarantee of quality products is paramount.

Encased in wax shells, Young Yum pills reflect a sense of rare quality that customers can count on.

This century-old contract on red paper outlines details of the Wai Yuen Tong partnership.

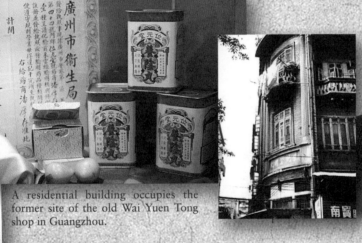

A residential building occupies the former site of the old Wai Yuen Tong shop in Guangzhou.

The receipt of the Wai Yuen Tong in 1926

"In the past the constant threat of malnutrition meant that people ingested copious amounts of medicine, which was presented in the form of large pills." As people's health improved and lifestyles changed, smaller doses of medicine sufficed, and, after repeated research and testing, Wai Yuen Tong presented pellets in convenient pocket-size tins. Later, Young Yum pills were packaged to resemble candy to appeal to youngsters. Wai Yuen Tong still provides larger pills for the elderly, though, in recompense for their declining health and sluggish metabolism. In so doing Lai aims to meet the needs of all age groups. She has firmly held convictions in the power of Chinese medicine and in the future development of Wai Yuen Tong. "The superiority of Chinese medicine," she claims, "lies in facilitating the body's circulation and keeping a balance between yin and yang. Western medicine only affords stopgap measures by alleviating the symptoms of an illness."

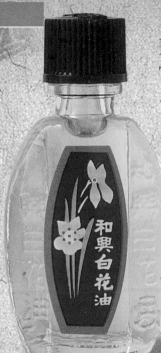

Hoe Hin Pak Fah Yeow:
The Triumph of the Little White Flower

The Pak Fah Yeow brand stands at the forefront of Chinese medicinal oil products. Once sniffed, the uniquely pure and fresh fragrance is never forgotten. Compared with other traditional medicine companies, Hoe Hin Pak Fah Yeow has a relatively short history, which hinges on an ambitious overseas Chinese entrepreneur who started from scratch.

Born in 1900, Pak Fah Yeow's founder, Gan Geog Eng 顏玉瑩, grew up in Penang, where he ran errands between Malaysia and Singapore for his father's grocery business. His ancestral home, however, was in Haiqing county, Fujian province. Two different stories circulate about how he obtained the formula for Pak Fah Yeow. The first alleges that a doctor working on an ocean liner gave Gan the prescription when he was on a buying trip. The second tells of a secret formula handed down by the ancestors of Gan's first wife, Low Khoon

Despite subtle changes in Pak Fah Yeow's packaging over the years, the medicine remains as popular as ever and retains its signature glass bottle.

Packaging destined for various markets around the world is distinguished by different colors to curtail the confusion caused by the sale of parallel products.

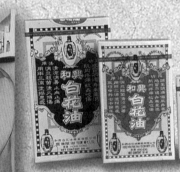

Gan Geog Eng rubs shoulders with famous stars of the era.

In the 1950s the delivery vans of Pak Fah Yeow's Burmese agent served to raise the product's profile.

Choo. Although these stories may be fictionalized, there is no disputing the enduring popularity of Pak Fah Yeow. Gan's reputation rested on this product alone; in this respect he was considered a pioneer. He set up a factory in Penang in 1927 and registered in Malaysia under the name Hoe Hin Company 和興公司. Eyeing huge market potential in China, he registered in Nanking in 1945 and shifted the company base to Hong Kong in 1950, bringing his family with him. Inspired by the Southeast Asian tycoon Aw Boon Haw of Tiger Balm fame, he set up a production plant in

Hong Kong and carried out extensive promotional campaigns with high hopes of building a name for the company.

According to longtime employee Chao Sin Kuen, "Gan created the name Pah Fah Yeow [white flower embrocation] because he liked the narcissus flower, and the name's three characters had a ring of simplicity that even children could grasp." Chao gives high praise for his boss's creativity and insight. "Fifty years ago," he recalls, "posters and adverts for the oil could be seen everywhere, particularly in the Aberdeen Typhoon Shelter, where the owners of junks and sampans were paid to drape banners over the rear of the boat. This image was even captured in the Western movie *Love Is a Many Splendored Thing*, starring William Holden and Nancy Kwan!" Chao recalls with a smile.

By the 1970s Gan had begun to nurture hopes of listing Pak Fah Yeow on the stock market. To his dismay, however, the 1973 Middle East oil crisis and a heavy slump in the local stock market forced him to put his plans on hold. He died in 1981, and his dream was not realized until 1991. The family business is now managed by his youngest son, Stephen Gan Fock Wai 顏福偉 (picture below, right), his eldest grandson, Gan

In the 1970s the forward-thinking pharmacy set up its own laboratory for quality control and inspection, paving the way for trade with overseas markets.

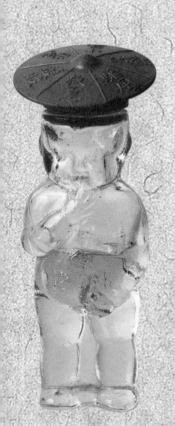

A souvenir was created for the 1951 Hong Kong Products Expo that was inspired by Gan Geog Eng's favorite novelty fountain in Belgium.

Wee Sean 顏為善, and his loyal employee Chao Sin Kuen. In recent years the company has invested some ten million dollars in establishing a plant to meet international regulations governing the industry and has developed a modernized production line. It has also developed a delicately perfumed series enhanced with spices and introduced a modern aromatherapy line to appeal to the younger generation.

Last year Gan Fock Wai advocated setting up a hospital to advance research in Chinese medicine, to enhance both its status and quality. The company also sets aside ten percent of the proceeds of its sales to cover the cost of research and development.

Gan Fock Wai models himself on his father's exemplary image, fervently seeking to open up a new era for Pak Fah Yeow. His greatest wish is to make Pak Fah Yeow an international household name and to stamp his own indelible mark on the family business.

Eu Yan Sang:
Breaking New Ground

Eu Tong Sang took over the reins from his father, turning Eu Yan Sang into a thriving business. By the 1920s he had established a reputation as one of Southeast Asia's most successful Chinese tycoons.

Eu Kong, founder of Eu Yan Sang.

Whenever I pass by Eu Yan Sang's medicine shop on Queen's Road, Central, I am always struck by the resplendent storefront, especially by the mounted knight in shining armor, whose lance is raised in a posture of strength and honor. Since it was established in 1926, the company has only moved once, in 1991, but it is still located on the historic Queen's Road, Central. For four generations the business has engaged not only in selling precious medicinal materials but also in the manufacturing of numerous traditional herbal products. The Eu Yan Sang brand name has become synonymous with success.

Its origins can be traced back to groups of overseas Chinese workers in the nineteenth century. In 1870 Eu Kong Pui 余廣培 (alias Eu Kong) together with his wife left his hometown in Foshan, bound for Malaysia. Many Chinese worked in the tin mines there, and, subjected to the rigors of hard labor and perilous working conditions, they smoked opium to forget their woes. In time the debilitating effects of their work environment, coupled with their opium addiction, meant that most were in a poor state of health. Without proper medical attention they ultimately died a lonely and painful death in an unfamiliar land. Concerned for the miners and their miserable lives, Eu Kong tried to help the workers by producing medicine based on a prescription, handed down by his ancestors, using quality medicinal herbs. He set up his first Chinese medicine shop in Gopeng in 1879 and named it Yan Sang 仁生藥店, which means "caring for mankind." The business was further developed by his son, Tong Sang 余東旋, who also operated tin mines and ran a gum trade. By the 1920s he had become one of Southeast Asia's wealthiest and most successful Chinese merchants, with medicine shops in Kuala Lumpur, Padang, Ipoh, Singapore, Hong Kong, and China.

余

開拓革新

生

Edified by Western culture, Tong Sen developed a liking for the British colony of Hong Kong. In the 1930s he owned three palatial residences in Hong Kong, all modeled on a classical European style and an ample demonstration of his wealth and status. The now demolished Eu Yuen [Eu mansion], located on Bonham Road, was a familiar sight to the people of Hong Kong.

Living a life of luxury, Tong Sen collected antiques, savored French wines, and wore superbly tailored Western suits. With his customary silk scarf peeking out of his suit pocket, Tong Sen had a striking appearance and refined tastes, which distinguished him from his nouveau riche peers. He died in Hong Kong in 1941 at the age of sixty-four, and his legacy was divided among thirteen sons. Ownership of the business was also divided for more than half a century, and it was only in 1996 that the family was unified once again, putting an end to many years of discord.

Eu Yan Sang's store on Queen's Road, Central, was established in 1926.

Eu Yan Sang produces numerous herbal products that boast superior medicinel effects.

The present-day Eu Yan Sang has an eye-catching and resplendent window display, complete with a mounted knight to guard the shop.

More recently Eu Yan Sang has actively launched reforms, marking a bold departure from the approach of conventional Chinese-medicine shops. New branches have been set up in the newly established shopping arcades of residential estates, appealing to younger consumers. The company has also developed new forms of herbal medicine to complement its existing range of well-known medicines, like Eu Yan Sang Pak Foong Pills 余仁生 白鳳丸, the product of choice for generations of women. In the 2000s the company took steps to scientifically prove the curative effects of Pak Foong Pills and has cooperated with the government to promote the territory as a hub for Chinese medicine.

Legendary Aw Boon Haw

Aw Boon Haw 胡文虎 was an outstanding figure, renowned among Chinese communities everywhere for his philanthropy and his dramatic rise from being the reputed King of Tiger Balm to being a newspaper mogul.

His father, Aw Chu Kin, was a poor herbalist of Hakka descent who migrated from Fujian province to the Burmese capital, Rangoon, where he set up a small Chinese herbal shop called Eng Aun Tong [Hall of Everlasting Peace]. He had three sons; the first-born died young, the second was called Boon Haw [Gentle Tiger], and the third was named Boon Par [Gentle Leopard]. At the age of ten Boon Haw was sent back to China by his father to receive his education, a common practice among overseas Chinese who wished their sons to be acquainted with their origins. When Aw Chu Kin died in 1908, he left the Eng Aun Tong business to his two sons. While the conservative Boon Par was content to remain in Rangoon, his more outgoing brother was highly ambitious, setting off on missions to Singapore and Malaysia to promote the sale of the family's medicinal goods. Fortune smiled on Boon Haw, and in Singapore he met an old man of the same Aw clan, a doctor trained in Western medicine and an expert herbalist who practiced in the local Chinese town. In spite of their age difference, the two became good friends, the older man bestowing on Boon Haw a secret formula for producing tiger balm. Upon his return to Rangoon, Boon Haw roamed through villages with his medicine chest and assistants, promoting the ointment with conspicuously positioned posters. He often worked late into the night, fueled by an unwavering determination and assiduousness.

With his savings he set up a small factory in 1926 to produce Tiger Balm and powder for healing headaches, relocating to Singapore in the same year. The decision to move with his family was a shrewd one, for he fully recognized Singapore's potential as a

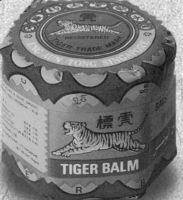

Tiger Balm has used this hexagonal-shaped packaging since 1926.

commercial center, having a large overseas Chinese community and being an important gateway for both China and India, with strategic transportation routes. When Aw Boon Haw first arrived in Singapore, there was no shortage of herbal remedies available for minor illnesses; thus, he had to adapt to the local market and lower the price of his products accordingly.

In 1929 and 1938 respectively, Aw Boon Haw founded *Singapore Daily* (Sin Chew Jit Poh) in Singapore and *Sing Tao Daily* in Hong Kong, enabling him to gain wider exposure for his leading remedy Tiger Balm. Despite the stricken global economy of that time, Aw Boon Haw's newspaper became the preferred reading matter, and he launched more than ten Chinese - and English-language newspapers across Southeast Asia. His influence spread far and wide, and he came to be considered an entrepreneur who "served and spoke on behalf of Chinese society."

At one time the "gentle tiger" boasted a string of medicine shops spanning Burma, Thailand, Malaysia, Singapore, the East Indies, Hong Kong, and China, as demand increased for his medicine during the Second World War. He had amassed fabulous wealth and held a high position in society. Eventually, however, the chinese medicine business suffered heavy losses during the country's changing political climate and was further eclipsed by the growing popularity of Western medicine.

Aw Boon Haw made every endeavor to preserve and promote Chinese culture, establishing the Aw Boon Haw Mansion in

Hailed the Disneyland of the East, the Aw Boon Haw Garden is one of Hong Kong's best-loved scenic spots, popular with tourists and locals alike.

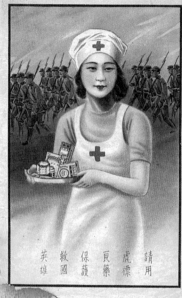

Tiger Balm ointment was included among vital military supplies during the war.

Singapore and the Aw Boon Haw Garden in Hong Kong. The latter, described as the Disneyland of the East, attracted hordes of visitors, locals, and tourists alike, who praised the design of the beautiful mansion and bewitching garden (complete with fantastic grottoes). Sadly the Aw Boon Haw Gardens was demolished in 2002. Though becoming a distant memory, the legendary life of Aw Boon Haw still remains firmly implanted in the minds of the Chinese.